Ghirlandaio

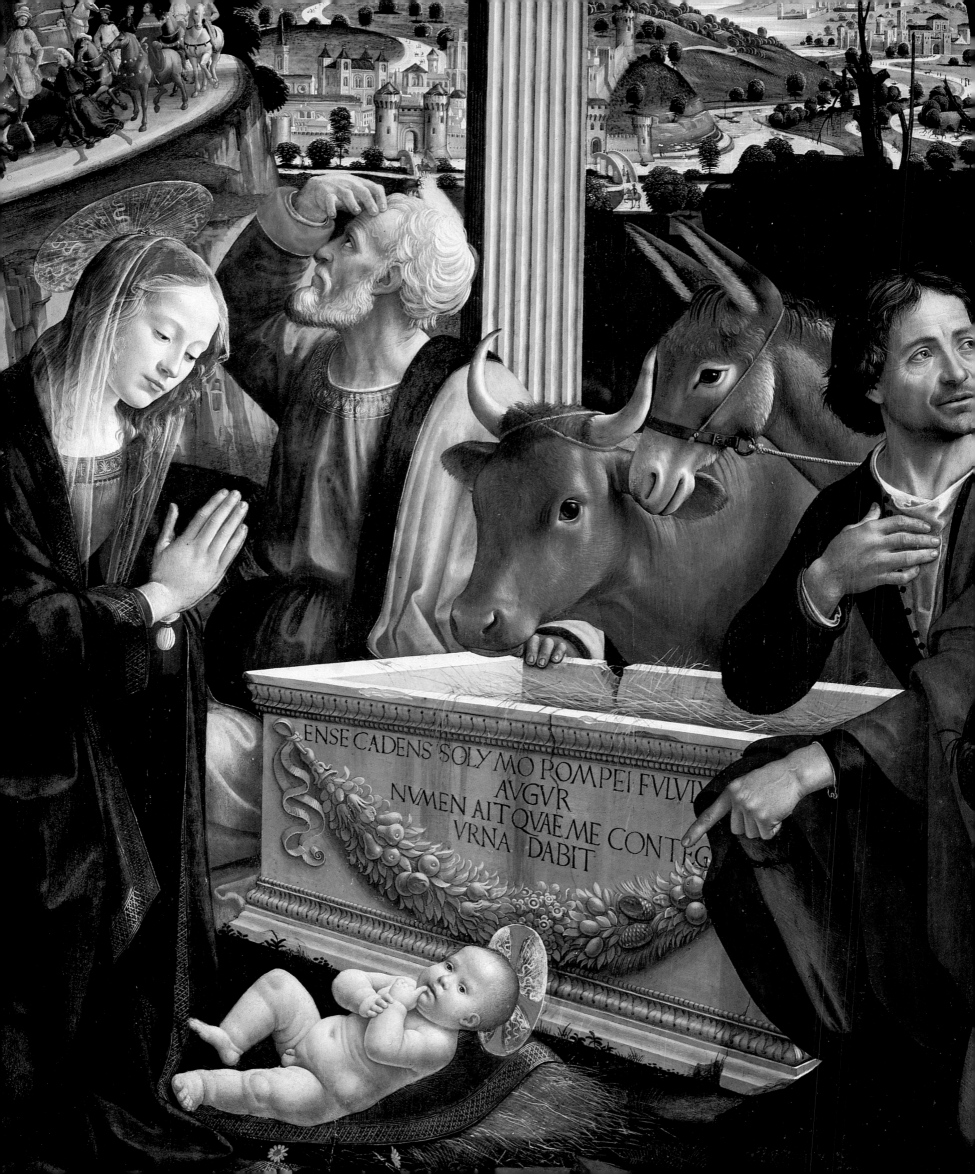

Andreas Quermann

Domenico di Tommaso di Currado Bigordi
Ghirlandaio

1449–1494

KÖNEMANN

1 (frontispiece)
Adoration of the Sheperds (detail ill. 59), 1485
Panel, 167 x 167 cm
Santa Trinità, Cappella Sassetti, Florence

© 1998 Könemann Verlagsgesellschaft mbH
Bonner Str. 126, D-50968 Köln

Art Director: Peter Feierabend
Project Manager and Editor: Sally Bald
Assistant: Susanne Hergarden
German Editor: Ute E. Hammer
Assistant: Jeannette Fentroß
Translation from the German: Fiona Hulse
Contributing Editor: Chris Murray
Production Manager: Detlev Schaper
Layout: Andi Huck
Typesetting: Greiner & Reichel Fotosatz, Cologne
Reproductions: Omniascanners, Milan
Printing and Binding: Neue Stalling, Oldenburg
Printed in Germany

ISBN 3-8290-0248-3

Contents

INTRODUCTION

2 *Expulsion of Joachim from the Temple* (detail ill. 63), 1486–1490

Here Domenico Ghirlandaio himself appears on the edge of a religious scene, looking very self-assured. Standing on the far right, he looks at the viewer and with his right hand points proudly at his chest. According to Vasari, the figure in front of him, with his back to us, is his brother Davide; the figure behind Domenico is his brother-in-law Sebastiano Mainardi. Both Davide and Sebastiano worked in Ghirlandaio's large workshop. Apparently Tommaso Bigordi, Domenico's father, completes this family group.

The painter Domenico Ghirlandaio died of the plague in 1494 in his native city of Florence when he was only forty-five years old. He was one of the most famous artists of his age and, according to tradition, the teacher of Michelangelo. The most important social, political and ecclesiastical figures of the day commissioned him; influential families chose him and his workshop to decorate their private chapels with monumental cycles of frescoes and large panel paintings. Some of these ensembles, which still exist in their entirety today, are among the most important expressions of the Italian Early Renaissance, which drew to a close with Ghirlandaio.

Most of Ghirlandaio's works are still in Florence. This was the city where he directed a very busy workshop in which both his brother-in-law Sebastiano Mainardi and his brothers Benedetto and Davide worked (ill. 2); Davide is thought to have dealt primarily with the business side of the workshop. This, therefore, was a family business, a familiar division of labor among artists at that time. Though others worked on the paintings that came from the workshop, contemporaries felt them to be "genuine Ghirlandaios" – a brand name for artistic excellence.

Ghirlandaio's real name was Domenico di Tommaso di Currado Bigordi. In his description of Ghirlandaio's life, the famous artists' biographer Vasari wrote how he came to have his artist's name of "Ghirlandaio": Domenico's father, a master goldsmith, invented a head ornament for the city's noble women that consisted of flower garlands made of precious metal. This piece of jewelry became so popular that the goldsmith was nicknamed "the garland maker, il Ghirlandaio", a name

which his sons inherited. Surviving land registers, however, state Domenico's father was a dealer or broker.

According to Vasari, it was intended that Domenico, as the eldest son, should train to become a goldsmith so that he could take over his father's workshop. But he preferred the art of drawing, and instead of learning his trade sketched the people who went past the workshop. This is how Domenico developed his ability as a portrait painter from an early age. Eventually his father allowed him to learn the techniques of painting and mosaic making from the Florentine artist Alessio Baldovinetti. Later, it is likely that Ghirlandaio spent some time in the workshop of Andrea del Verrocchio, which produced some of the most famous artists of the era: Lorenzo di Credi, Sandro Botticelli, Perugino and Leonardo da Vinci. Like Leonardo, Ghirlandaio was made a member of the Florentine brotherhood of Saint Luke, a painters' guild, when he completed his training in 1472.

As a contemporary of the already famous artists Domenico Veneziano, Piero della Francesca and Andrea del Castagno, Domenico Ghirlandaio took his place among a series of outstanding Early Renaissance painters. He was certainly the equal of his artistic colleagues and competitors Botticelli and Perugino, who were about the same age; they survived him and, together with Leonardo da Vinci, marked the transition to the High Renaissance about 1500. Ghirlandaio, then, belonged to the last generation of painters of the Early Renaissance. The High Renaissance was to reach its zenith in the 16th century with Raphael, Michelangelo and Titian.

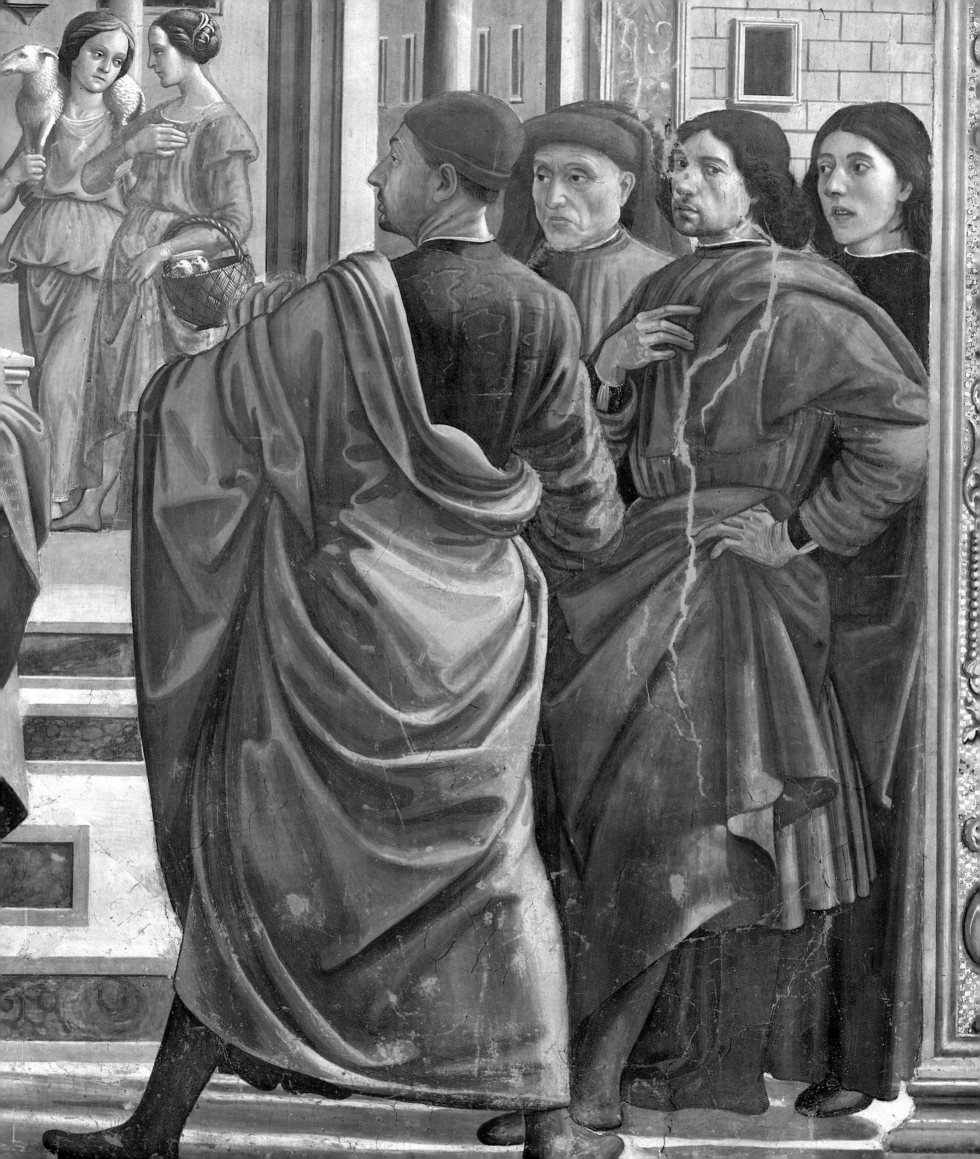

The Early Work, Ghirlandaio's Teachers and Models

The Apse Fresco in the Pieve di Sant' Andrea

Ghirlandaio's earliest surviving work can be found in a parish church close to Florence. In 1471, he painted a fresco in a side apse of the small parish church of Sant' Andrea in the town of Cercina. Within the small space of the apse he created an illusory architectural setting consisting of three niches separated by Corinthian pilasters. In the center niche Saint Barbara is standing on the body of her father, who has been struck down by lightning. On either side of her are saints Jerome and Anthony (ill. 3). Everything is arranged to highlight the female saint. The gentle colors in which she is depicted, purple and a light, almost violet red, harmonize her with the golden orange of the capitals and upper part of the apse. The large square under her niche is also painted in a reddish brown imitation marble to emphasize the central axis, while the squares on either side correspond to the muted colors of the two hermits.

In this fresco, the young Ghirlandaio was playing with illusionistic techniques in order to prove what he and his art were capable of. The shadows cast by the figures suggest they are standing freely in the niches; the figures are not rigid, and their movements and their physical presence expands the space they seem to occupy. Here painting is becoming three-dimensional, the figures free to move.

Saint Anthony is marking the outer border of his niche with his staff and is not venturing across it (ill. 6). In contrast, Saint Jerome, cautiously taking a step forward, is feeling his way onto the painted cornice with his bare toes (ill. 4). In this detail the artist is not only creating a spatial effect, he is also adding a tactile element that is reminiscent of Flemish painting – in Jan van Eyck's *Ghent Altarpiece*, painted in 1432, Adam and Eve are taking a step forward in their niches. There is, however, a more immediate model for Saint Jerome's posture and physical stature: a fresco by Domenico Veneziano, painted after 1455, in the Florentine monastery of Santa Croce, in which Saint John the Baptist is depicted in a similar manner.

The hands of Saint Barbara's father, who has been struck down for having his daughter killed because of

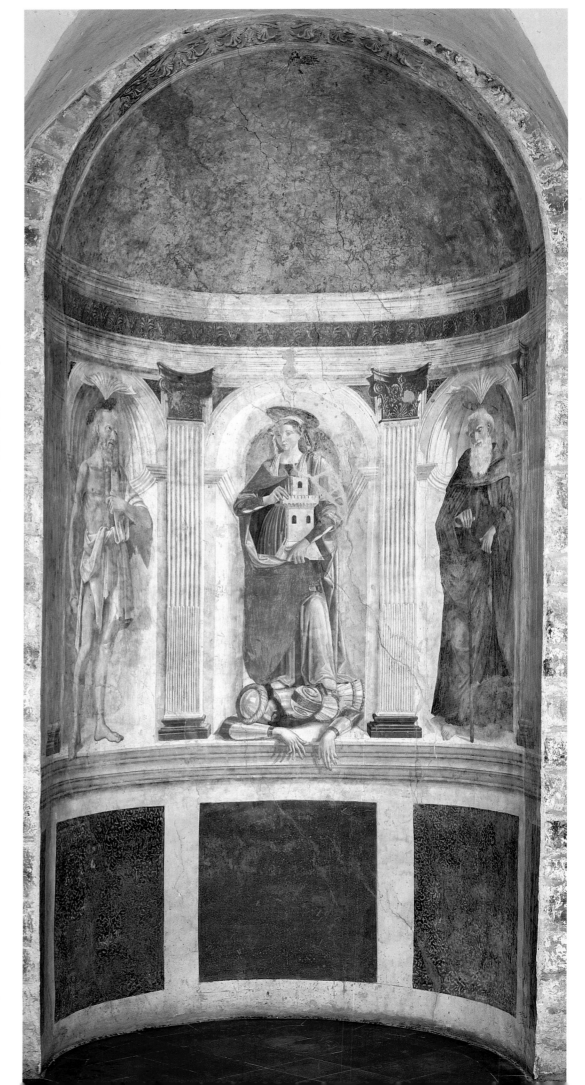

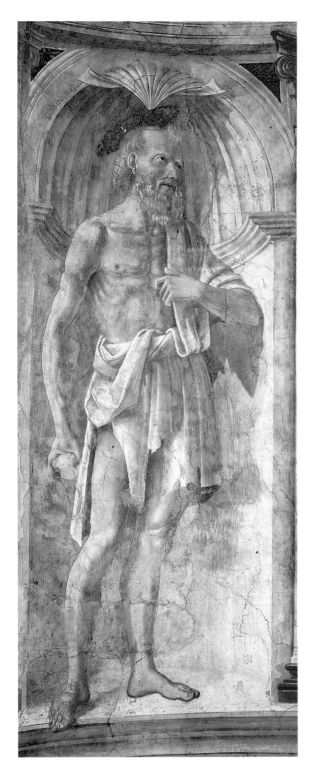

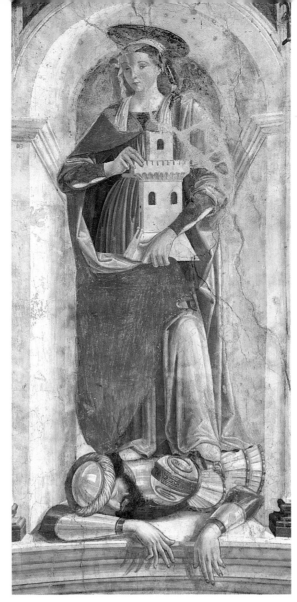

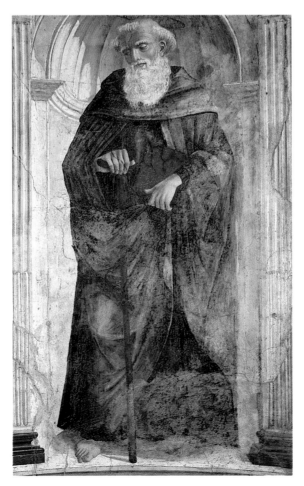

3 (opposite) Apse fresco, ca. 1471
Santa Andrea, Cercina near Florence

This fresco is Ghirlandaio's earliest surviving work. Saints Barbara, Jerome and Anthony are standing in illusory niches between painted pilasters. The vivid color of her garments and the different shape of her niche give greater emphasis to the figure of Saint Barbara, who stands between the two old men. She is holding her attribute, a tower, and in contrast to the two other saints is looking directly at us.

4 (this page, left) *Saint Jerome*, (detail ill. 3), ca. 1471

Saint Jerome, wearing a torn penitential robe, is looking across at Saint Barbara. His wiry, semi-naked body seems to have been ravaged by the hardships of his hermit's life. In his right hand he is holding a stone with which to beat himself. His stance is reminiscent of classical contrapposto, his right foot protruding out of the space of the niche across the painted cornice.

5 (this page, above right) *Saint Barbara*, (detail ill. 3), ca. 1471

Because she was so beautiful, Barbara's pagan father locked her in a tower. She converted to Christianity, and against his wishes built in her tower a chapel, its three windows symbolizing of the Trinity. Enraged, her father had her beheaded. Here she is depicted standing triumphantly on the armor-clad corpse of her father, who has been killed by a bolt of lightning. His hands are hanging down over the cornice, where they are casting illusory shadows.

6 (this page, below right) *Saint Anthony*, (detail ill. 3), ca. 1471

In contrast to his counterpart, Saint Jerome, Saint Anthony is dressed in a dark monk's habit. He is looking downwards at the figure on which Saint Barbara is standing. The attributes he is carrying are a book and the T-shaped staff on which he is leaning.

her Christian beliefs, are casting shadows on the cornice underneath (ill. 5). The hands appear to be projecting right out of the niche into real space, an impression that raises the question of whether these figures are painted or sculpted. Such illusionistic methods of depiction lead us to assume that there was competition between the arts. A few years later, Andrea del Verrocchio extended the "play" between the internal and external in sculpture on the façade of the shrine of Orsanmichele in Florence, by placing the figure of Doubting Thomas at very front of the niche in which Christ stands.

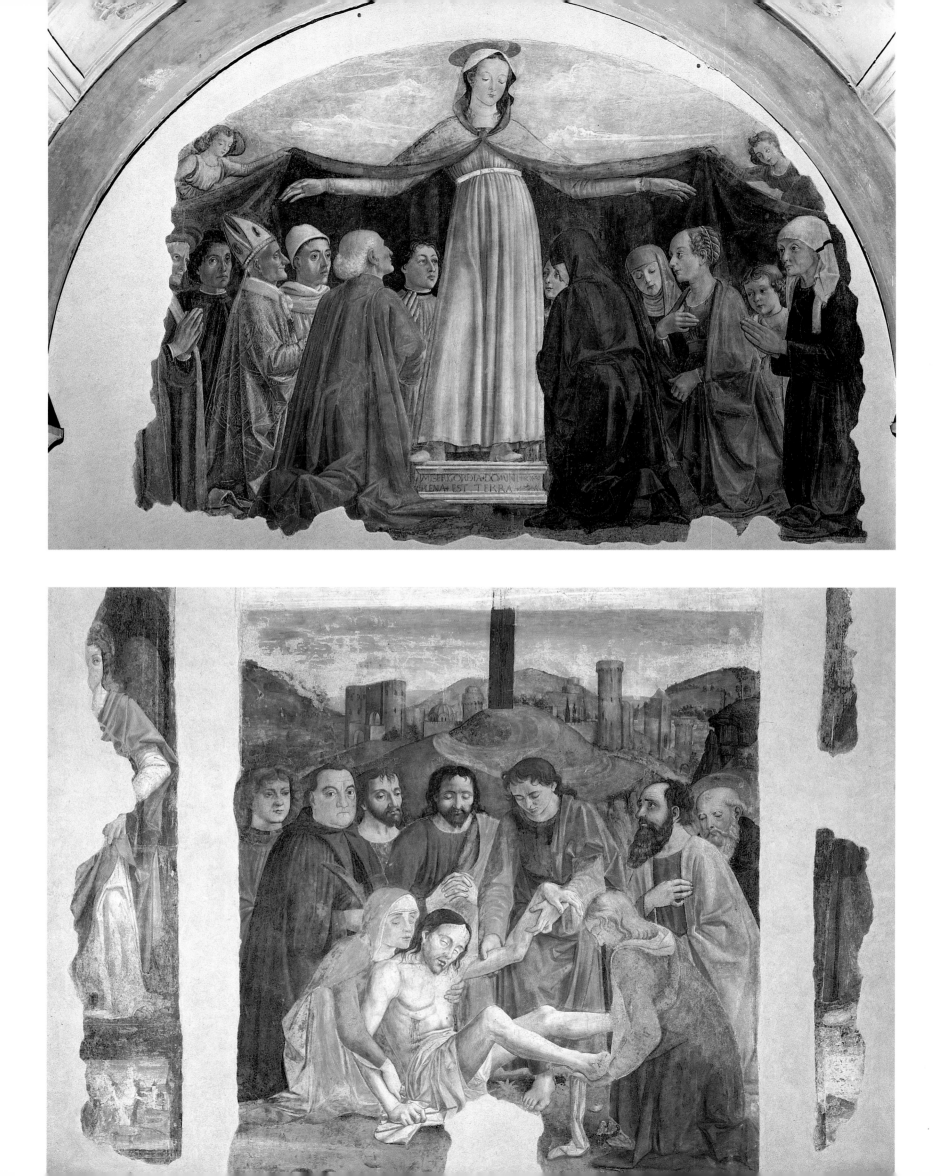

THE VESPUCCI CHAPEL
IN THE CHURCH OF OGNISSANTI

The influential Florentine Vespucci family commissioned Ghirlandaio to decorate their mortuary chapel, which had been built in 1471, with a *Madonna of Mercy* and a *Lamentation*. The frescoes were later moved and are now in a poor condition in the second altar niche to the right of the entrance to the church. In these frescoes, Ghirlandaio for the first time demonstrated his ability to incorporate vivid portraits of his contemporaries into religious paintings in a completely natural manner.

The *Madonna of Mercy* (ill. 7) in the tympanum above the *Lamentation over the Dead Christ* (ill. 8) has some stylistic similarities with Ghirlandaio's earliest fresco in Cercina. The standing Virgin is surrounded by a circle of young and old members of the Vespucci family, kneeling in prayer; the men have the place of honor on Mary's right. Under the protection of the *Madonna of Mercy*, the family are enjoying the mercy of the Lord, as promised in the inscription on the stone base under the Madonna: MISERICORDIA DOMINI PLENA EST TERRA (the earth is fully of the mercy of the Lord). It is debatable whether the Vespucci, gathered under the cloak that the angels are holding open, are seeking protection from earthly misfortune or from the anger of God at the Last Judgment.

Mary's garment, with its high waistline, has vertical folds like a fluted column. Raised a little higher by the marble base on which her feet rest, her figure forming a gentle S-shape, she stands above those entrusted to her, a gentle protector. In contrast to earlier examples of this theme, the figures in this fresco are just as large as the Virgin herself. Piero della Francesca, for example, depicted his *Madonna of Mercy*, painted between 1445 and 1462 in his home town of Borgo San Sepolcro, as a figure much larger than those kneeling in a circle around her, in keeping with the tradition that a person's importance determined their size. Piero's Madonna is opening her cloak herself and, because of her size, does not need to stand on a pedestal. In Piero's panel painting only the donors appear particularly vivid; in Ghirlandaio's fresco the figure of the Madonna has a gracefulness that overcomes the frontal rigidity of Piero's Madonna.

Piero della Francesca had also separated the figures in his painting according to gender, and depicted those at the front in *profil perdu*. Ghirlandaio makes an even more marked use of this technique: the impressive old man in a shining red cloak, whose back is turned to us, is presumably the head of the Vespucci family. Ghirlandaio traced his profile boldly. But the face of the other figure seen from behind kneeling in front of the Madonna, the old man's wife, is scarcely visible.

Ghirlandaio's young lady, between the two old women dressed in black, is wearing her plaited hair up, and in keeping with Florentine fashion of the time her forehead is shaved smooth. Her counterpart on the men's side is the kneeling archbishop, possibly the archbishop of Florence. Ghirlandaio depicts the age of the churchman, who is depicted in a full profile, with merciless candor. His toothless mouth appears to have sunk in between his pointed nose and chin.

The reddish-yellow gold of the archbishop's brocade cloak is a color accent that Ghirlandaio has placed next to the red of the figure seen from behind, and repeated to a lesser degree in the figure on the far left wearing a fashionable hat. Contrasted with a dark green, the red sounds again, though more faintly, in the cloak of the young woman on the right and the angels' robes. Black and other muted colors dominate the women's side of the painting.

The Madonna is painted in a stone color like that of the marble base on which she is standing. Even the flesh tones of her hands reflect its color, in contrast to her face, which is tinged with pink. As in the Cercina fresco, Ghirlandaio is playing with the possibilities of painting here. Did he conceive this Madonna, painted in grisaille, as a painted sculpture contrasting with the more vivid donors?

Unusually, the viewpoint of the observer in this composition is at the level of the Madonna's pedestal, so that it is possible to see the inside of the back of her cloak. The reason Ghirlandaio used this viewpoint was that the fresco's position was high and so, because of foreshortening, the area on which to he could arrange his figures was in effect greatly reduced. He nonetheless succeeds in creating a convincing spatial effect in the circle of kneeling figures that is open at the front.

On the wall below the *Madonna of Mercy*, and directly above the altar, there is the fresco the *Lamentation over the Dead Christ* (ill. 8). Covered over until rediscovered in 1898, it is in poor condition. The austerity of this scene, which suggests influences from north of the Alps, corresponds to the bitter subject. It is possible that Ghirlandaio was basing his work on engravings of the Pietà from north of the Alps. The broken body of Christ – a fine nude study with successful foreshortening – has been taken down from the Cross and is being tenderly laid down by his mother, the Apostle John and the blonde Mary Magdalene.

The arrangement of these two frescoes above each other is worthy of note. The way the Madonna of Mercy is standing in the upper picture with her arms outstretched makes her look as if she is crucified on an extension of the Cross in the lower picture. It is doubtful whether this effect was intentional, however, as both pictures have been moved from their original positions.

7 (opposite, above) *Madonna of Mercy*, ca. 1472
Fresco
Ognissanti, Florence

Members of the Vespucci family – men on the left and women on the right – are kneeling in devout worship below the Madonna's cloak, which angels are holding open. Her arms extended, the merciful Virgin is taking the family under her protection. According to Vasari, the figure kneeling behind the Madonna is the young Amerigo Vespucci, the seafarer and cartographer who discovered the Amazon, and after whom the continent of America was named.

8 (opposite, below) *Lamentation over the Dead Christ*, ca. 1472
Fresco
Ognissanti, Florence

Marked by the signs of grief, Mary is embracing her dead son. Mary Magdalene and Saint John are holding Christ's arms and legs, his hands and feet marked with the stigmata. Around the group are six other saints, including, on the right, Joseph of Arimathea and Nicodemus. Behind them, on the Hill of Golgotha, the trunk of the Cross is towering up in front of a view of the city of Jerusalem.

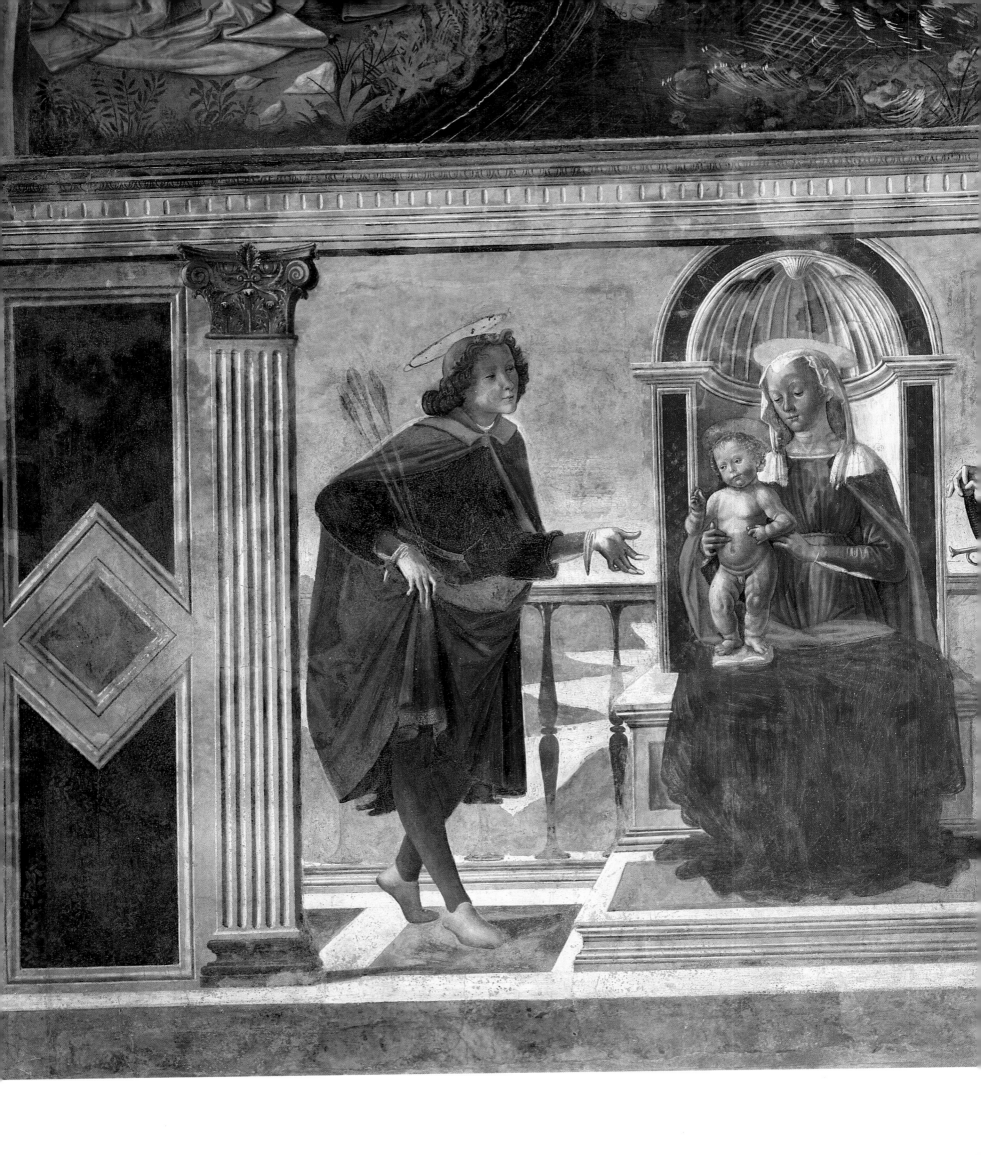

9 *Madonna and Child with Saints Sebastian and Julian*,
ca. 1473
Fresco
Sant' Andrea a Brozzi, San Donnino near Florence

Here Ghirlandaio uses the theme of the *Sacra
Conversazione*, so popular in Italian Renaissance art, for
the first time. The Madonna is sitting on a marble throne,
presenting her child, who is standing on her thigh, His
right hand raised in blessing. Saint Sebastian with his
arrows and Saint Julian with the sword appear in
contemporary dress.

10 *Madonna and Child with Saint Clement, Saint Sebastian, Saint Peter and Saint Paul*, ca. 1479
Panel, 170 x 160 cm
Duomo San Martino, Lucca

A curtain of gold brocade is drawn to one side, making it possible for us to see the enthroned Madonna and the Christ Child. Held gently by His mother, Christ is standing upright on a cushion, His left hand casually resting on His hip, His right hand raised in blessing. Saint Peter and Pope Clement are on the left of the throne, Saint Paul and Saint Sebastian on the right.

MADONNA AND CHILD WITH SAINTS AND THE BAPTISM OF CHRIST, BROZZI

About 1473, Ghirlandaio painted the fresco *Madonna and Child with Saints Sebastian and Julian* (ill. 9) in the church of Sant' Andrea a Brozzi in San Donnino near Florence. It is still disputed whether Ghirlandaio carried out this work, which is in a regrettably poor state of preservation, before or after his work in San Gimignano in about 1475. It is clear that in this Madonna and Child he does not appear to have found his own style yet.

When compared to Ghirlandaio's later versions of this theme, the composition appears to have been constructed rather summarily. The figures seem simply to have been lined up, as if placed on pedestals in niches, a feature that brings to mind the apse fresco in Cercina. In Sant' Andrea a Brozzi, however, the architecture – with the exception of the seashell-shaped niche above the throne and the framing pilasters – has been minimized in favor of a landscape. The saints are no longer standing in niches, but posing on a terrace high above a river. The strictly arranged figures do not overlap in any way and are standing in front of a poorly developed space. In his later use of such themes, Ghirlandaio would attempt to fill every empty space in the picture.

The type of Madonna depicted and the form of the standing Christ Child are clearly influenced by Verrocchio, and it is likely that Ghirlandaio spent some time working in his workshop. It therefore comes as no surprise that Ghirlandaio's name has been put forward as the possible young painter of a comparable panel painting, the *Madonna and Child* from the school of Verrocchio in the Berlin Gemäldegalerie (Inv. no. 108).

The high forehead, sharp chin and narrow lips of Mary, and the upright contrapposto pose of her sturdy child are the features most clearly reminiscent of figures by Verrocchio. The Christ Child, shown naked, is seen from a frontal view standing on a small cushion lying on his mother's right thigh. This motif also was borrowed from Verrocchio and is used by Ghirlandaio on a further occasion in about 1479, on the altarpiece in Lucca (ill. 10), where he makes only slight changes to the child's stance. In both works, the figure of Mary with the high waistline belongs to the same type. Her garment, which has been totally destroyed above the knees in the fresco, can be reconstructed using the one shown in the later panel painting.

Because of the fresco's poor state of preservation, there is little that can be said about the effect of the colors and modelling of the garments. The artistic qualities of this work have been largely destroyed, though this is not a reason for dismissing the fresco too readily.

The two saints on either side of the throne are wearing fashionable clothing and posing rather affectedly. Both figures are derived from models in Castagno's *Assumption of the Virgin* dating from about 1450 and now in the Berlin Gemäldegalerie. This type of young man will frequently appear in Ghirlandaio's later works. Saint Sebastian on the left is turning to the Christ Child with an affectedly elegant gesture, and Saint Julian is holding out his sword. As he does so, he casually places his left hand on his hip. The same posture is rather amusing when seen in the Lucca Christ Child, as it is so unusual for a small child. The relationship of the motifs in the panel painting in Lucca and the fresco in Sant' Andrea can also be seen in the posture of the gray figure of Saint Paul, who is holding his sword in the same manner as Saint Julian. The Saint Sebastian in the panel painting has a similarly angelic face to the one in the fresco. In addition, both figures are holding arrows, the symbols of their martyrdom, with their fingertips.

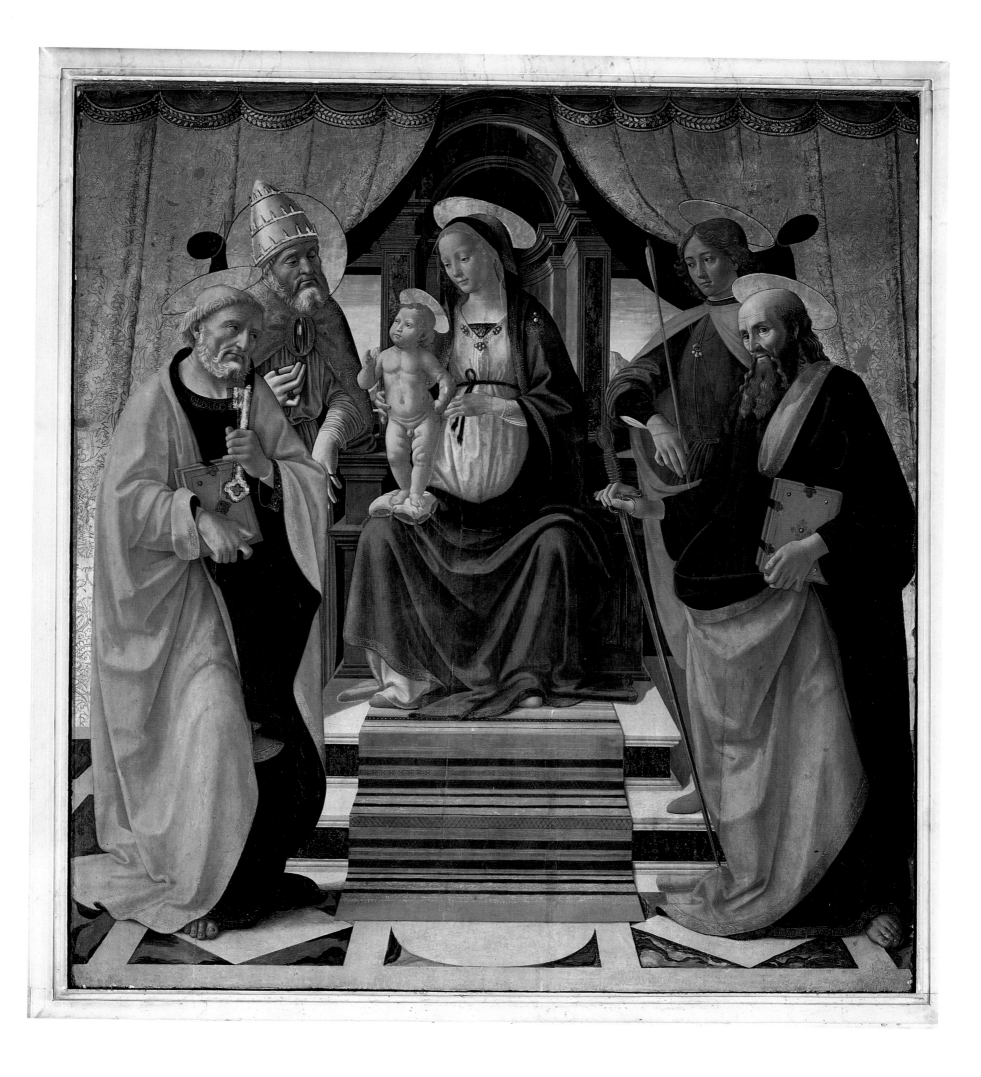

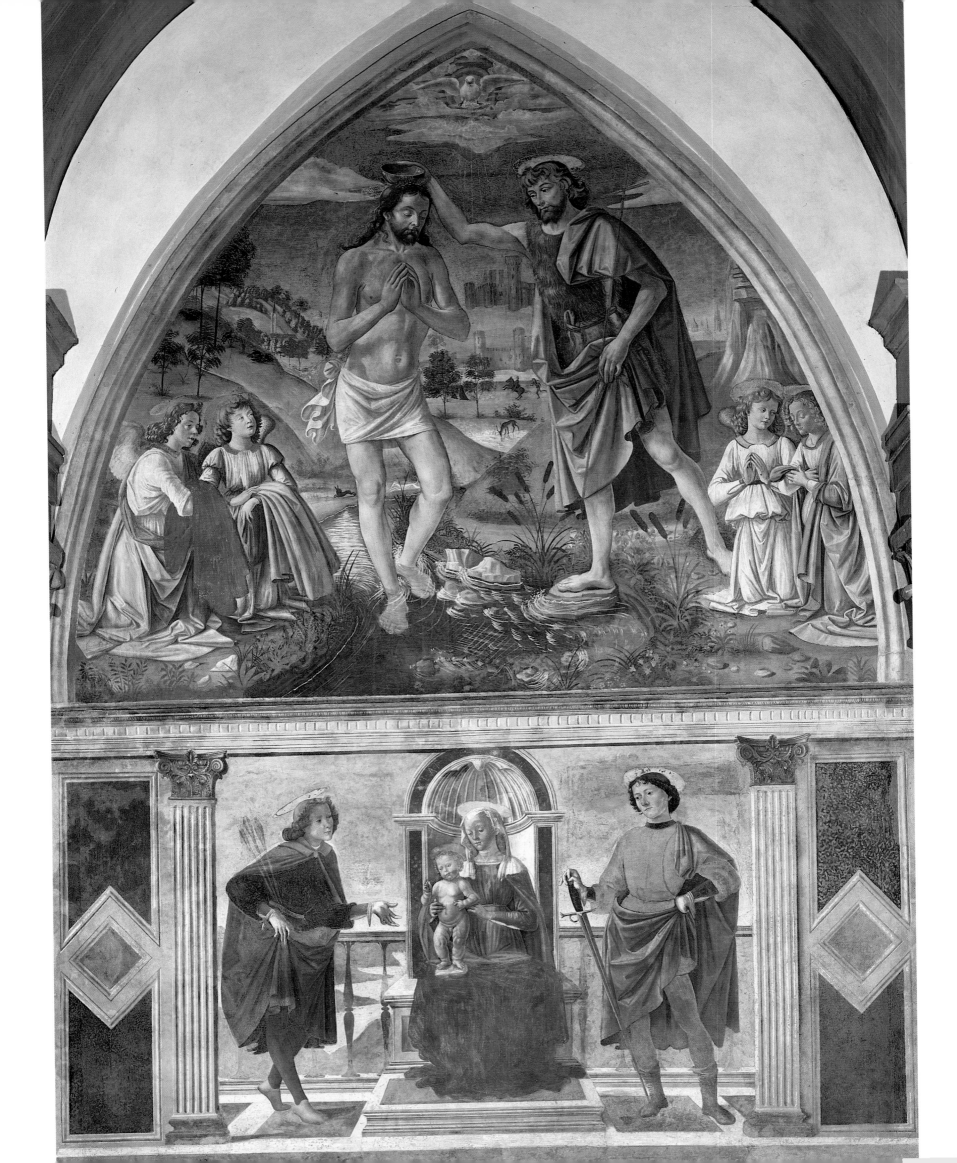

11 (opposite) *Baptism of Christ and Madonna and Child with Saints Sebastian and Julian*, ca. 1473
Fresco
Sant' Andrea a Brozzi, San Donnino near Florence

In the tympanum above the *Madonna and Child with Saints*, two angels are kneeling on the left bank of the River Jordan, shown as a little flat stream flowing towards us. They are holding the clothes of the person being baptized, who is clad only in a loincloth. Christ is standing in water up to his ankles. Saint John the Baptist, in a fur robe, is gathering up his cloak and stepping carefully on to a stone to baptize Christ.

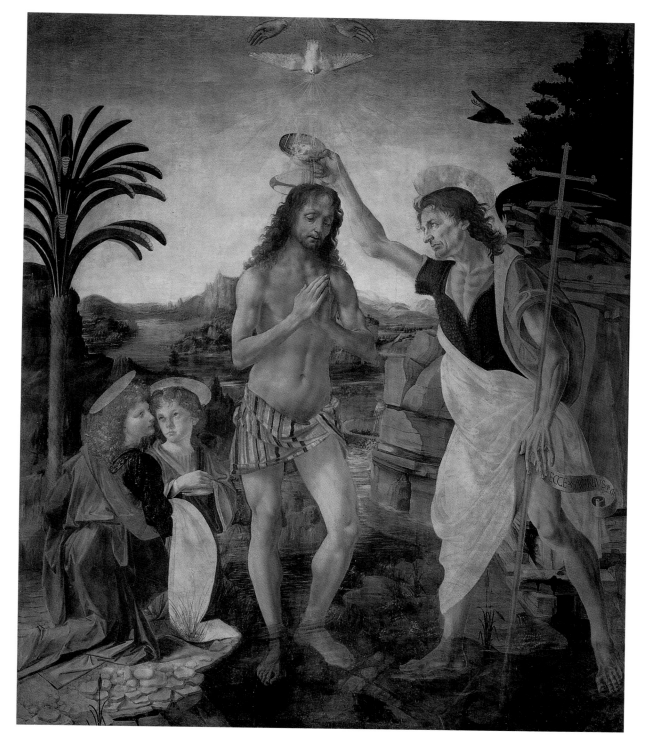

12 (right) Andrea del Verrocchio and Leonardo da Vinci
Baptism of Christ, ca. 1470
Panel, 177 x 151 cm
Galleria degli Uffizi, Florence

Stylistic differences in this picture have led to differences of opinion as to its attribution. Verrocchio is generally though to have painted the figure of the Baptist and the rocky landscape behind. Leonardo is though to have added the much more charming angel on the left, depicted in profile, and the distant hazy landscape. It is also possible that he painted the figure of Christ over Verrocchio's preliminary drawing.

In the tympanum above the *Madonna and Child with Saints Sebastian and Julian* is the fresco the *Baptism of Christ* (ill. 11), which, because of its poorer quality, is frequently attributed to assistants from Ghirlandaio's workshop. It is unmistakably a loose copy of the famous panel painting in the Uffizi (ill. 12) which Verrocchio painted in tempera and oil about 1470 with the help of his brilliant student and assistant Leonardo da Vinci. The styles of the two artistic personalities can be distinguished in the painting, and there are hints of the imminent change from the Early to the High Renaissance.

Ghirlandaio added the two praying angels on the right of his composition, and these, together with the corresponding figures on the other side of the river, form a compositional frame for the work. This assumption that clear symmetrical balance is important shows that the artist was still rather conservative.

FLEMISH PAINTINGS IN FLORENCE

With its conquest of Pisa in 1406, Florence gained access to a seaport that secured its long distance trade. One consequence of this was that Florence developed strong trading links with the Netherlands, trading links in which not only everyday items but also works of art – in particular panel paintings and tapestries – were shipped in both directions. Many Florentine merchants lived for a time in Ghent, Bruges and Antwerp, and the Medici not only established branches of their bank in the north of Europe, they also fostered good diplomatic relationships with the Burgundian dukes. As a result, noblemen and merchants in Florence gave important commissions to Flemish painters such as Rogier van der Weyden, Hugo van der Goes and Hans Memling.

Like Italian artists, painters north of the Alps were trying to reproduce reality in a way that was as close to nature as possible. In order to do this, they relied in particular on a

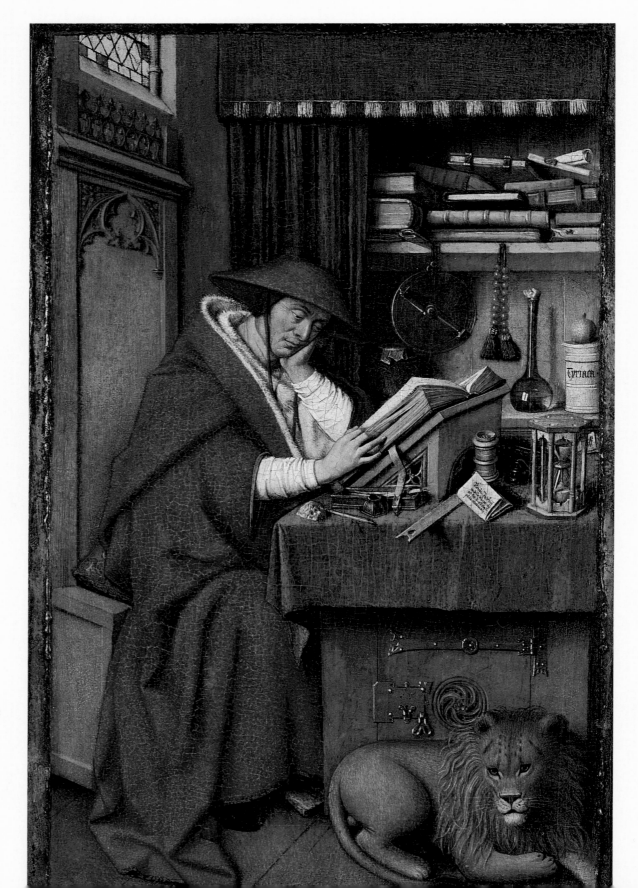

13 Workshop of Jan van Eyck
Saint Jerome, 1442
Parchment on wood, 20.5 x 13.3 cm
The Detroit Institute of Art, Detroit

The date of 1442 appears on the painting, showing that it was completed by workshop associates just a year after van Eyck's death. In his fresco in Ognissanti, Ghirlandaio not only uses the overall composition of this panel painting, he also copies the pensive look of the saint, his head resting on his hand, and the curtain and the many realistically depicted objects. He has not, however, added the lion, the attribute of Saint Jerome.

close attention to detail, and also on an ability to depict the precise appearance and texture of things. In contrast, painters south of the Alps discovered how to use linear, single-point perspective, a skill that allowed them to depict three-dimensional space on a two-dimensional picture surface in a mathematically correct way.

What both Flemish and Italian artists had in common was their search for ways to reproduce reality; both groups were stimulated by the reciprocal exchange of ideas that trade brought. Italian artists could study Flemish works in Italy.

Ghirlandaio never left Italy; the furthest he travelled was to Rome. His clients and patrons, however, fostered close

very similar to the famous painting in Detroit, and might even be that particular work (ill. 13). The inventory also lists a portrait of a young lady as being by "Pietro Cresti da Bruggia" (Petrus Christus of Bruges). This panel painting is possibly the portrait by Christus now in Berlin. We must assume that Florentines owned far more Flemish works than surviving examples might suggest.

What Italian artists gained from this contact with Flemish works was a new skill in depicting the materiality of objects, and also an appreciation of the role that could be played in a painting by elements of everyday life, landscape, and still life. From now on, Italian painters integrated landscapes,

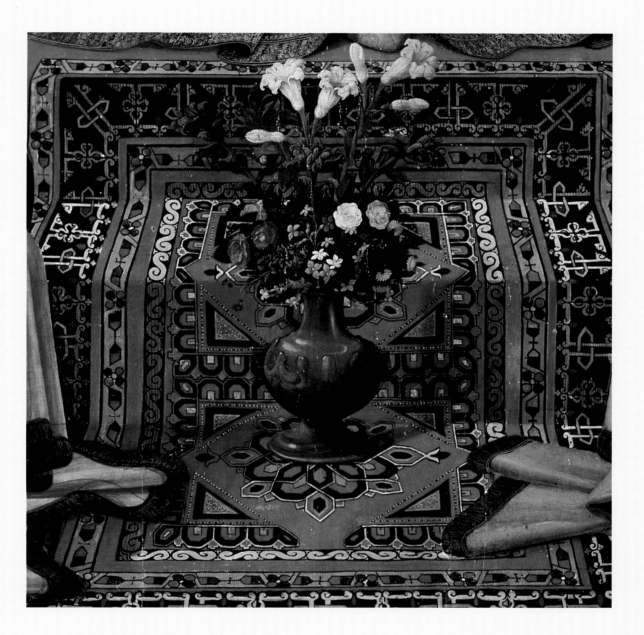

14 *Madonna and Child Enthroned with Saints* (detail ill. 117), ca. 1483

This detail of a flower vase on a colorful carpet could also be taken from a Flemish panel painting if it were painted using the oil technique developed there rather than tempera, which Ghirlandaio used. In this detail, the artist creates a positive frenzy of colors and forms to enliven the picture.

relations with Flemish trading partners and obtained from them paintings for their private collections. The Medici's passion for collecting encouraged other families. The inventory of Lorenzo de' Medici's private art collection, made in the year of his death, 1492, lists among other paintings a *Saint Jerome* by Jan van Eyck. It was probably

interiors, portraits and still lifes into their works, which were mainly religious scenes. The careful analysis of faces in terms of the subtle play of light, and the accurate depiction of the landscape are both features we find in Ghirlandaio's paintings. A range of Flemish stylistic elements became a permanent part of his repertoire (ill. 14).

THE ROAD TO SUCCESS:
the FIRST MAJOR COMMISSIONS

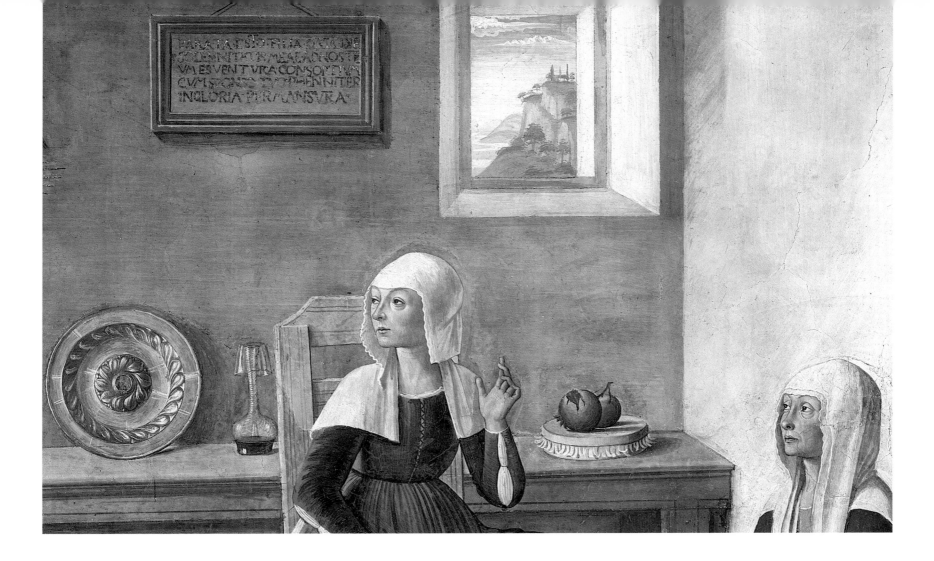

GHIRLANDAIO FINDS HIS STYLE: THE SAINT FINA CHAPEL IN SAN GIMIGNANO

Violets flower in March in San Gimignano, a town of many towers; they are celebrated as the "Fiori di Santa Fina", the flowers of Saint Fina, the town's patron saint. Between 1468 and 1472, architect Giuliano da Maiano built Saint Fina's mortuary chapel in the collegiate church (his brother Benedetto da Maiano created the saint's burial altar about 1475) and Ghirlandaio covered the walls with frescoes. Both artists were working in direct competition with each other, for they were depicting the *Obsequies of Saint Fina* side by side, each using his own medium, fresco and relief carving.

There is even a Latin inscription on the saint's tomb alluding to the frescoes: "Do you seek miracles? Then look at the ones which these walls and living pictures tell of – 1475." The entire layout of the magnificent ensemble, which is still in its original location, is reminiscent of Antonio Rossellino's mortuary chapel for the Portuguese cardinal dating from 1461–1466 in the Florentine church of San Miniato al Monte, the frescoes for which were painted by Ghirlandaio's first teacher, Alessio Baldovinetti. In that chapel, which is approximately the same size, the architecture, sculptures and painting are related to each other just as artistically as in the Saint Fina Chapel.

It was in the frescoes for this chapel Ghirlandaio was able to develop his own style. The second fresco, the *Obsequies of Saint Fina* (ill. 18), is more clearly derived from traditional pictorial patterns, but even here there

are already the portraits so typical of Ghirlandaio. The narrative structure of the painting reflects the poetic character of the saint's life.

Fina, the pious daughter of poor parents, died on the feast day of Saint Gregory in 1253 after a long and painful illness. She was just fifteen years old (ill. 15). According to legend, after the death of her mother Fina lived an ascetic lifestyle so strict she was, in the end, scarcely able to move. Vermin and rats gnawed at her body until death finally liberated her from her prolonged sufferings. Pope Gregory the Great, in full regalia, appears floating in a glory of red winged angels to bless the young woman and announces her imminent death. At the instant she died, white, beautifully scented flowers blossomed forth from her bed of pain. The witnesses to this miracle are her old nurse and another woman, possibly a helpful neighbor.

The neighbor greets the great Church Doctor hesitantly (ill. 16) with a gesture of restrained fright. Behind her is a row of objects on a bench. One of the items leaning against the rear wall of the box-shaped room is a golden bowl, an object that seems out of place in this bleak scene. The same is true of the pilasters on either side, whose golden capitals support the huge architrave. This architecture is designed to create an opulent frame for the picture rather than to reflect the place where the events are unfolding.

Next to the shining bowl is an almost empty decanter, covered by an inverted glass to protect the valuable wine. As the artist repeated both vessels in his later frescoes of the *Last Supper*, it is possible that they are a reference to

16 (above) *Announcement of Death to Saint Fina* (detail ill. 15), 1473–1475

On a framed panel on the rear wall are the Latin words that Saint Gregory spoke to Fina:"Be prepared, my daughter, for on my feast day you will be taken up into our community and live there forever with your bridegroom." A window in the rear wall allows air and light to enter the bare room. A picture within a picture, the window appears very much like a landscape painting. The few domestic objects on the bench at the back give the room a home-like quality.

15 (opposite) *Announcement of Death to Saint Fina*, 1473–1475
Fresco
Collegiata, San Gimignano

Weakened by a strictly ascetic way of life, Saint Fina spent her short life lying motionless on a hard bed. Her old nurse Belida is supporting the virgin's head, and the saintly Pope Gregory appears in order to announce to the humbly praying saint her imminent death. Flowers are blossoming forth from her bed of pain. Above this scene, two angels are carrying the soul of the saint to heaven.

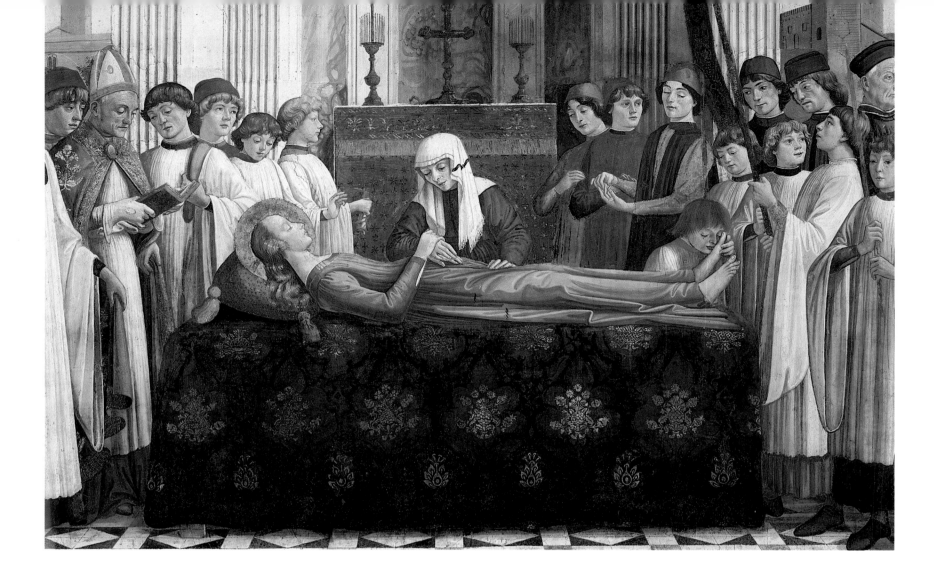

17 *Obsequies of Saint Fina* (detail ill. 18), 1473–1475

The body of Saint Fina is lying in state before an altar. At her head, a dignified bishop is saying requiem mass, assisted by a whole series of servers. Some citizens of San Gimignano – doubtless portraits of those who commissioned the paintings – are also taking part in the ceremony.

the sacrament of Holy Communion. The character of the objects, so like a still life, is an approximation to Flemish paintings, though Ghirlandaio has not yet achieved a Flemish materiality in his work.

On the far right, two pomegranates are lying on a box; they may be references to the Fall of Man in the Garden of Eden. Saint Fina did not attempt to gain the biblical forbidden fruits and will therefore be made a saint. Is it possible that the large split on one of the fruits is an allusion to the bodily decay of the saint, which the artist did not dare depict in all its gruesomeness? There is just one rat hiding under the bench at the back, reminding us of Fina's horrific martyrdom.

For her obsequies, in stark contrast, the beautiful saint is lying not on her wooden bed, but on a rich cloth and pillow in front of the altar (ill. 17). The living flowers have been changed into gold brocade that is shining on the black and dark turquoise cloth. Let us follow the inscription on her grave and look for the miracles depicted on the walls. Because the old nurse had held Fina's head for so long, her arms became paralysed. Now, kneeling behind the bier in the center of the scene, she is healed by the touch of Saint Fina's hands. Another healing is taking place at the feet of the dead woman. Here, a blind boy regains his sight by touching his eyes to the saint's feet. A third miracle is taking place in the background on the left, where an angel has appeared to ring the death knell (ill. 18).

The painted pilasters that flanked the front pictorial zone of Ghirlandaio's early works are now integrated into the background of the picture as parts of a monumental sacred architecture. Behind the scene is an apse, which harmonizes with the chapel wall's tympanum at the top, and which also guides our eyes back to the center of the scene. The vanishing point in this composition is the altar cross-flanked by two candles. Ghirlandaio would have found models for this architecture, which skillfully uses colorful marble, in the monumental tombs of his age – such as the work of Bernard Rossellino in the church of Santa Croce in Florence. The immediate inspiration for the composition, however, was Fra Filippo Lippi's fresco in the choir of Prato Cathedral, the *Obsequies of Saint Stephen*. Ghirlandaio would later create another variation on this composition in a fresco for the Sassetti Chapel in Florence.

The two frescoes in the Saint Fina Chapel are the first major works of Ghirlandaio's career. There are already signs of the architecture that will feature in his later works, here imaginatively and skillfully constructed according to the laws of perspective. The spaces appear to be filled with light and air and to create a bright atmosphere that is enhanced by the luminous colors of Domenico Veneziano. Also evident here is Ghirlandaio's ability, which was much appreciated by his patrons, of including them and their families in religious scenes (ill. 19).

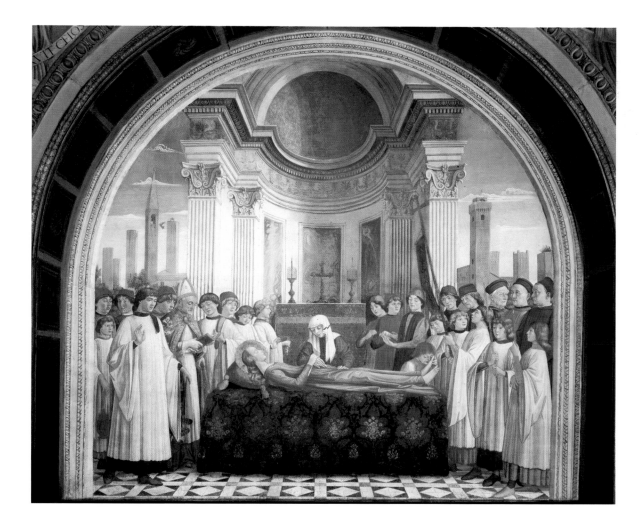

18 (left) *Obsequies of Saint Fina*, 1473–1475
Fresco
Collegiata, San Gimignano

In the background, the towers built by the town's noble families, so characteristic of San Gimignano, are towering into the sky. All the bells in San Gimignano are supposed to have tolled miraculously, without human aid, at the hour of Saint Fina's death. The artist uses an artistic device to produce the effect of the acoustic miracle, placing an angel on the left to strike the bells in the town's highest tower.

19 (below) *Obsequies of Saint Fina (detail ill. 18)*, 1473–1475

In this long row of expressive heads Ghirlandaio already reveals his unique ability to create convincing character studies, a skill that was to bring him fame and many well paid commissions. Some of those depicted do not seem to be taking part in the ceremony, while others are deeply moved. The server at the saint's feet is more interested in his processional cross than in the ceremony, and the server next to him is looking around to keep himself amused.

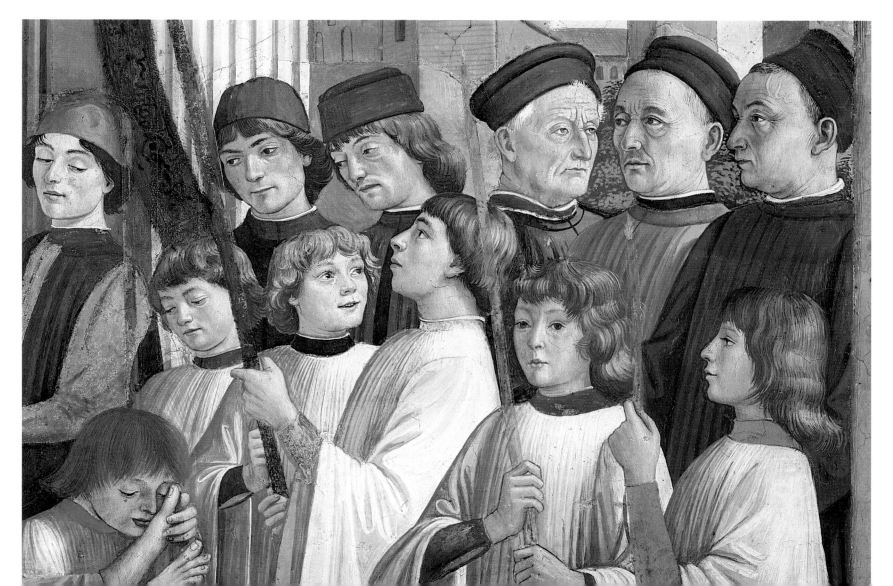

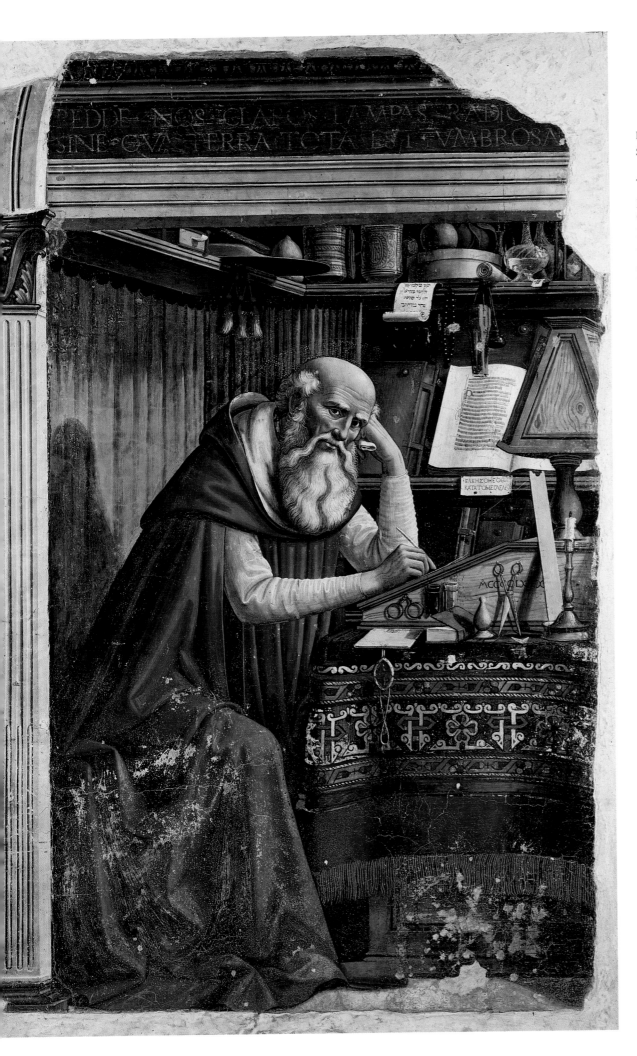

IN COMPETITION WITH BOTTICELLI: SAINT JEROME

The Vespucci family also commissioned Ghirlandaio to produce a fresco of Saint Jerome in the church of Ognissanti as a pendant to the *Saint Augustine* that Botticelli had recently painted on the chancel screens in the church. When these chancel screens were later taken apart, both wall paintings were moved. In the process, both were damaged and both lost their original architectural context. They are now opposite each other on the walls of the church. So in 1480, while in competition with Botticelli, an artist who was three years older and was to survive him by fifteen years, Ghirlandaio created the work that most clearly showed the influence of artists from north of the Alps (ill. 20). As already mentioned in the inset on Flemish paintings in Florence (pp. 18/19), Lorenzo de' Medici owned a Flemish panel painting entitled *Saint Jerome in his Study*, and Ghirlandaio may have seen it. It was probably painted in Jan van Eyck's workshop and was very like the panel that is now in Detroit (ill. 13), which dates from 1442, a year after the master's death.

There are numerous differences in the way the two Church Fathers are depicted in Ognissanti. While Botticelli's Augustine is filled with prophetic fervor and holding his hand to his breast in a dramatic gesture (ill. 21), Ghirlandaio's Jerome has stopped writing and is thoughtfully leaning his balding head on his hand. All

20 *Saint Jerome*, 1480
Fresco, 184 x 119 cm
Ognissanti, Florence

In contrast with the *Saint Jerome* Ghirlandaio painted in Cercina (ill. 4), this *Saint Jerome* is not depicted as a penitent but as the scholarly translator of the Bible. While he was writing, the Church Father was careless and splattered red ink on his wooden desk. The artist took the liberty of including the visual joke that the saint's spectacles are so close to his scissors that he might mix them up.

around are papers covered with Greek, Latin and Hebrew writing, a reference to the saint's translation of the Holy Scriptures. He is gazing good-naturedly at us from his study, while Augustine in contrast has a creased forehead and appears to be completely absorbed by his visions. His place of work is orderly and the valuable manuscripts are lined up on a ledge. Jerome's study, in contrast, has a wide collection of objects. His desk and several wooden shelves are covered with books, a sealed letter, an extinguished candle for him to work by at night and various earthenware containers, glass carafes, boxes and fruit. He has laid his red cardinal's hat on the shelf above him. Flemish influence is most clearly seen in the carefully arranged still life on the top shelf. This still life is reminiscent of the side wings of the *Annunciation Altarpiece* in Aix-en-Provence, which are now in Brussels and Rotterdam. On these wing panels the artist Barthélemy d'Eyck had (between 1443 and 1445) painted still lifes above images of standing saints. The still lifes were so greatly admired that one of them was later taken off so that it could be viewed independently from the rest of the panel. The carpet on Jerome's desk in Ghirlandaio's fresco is also a familiar detail from Flemish painting: we find it in the works of Jan van Eyck, and also Hans Memling, who died in the same year as Ghirlandaio. With the help of exaggerated perspective, Botticelli's Augustine is more expressive. His affected pose is already a sign of the development of Italian art after 1500.

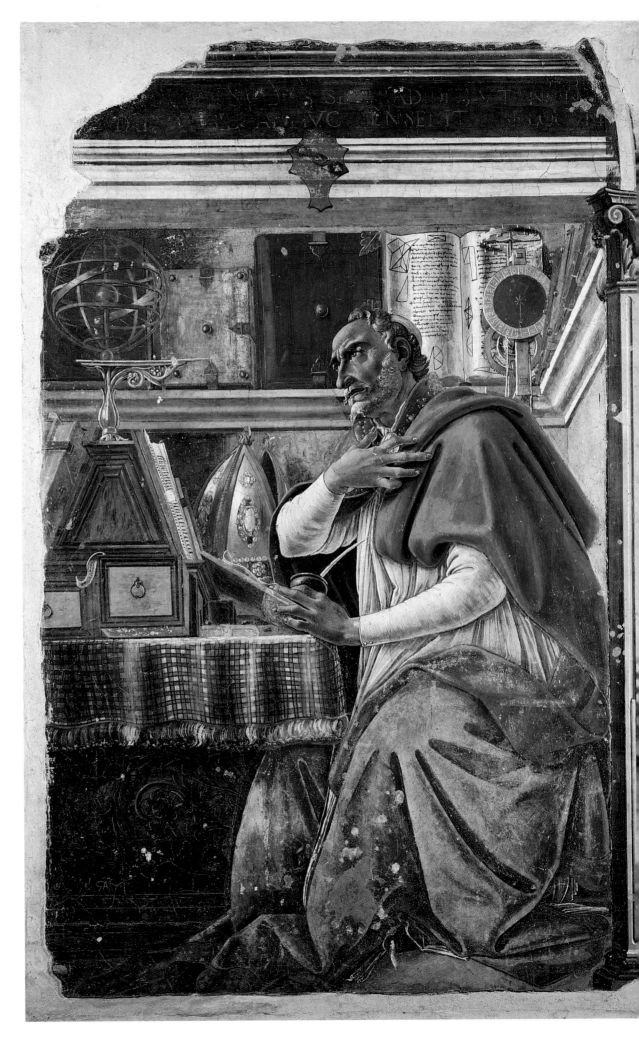

21 Sandro Botticelli
Saint Augustine, 1480
Fresco, 152 x 112 cm
Ognissanti, Florence

This fresco by Botticelli determined the structure of Ghirlandaio's Ognissanti *Saint Jerome* (ill. 20), the corner of the room and the entablature at the top being architectural features common to both works. Botticelli continued this entablature into the depths of the picture in a different form, in order to place a row of large books and astronomical instruments on it. He shows the room and the saint from a low angle, whereas Ghirlandaio provides a higher viewpoint. It is a method that enables Botticelli to give greater emphasis to Augustine's dramatic gesture.

EATING AND DRINKING WITH THE LORD: THE THREE FRESCOES OF THE LAST SUPPER

Some subjects were particularly popular in Florence in the 14th and 15th centuries and were suited to the decoration of specific rooms. As a result, there are a conspicuously high number of enthroned Madonnas, Annunciations, and Adorations of the Magi in museums today. It can come as no surprise that artists painted particular subjects more than once, and sometimes frequently. The Last Supper was one of these popular subjects, repeatedly commissioned for the dining halls or refectories in monasteries. It shows Christ, having

gathered His disciples together for a meal, announcing that one of them will betray Him. The best-known example of this theme is probably Leonardo da Vinci's *Last Supper* in Milan.

Ghirlandaio painted this scene on several occasions within the space of a few years. In all three works of his that still remain, the basic arrangement is the same as that in the fresco by Andrea del Castagno in the Florentine Cenacolo di Sant' Apollonia dating from about 1450 (ill. 22). The disciples are sitting at a long table in front of a rear wall that runs parallel to the picture plane. Christ is sitting in the center, and His favorite disciple John is leaning sadly against Him. To the right of Christ, in the place of honor, is the chief

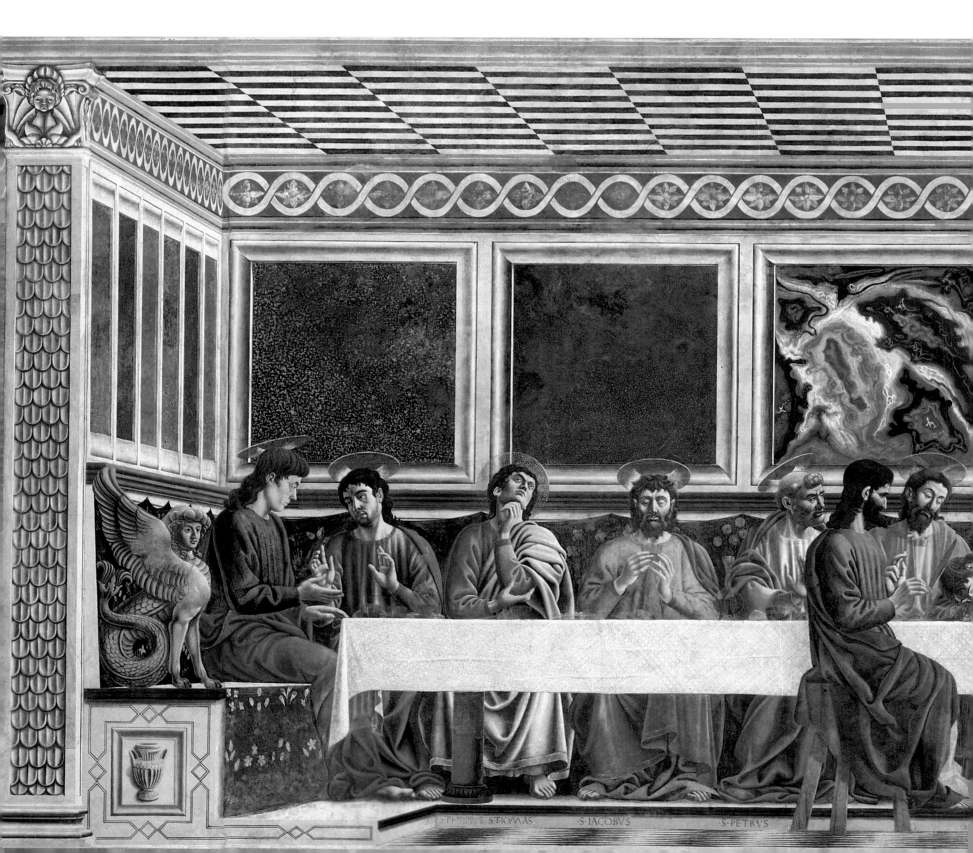

Apostle, Peter. In Ghirlandaio's picture (ill. 23), he is holding a knife, a reference to the fact that he will cut off the ear of one of the henchmen who comes to arrest his Lord during the following night. Judas the traitor is the only one to be separated from the others: he is seated in front of the table.

Despite all these similarities, there are still clear differences between Ghirlandaio's three frescoes of the Last Supper, differences that reveal the artist's development.

The earliest example was painted in 1476 in the abbey of Santi Michele e Bagio in Passignano sul Trasimeo near Florence, and is most strongly influenced by Castagno (ill. 23). As in Castagno's *Last Supper*, the table

is straight, and the space is still flat and is closed at the back. The various emotions of the Apostles are indicated by stiff hand movements that scarcely seem alive and express little of the character of the individuals. In contrast to Castagno, Ghirlandaio shows the table seen slightly from above, so that he can depict a line of food and drink, mainly bread and red wine, as in a still life. The greatest difference from the composition of the older painter is the turning and shifting of the traitor Judas to the right. As a result, in Ghirlandaio's painting he is moved unpleasantly into the centre of the picture and covers the body of the melancholy John.

Just four years later Ghirlandaio produced a *Last Supper* with a more strongly individual style in the

22 Andrea del Castagno
Last Supper, ca. 1450
Fresco
Cenacolo di Sant' Apollonia, Florence

Ever since Taddeo Gaddi's monumental frescoes in Santa Croce in Florence, painted about 1330–1340, the scene of the Last Supper depicted with life-size figures had been a traditional subject for Florentine refectories. In his work, Castagno made a decisive step towards a more realistic depiction of the figures in a pictorial space carefully constructed according to the laws of perspective. The coarse faces and rigid forms that appear to have been turned to stone are typical of his work.

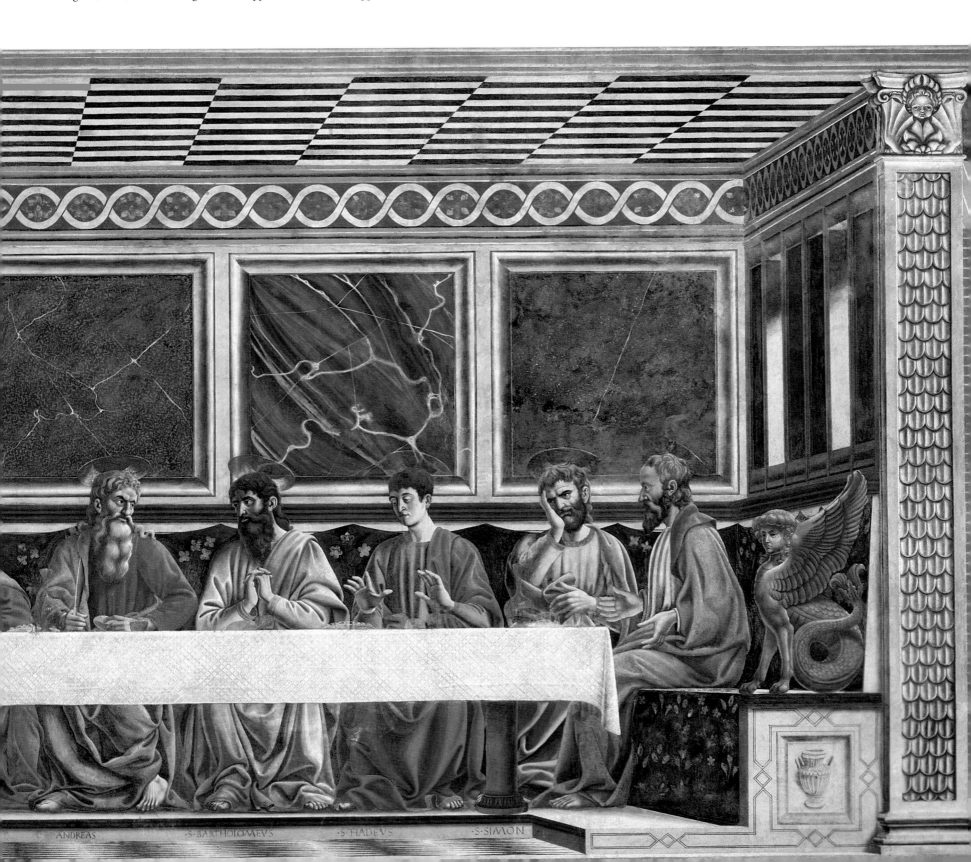

ANDREAS S·BARTHOLOMEVS S·HADEVS S·SIMON

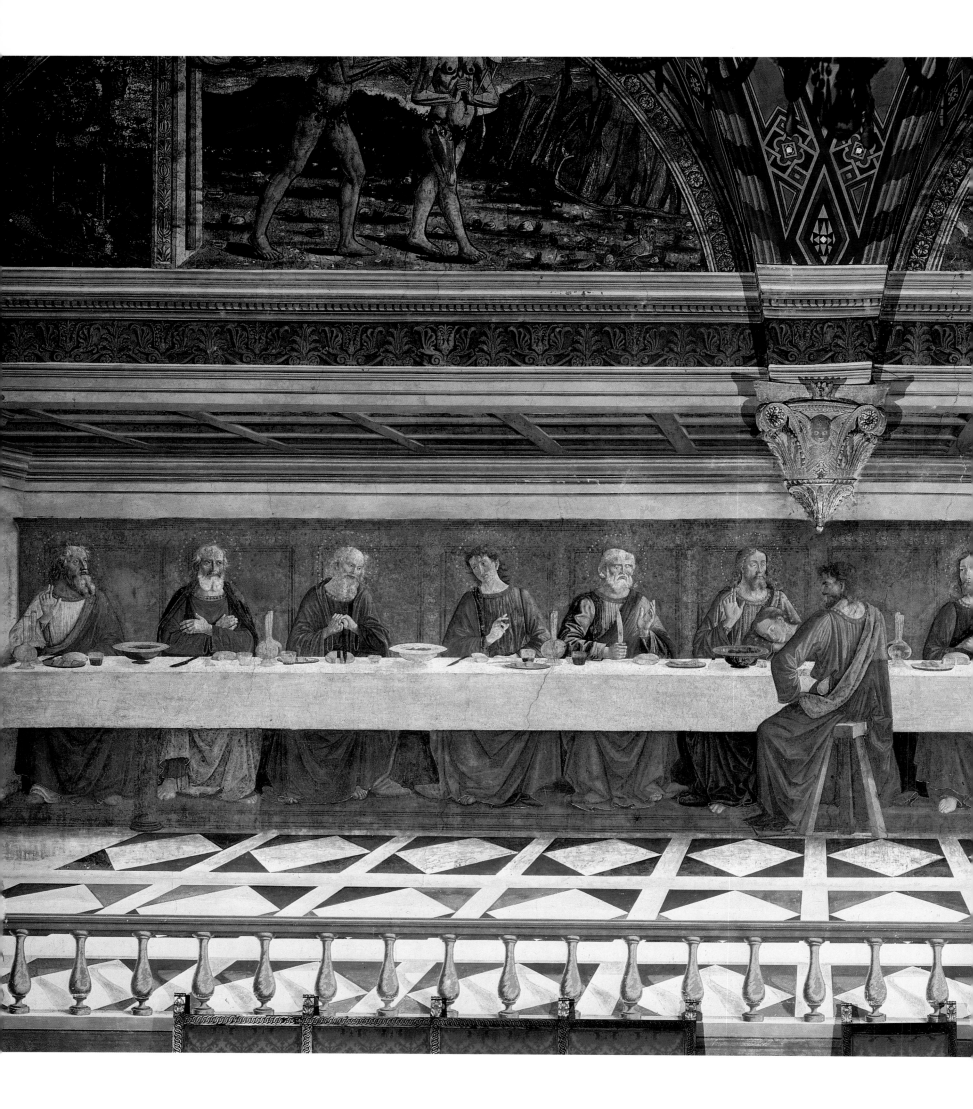

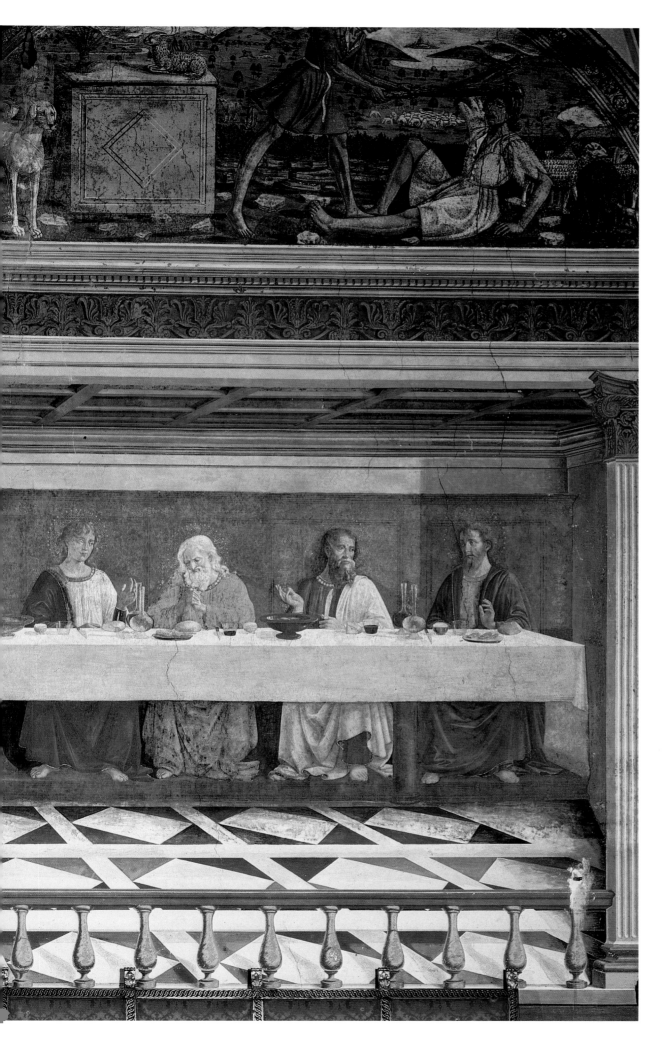

23 *Last Supper*, 1476
Fresco
Badia dei Santi Michele e Biagio, Passignano sul Trasimeo
near Florence

The Apostles and Christ are sitting together for the Last
Supper in a room with a flat ceiling that appears to be a
little too low. Judas the traitor is sitting opposite Christ
on a three-legged stool in front of the laid table. The
figures are set back some distance from us, to a depth of
three large floor tiles.

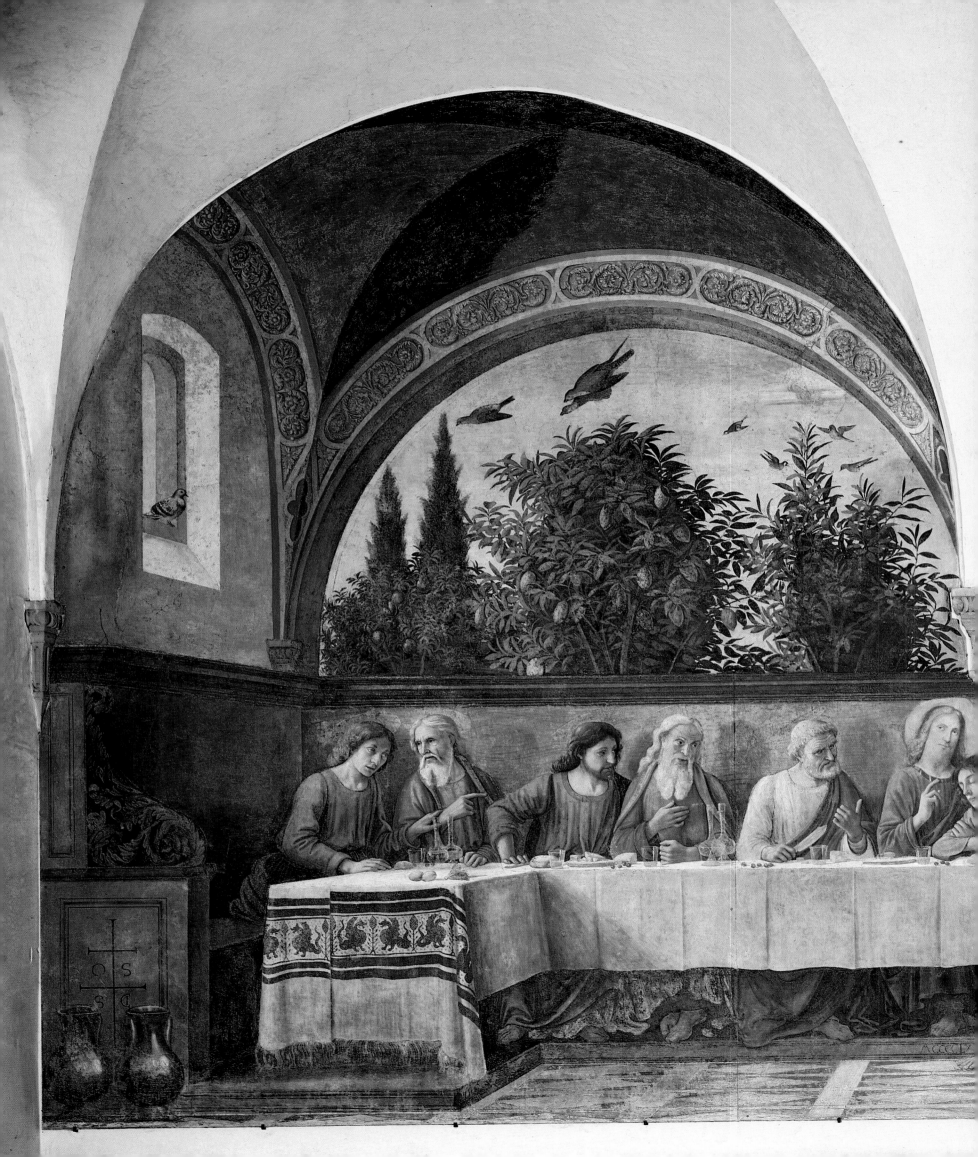

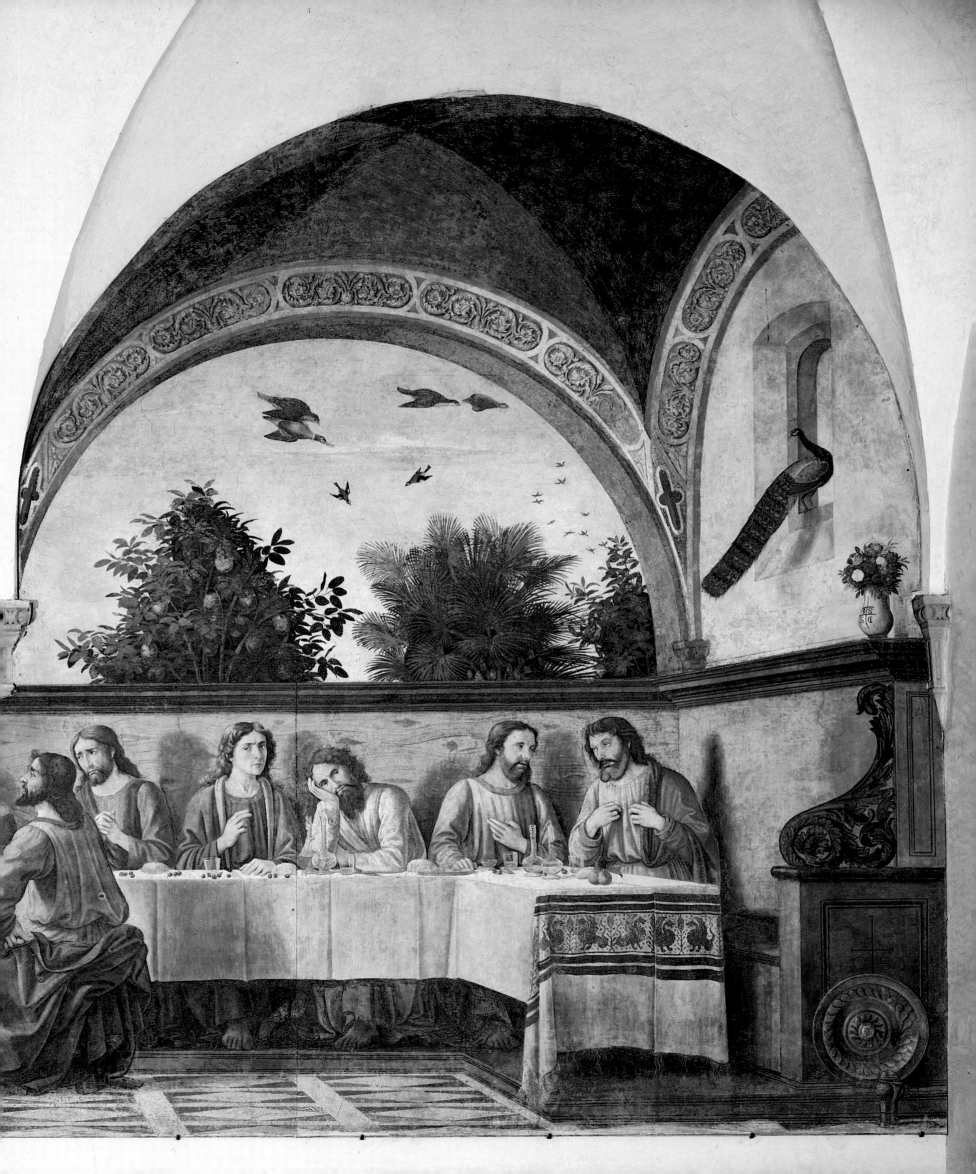

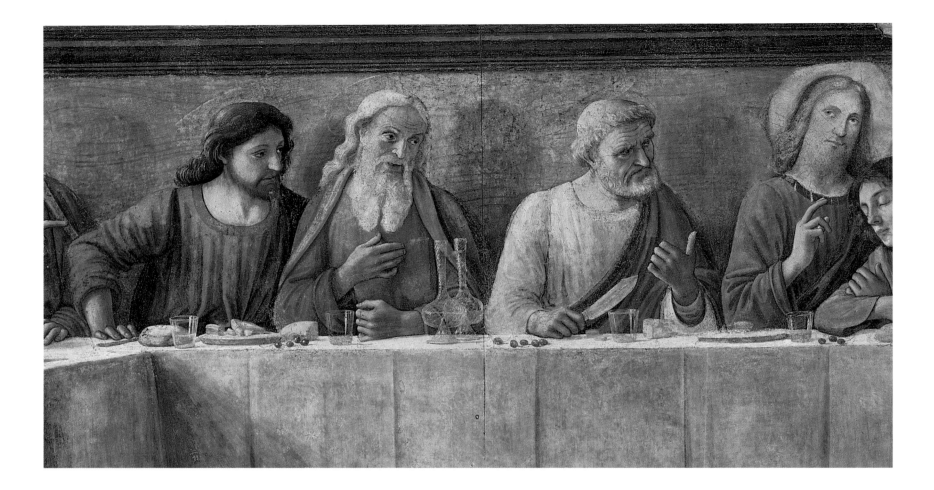

25 *Last Supper* (detail ill. 24), 1480

Saint Peter has picked up his knife angrily and is pointing to Christ with it and his thumb. He appears ready to defend Our Lord. The younger Apostle on the left in the green garment is energetically pushing at the table with his arm as if about to jump up and start an argument with Judas. When this fresco is compared with its sinopia, which had recently been revealed, it becomes clear that these are the very details that were changed.

24 (previous double page) *Last Supper*, 1480
Fresco, 400 x 880 cm
Ognissanti, Florence

In contrast to the earlier versions of the theme (ill. 22), here the table is arranged in a U-shape, making more space available at the sides. However, the Apostles do not make use of this additional space: they continue sitting close together along the top end of the table. Arranged in pairs, they react in differing ways to Christ's announcement that there is a traitor among them. The head of Christ is a poor restoration.

refectory of the monastery of Ognissanti in Florence, at roughly the same time as his version of *Saint Jerome*. Built just a short time before, the refectory in this monastery is a long vaulted hall and the *Last Supper* (ill. 24) is on the rear wall. Here Ghirlandaio's fresco creates an illusion of the extension of the real space of the hall. It looks as if the actual vaulting continues into the picture, because the consoles in the hall are repeated in the depths of the painted picture. Ghirlandaio also skillfully captures in his fresco the way in which the hall is actually lit: he shows two windows and allows bright light to enter the painted scene from the left. The right window provides less light, in accordance with the lighting conditions in the real hall. The window on the left of the hall allows bright light to fall onto the wall with the fresco; the windows on the right side of the hall provide less light because of the roof of the cloisters next to it. Ghirlandaio integrated this impression into his fresco. It mingles real space and pictorial space to form a single dining hall, so that the monks seem, as it were, to take part in the Last Supper with their Lord, who is depicted as part of an elevated group in front of them.

Ghirlandaio opens up the rear wall of the painted room with arches through which we can see trees in a Tuscan garden. The open arches admit air and light, so that we almost feel we can hear the birdsong and smell the fruit. In the sky on the left, a hawk is catching his prey on the wing, and on the right another is hunting a duck; goldfinches fill the sky. The trees and bushes, depicted with botanical precision, are lavishly hung with fruit: pomegranates seem about to burst, swollen

lemons, oranges, and apples are shining in the light, and dates are gleaming at the tops of the palms. Some of the fruit has found its way onto the Apostles' table, and only the cherries arranged across the table do not seem to have come from the garden as it does not contain a cherry tree.

The table itself is depicted with an equally keen delight in detail. The Apostles are drinking white wine and water, which stands ready in paired glass carafes alongside their bread, ham, and cheese. Some of the Apostles have already emptied their glasses (ill. 25). Peter has just cut up the cheese into bite-sized pieces on the tablecloth instead of on a wooden board.

The sinopia underdrawing of the fresco was revealed during the course of restoration work. This design for the fresco, painted in reddish brown, was made visible by being painstakingly separated from the layer of color above it. Now on display in the same hall, it shows the alterations that Ghirlandaio made between drawing it and painting the final version. Neither the background nor the objects on the table were designed in advance, and the gestures of the Apostles on the left were altered in order to make them more expressive.

One is due for a disappointment if one expects the third *Last Supper*, painted six years later in San Marco, to show a similar development (ill. 27). It is, rather, a schematic repetition of the ideas that Ghirlandaio had developed so wonderfully in Ognissanti. It is probable, in fact, that he got his workshop assistants to carry out the majority of this commission. The Apostles are once again as stiff as those in the first *Last Supper* (ills. 28, 29). The assertive

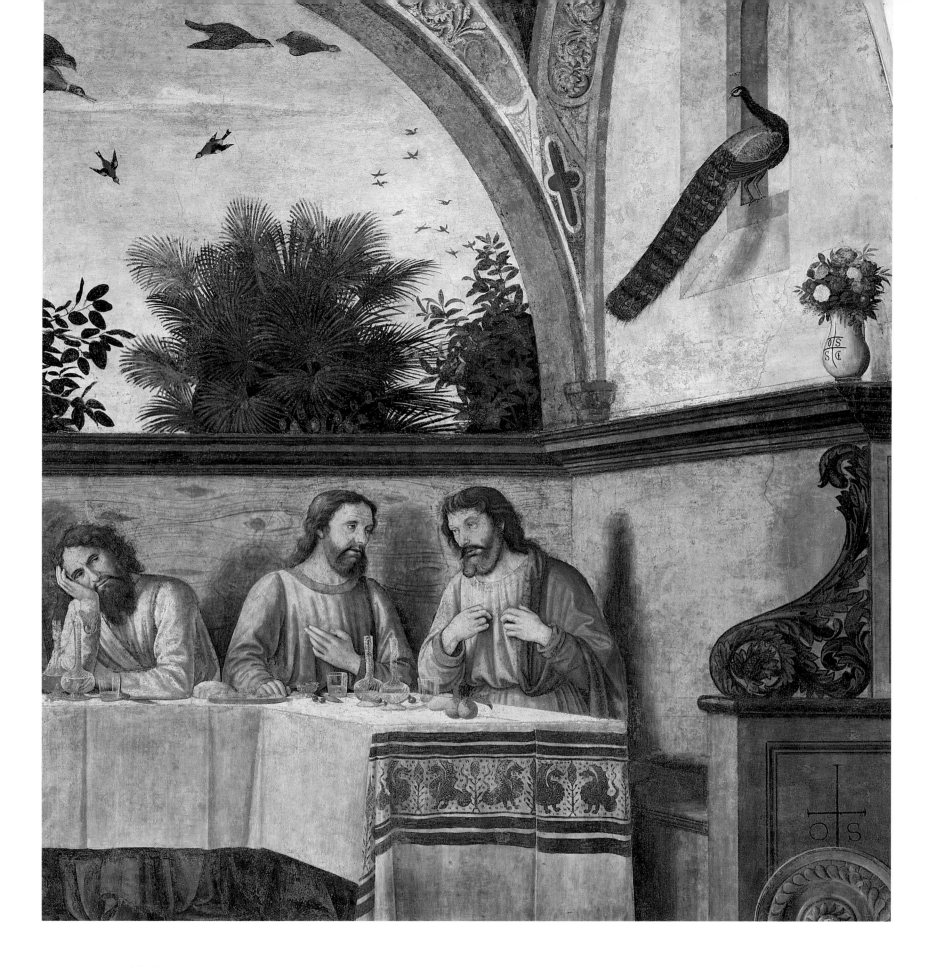

26 *Last Supper* (detail ill. 24), 1480

On hearing Christ's claim that the traitor is among them,
the two Apostles on the far right appear to be asking each
other: "Am I the one?" – and others are becoming
melancholy. On the right of the picture four decorative
elements are depicted above each other in much the same
way as a border in book illumination: a peacock is sitting
in the window and looking around, and a richly carved
bench-end between two still lifes, a vase of flower above
and a metal dish and jug on the floor.

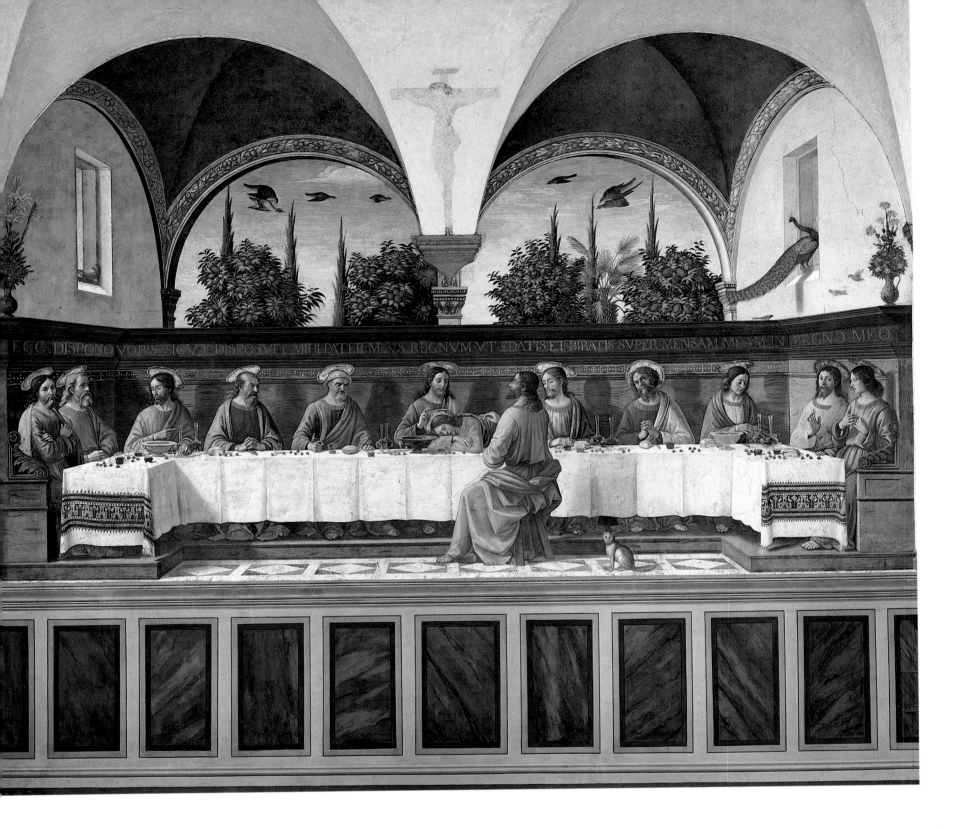

27 *Last Supper*, ca. 1486
Fresco
San Marco, Florence

It is probable that Ghirlandaio's fresco in Ognissanti
(ill. 24) was so highly thought of that the monks of
San Marco decided that they wanted just such a work for
the refectory in their hostel. In this picture, two of the
Apostles have moved around the sides of the U-shaped
table on each side. This makes the others, against the rear
wall, appear more isolated. A cat is sitting in front of the
table, eagerly awaiting a falling morsel.

way in which Judas leans forward in the Ognissanti *Last
Supper* has not been repeated. The excessive symmetry
of the vegetation means that it scarcely seems natural.
The lighting conditions that had been developed so
logically in Ognissanti also make little sense here, as the
windows in the real hall are along the opposite wall.

In his versions on the theme of the Last Supper,
Ghirlandaio did not make any great inventive leaps. That
would be left for Leonardo to do in his *Last Supper* of

1495–1497, which quickly became very famous
through numerous engraved reproductions. This
brilliant work in Santa Maria della Grazie in Milan (ill.
30) continues to determine our conceptions of this
pictorial theme to this day. It is possible that Leonardo
made use of some of the ideas developed by Ghirlandaio
in his Ognissanti *Last Supper*. The view of the garden, the
way the Apostles are gathered in groups, and some of the
hand gestures can already be seen in Ghirlandaio's work.

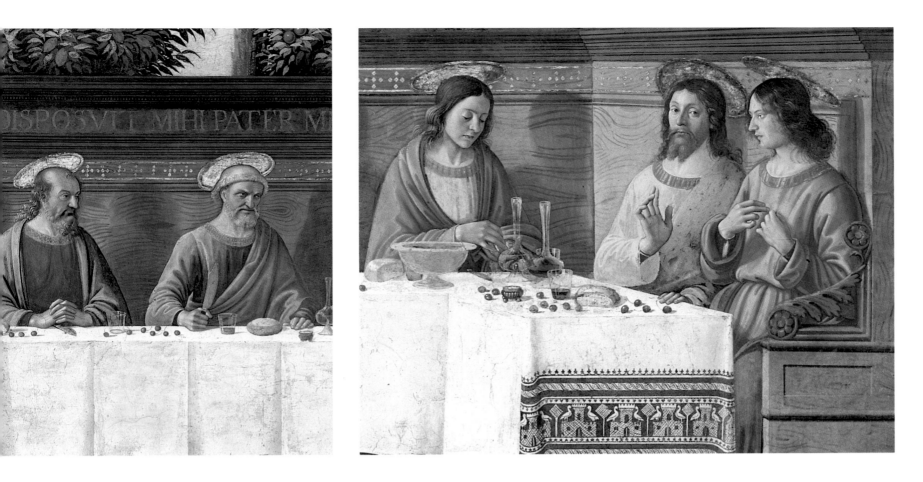

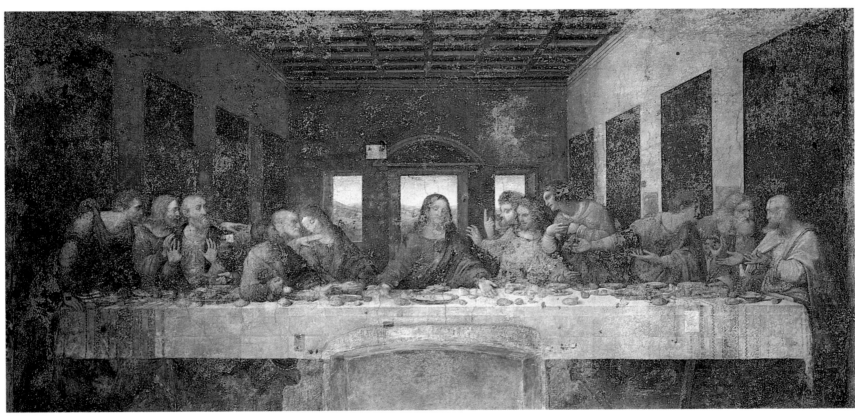

28 (top left) *Last Supper* (detail ill. 27), ca. 1486

Peter is holding the knife in exactly the same way as he does in the preliminary drawing for the earlier *Ognissanti Last Supper* (ill. 24). Ghirlandaio changed the position of the knife in the final painting, giving the *Ognissanti Last Supper* a greater degree of tension. The Apostle next to Peter has already drunk his wine, as can be seen by the traces of red wine forming a ring around the bottom of his glass

29 (top right) *San Marco Last Supper* (detail ill. 27), ca. 1486

The Apostles react in a variety of ways to Christ's words that He will be betrayed. While the disciple on his right appears to be asking: "Is it me, Lord, who will betray you?", the one on his left is gazing sadly at his hands. The artist offers additional proof of his sensitive powers of observation through his playful depiction of the glass vessels on the table: through one glass carafe, we can see hands resting on the table behind, and through another glass we can see a carafe.

30 (below) Leonardo da Vinci
Last Supper, 1495–1497
Wall painting in oil and tempera on plaster, 420 x 910 cm
Santa Maria della Grazie, Milan

By means of an unusual painting technique – oil and tempera on plaster – Leonardo achieved a subtly graduated play of light and shadow. But this novel medium was very sensitive to damp and the painting soon deteriorated badly. The composition broke with the traditional scheme by arranging the disciples in animated groups of three.

31 *The Calling of Saint Peter*, 1481–1482
Fresco
Vaticano, Cappella Sistina, Rome

In this picture Christ appears three times. In the background on the left He twice stands on the shoreline and on each occasion calls two fishermen, Simon Peter and Andrew, with the words: "Follow me, and I will make you fishers of men." On a third occasion, standing in the foreground, He blesses them. In a long series of portraits on the right, the artist depicts representatives of the Florentine colony in Rome.

ROME AND THE TRIUMPHAL RETURN HOME

In the early 1480s Pope Sixtus IV brought a number of famous Tuscan and Umbrian artists to Rome in order to decorate his new court chapel, the Sistine Chapel. Ghirlandaio must already have made a name for himself with his commissions, primarily the frescoes for the Saint Fina Chapel, in order to be considered for a task of this importance. The chapel's ceiling would not be decorated with Michelangelo's famous frescoes until the reign of Sixtus' nephew, Julius II. Between 1481 and 1483, the walls of the chapel were covered with frescoes by Sandro Botticelli, Domenico Ghirlandaio, Cosimo Rosselli, Piero di Cosimo and others – probably under the direction of Pietro Perugino.

On the left are scenes from the life of Moses, and on the right scenes from the life of Christ, a typological arrangement that sees Moses as the predecessor of Christ. This cycle of frescoes became one of the major artistic achievements of the Italian Quattrocento. In accordance with the Pope's wishes, in each picture several episodes of a story were presented together, a practice that by this time was already becoming outdated. The two frescoes Ghirlandaio painted were the *Calling of Saint Peter* (ill. 31) and *Resurrection*. By Vasari's time the second fresco had been largely destroyed and an entirely new version was painted in the 16th century.

The surviving work is divided into two zones. In the foreground, on a shallow stage, Ghirlandaio depicted several groups of people, tightly packed together in rows. At the center Christ is blessing the kneeling brothers Simon, Peter and Andrew, His first disciples. They follow Him and appear again in the background on the right. There they witness Christ calling James and John, who are sitting in a boat mending their nets with their father, Zebedee.

The massiveness of the heavy garments worn by the figures in the main scene in the center foreground is reminiscent of Masaccio's frescoes in the Brancacci Chapel dating from about 1424–1428. It is mainly Masaccio's *Tribute Money* that matches this one in terms of color, landscape, figure types.

It is at the sides of the picture field that Ghirlandaio dares to display his own developing style. The group of women on the left, including a woman in blue seen from behind, anticipates the female figures he paints in later works. In this fresco he also gives a free rein to the highly individual style of portraiture he had developed in the Vespucci and Saint Fina chapels. On the right, arranged in an exactly level row like pearls on a string, are members of the most influential Florentine families who maintained residences in Rome. In the center stands Giovanni Tornabuoni, representing the Medici family's merchant bank. He later became a sponsor of

Ghirlandaio and was made the Pope's treasurer despite the enduring enmity between Pope Sixtus IV and the Medici.

His son Lorenzo Tornabuoni – in front of him, wearing a black garment – lived to see his wife die young and his family go bankrupt after his father's death. In 1477, Ghirlandaio painted two episodes from the life of Saint John the Baptist and two from the life of the Madonna for the mortuary chapel of Lorenzo's mother, Francesca Pitti Tornabuoni, in the church of Santa Maria sopra Minerva in Rome. According to Vasari, these works were very famous at the time; unfortunately they no longer exist, though two charming portraits of Lorenzo's wife, Giovanna Tornabuoni, who died young, have survived.

To the right of Giovanni Tornabuoni stands the humanist John Argyropoulos, wearing a white beard. He wrote commentaries on Aristotle and fled to Florence from Constantinople when the city fell to the Turks in 1453. A friend of Cosimo de' Medici, he spent fifteen years as a court scholar and professor of Greek at the University of Florence, until he was summoned to Rome by the Pope. He nonetheless continued to see himself as a Florentine, as Lorenzo de' Medici had accorded him civil rights there.

The nobleman beside him, with white hair and no hat, is thought to be either Francesco Soderini from Florence, or Raimondo Orsini from Rome. The young man behind him, with the brightly shining face, is thought to be Antonio Vespucci. Separate from the other Florentines, behind Christ, stands Diotisalvi Neroni, an earlier friend of Cosimo de' Medici. He lived in a more or less willing exile in Rome, as he was involved in plots against Cosimo's son Piero.

It was not only his skill in portraits but also his skill in landscapes, visible in the fresco in the Sistine Chapel, that made Ghirlandaio famous. The entire upper half of this work is devoted to an extensive landscape with a high horizon. The Sea of Galilee, hemmed in by hills and mountains, is snaking its way like a river into the background, where, in accordance with aerial perspective, the colors are paler and lighter. In the sky brightly colored birds are swooping – birds derived from Benozzo Gozzoli's *Procession of the Magi*, painted between 1459 and 1461 for the Florence Medici palace, and also from works by Domenico Veneziano.

In addition to the narrative biblical scenes, the frescoes in the Sistine Chapel include portraits of the first thirty popes, who are depicted standing in seashell-shaped niches in the window register of the chapel. Some of these frescoes can be attributed to Ghirlandaio and his workshop.

This honorable commission in the Vatican was the prelude to Ghirlandaio's great artistic career in Florence: returning to his native city an acknowledged artist, he was inundated with important commissions.

THE MAIN WORKS

A PATRIOTIC COMMISSION: THE SALA DEI GIGLI IN THE PALAZZO VECCHIO

After his successful interlude in Rome, Ghirlandaio now raced from commission to commission. Often he simply sent assistants from his workshop to carry out the works in his name – the brand name of Ghirlandaio. In 1482 the *Signoria*, the city government, commissioned him to produce the decorations in the Sala degli Gigli in the town hall, the Palazzo Vecchio. This task differed from the others he had executed in that it did not come from an individual patrician family, but from the municipal authorities of Florence. It confirmed the high regard in which he was held by the citizens of Florence.

The most important consideration in the Sala dei Gigli was that the overall effect had to be magnificent, and as a result Ghirlandaio was able once more, after his work on the Sistine Chapel, to prove himself a master of working on very large areas (ill. 32). He was to create a monumental public work whose purpose was to express the pride of the city and Republic of Florence.

Ghirlandaio divided one wall by means of painted colossal pilasters, with three arches between them. The two outer arches are over a doorway and a blind window. The result is that the entire wall appears as a mighty triumphal arch. In the center is Saint Zenobius, the patron saint of Florence, with two saintly deacons. In the tympanum above the bishop is a terracotta relief of the Madonna and angels, a work similar to many that were produced by the workshop of the della Robbia family of artists. In the background on the left there is a view of Florence Cathedral. Under the side arches stand historical characters who embody civic and republican virtues: Brutus, Mutius Scaevola and Camillus on the left, and Decius, Scipio and Cicero on the right. For the Florentine government, these figures were a way expressing its debt to the classical ideal of humanity. In these figures Ghirlandaio produced very detailed variations of Roman armor and the classical contrapposto posture, features portrayed with considerable archaeological accuracy.

As important as this work may have been in Ghirlandaio's career, it did not provide him with an opportunity to display his own specific stylistic repertoire; there was scarcely any opportunity to depict still lifes here, no need for landscapes, and portraits based on living people did not seem appropriate. It is therefore likely that he only produced the overall design and personally devoted himself to the paintings in a private mortuary chapel, commissioned for the banker Francesco Sassetti.

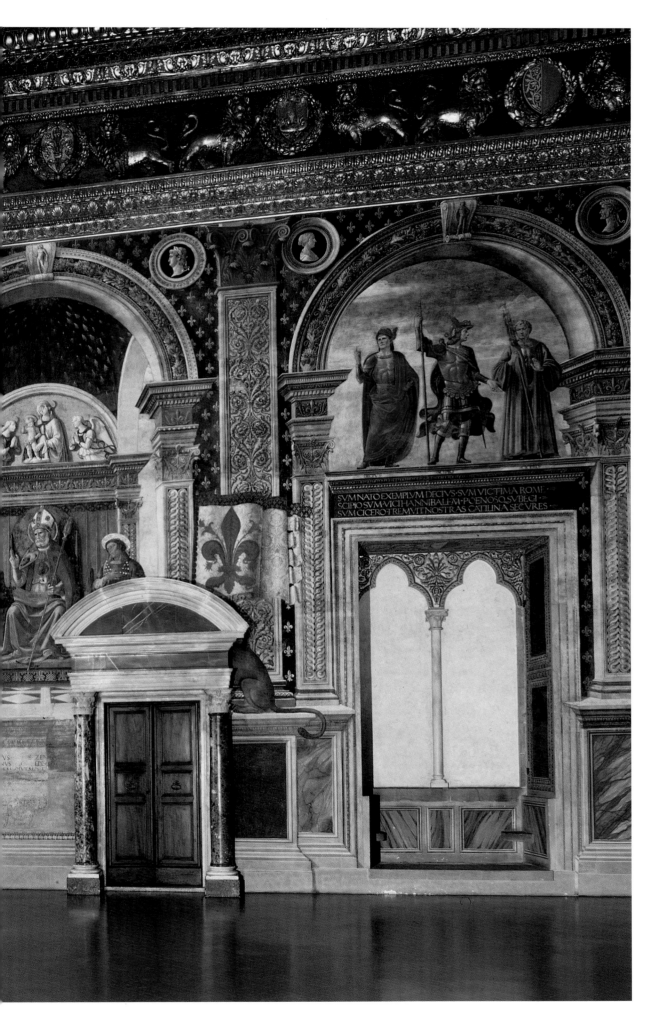

32 Wall decoration (including the *Apotheosis of Saint Zenobius*), 1482–1484
Fresco
Palazzo Vecchio, Sala dei Gigli, Florence

By creating the illusion of architectural features, Ghirlandaio opens up the real space by skillfully incorporating the actual conditions of this large room in the Palazzo Vecchio. Above the entrances at the sides stand classical Roman heroes. They are painted *sotto in sù*. In the center, the saintly Bishop Zenobius is enthroned between saints Eugenio and Crescenzio.

A · D · M · CCCCLXXX

V · DECEMBRIS

33 Portrait of the Donor Nera Corsi Sassetti, ca. 1485
Fresco
Santa Trinità, Cappella Sassetti, Florence

The two donors are in prayer on either side of the altar, as
if they are taking part in the *Adoration of the Shepherds*
depicted on the altarpiece (ill. 36). Linking the frescoes
and the central panel painting in this way, Ghirlandaio
creates what is almost a triptych. Astonishingly enough,
the wife, Nera Corsi Sassetti, is occupying the
traditionally more distinguished position on the right of
the religious scene.

34 Portrait of the Donor Francesco Sassetti, ca. 1485
Fresco
Santa Trinità, Cappella Sassetti, Florence

Francesco Sassetti's dealings as a patron of the arts were
not characterized by commercial acumen or sound
business sense. It is almost as if he wanted to record his
pointed rejection of the commercial mentality. As his
reputation as a banker faded, people made fun of him
by saying that he would rather study Cicero than his
account books.

THE DISPUTE OVER A CHAPEL AND HOW IT BENEFITED THE ARTIST

The rich Florentine banker Francesco Sassetti wanted to
furnish a mortuary chapel for himself and his family that
would bring honor to his name. He chose the most
prominent chapel he could find in Florence: the apsidal
chapel of the church of Santa Maria Novella. For
generations his family had owned the right to decorate the
main altar in this Dominican church, which apart from the
cathedral and the competing Franciscan church of Santa
Croce, was the most prestigious sacred building in the city.

But the right of patronage to the large main chapel
behind the altar belonged to the Ricci family. They, however,
had become impoverished and did not possess the means
to renovate the old frescoes by Andrea Orcagna, which had
become unsightly because of damp. As a result, the Ricci
were no longer able to maintain their right of patronage for
the apsidal chapel, and at a ceremonial meeting of the
chapter patronage was granted to Francesco Sassetti.

However, the Dominicans were dismayed when he
publicized his plans for the new frescoes: Francesco Sassetti
wanted his final resting place to be decorated with scenes
from the life of his patron saint, Saint Francis of Assisi. The

Dominicans, however, refused to have the most prominent
location in their church used, of all things, for the
glorification of the founder of the rival Franciscan order.
After a lawsuit lasting many years, the decision of the
Dominicans was given legal backing, and Sassetti angrily
withdrew from Santa Maria Novella.

He was able to carry out his project, however, in a small
chapel to the right of the choir in the church of Santa Trinità,
though the Vallombrosans who ran the church were also not
members of the Franciscan order (ills. 33, 34). There, in
accordance with Sassetti's wishes, Domenico Ghirlandaio
covered the walls with frescoes showing scenes from the life
of Saint Francis. What Sassetti had been prevented from
doing in Santa Maria Novella, he was able to accomplish here.

But that was not the end of it. The dispute over the
apsidal chapel in Santa Maria Novella was to gain
Ghirlandaio twice the expected amount of business.
Scarcely had he completed the Sassetti project in Santa
Trinità when, in 1485, another patron gave him the
commission to paint frescoes in the disputed chapel in Santa
Maria Novella (ill. 35). Giovanni Tornabuoni had skillfully
maneuvered to gain the right of patronage that had been
withdrawn from Francesco Sassetti.

Vasari reported that Tornabuoni made the following
promise to the Ricci family, who did not want to give up their

right of patronage: "he would bear the entire expense himself and would compensate them in some manner, and that he would furthermore place their coat of arms in the most prominent and honorable place in the chapel." In fact, however, Vasari reports that he had his own coat of arms painted large and very prominent, while the coat of arms of the Ricci family was hidden away, tiny and scarcely visible, in the frame of the altar painting near to the tabernacle. The chapel had scarcely been opened when, "making a great commotion, the Ricci looked everywhere for their coat of arms and finally, when they could not find it, they went to

the Eight Magistrates (a governing body) carrying their contract. The Tornabuoni argued that they had placed the Ricci coat of arms in the most prominent and honorable place in the chapel. When the Ricci objected that it could not be seen, the authorities told them that they were mistaken and that since the coat of arms had been put in a place as honorable as that one, and that since it was close to the Holy Sacrament, they should be satisfied with it." Vasari used this episode to "demonstrate how poverty is easy prey to wealth and how wealth accompanied by prudence will accomplish anything it desires without censure".

35 View along the nave of Santa Maria Novella to the Tornabuoni family chapel

In accordance with the wishes of the Dominicans who ran the church, the donor Giovanni Tornabuoni accepted the existing pictorial themes for his frescoes in his chapel in Santa Maria Novella: a series of paintings illustrating the lives of the Virgin Mary and of Saint John the Baptist. The designs of the three pointed arch windows were also produced in Ghirlandaio's workshop.

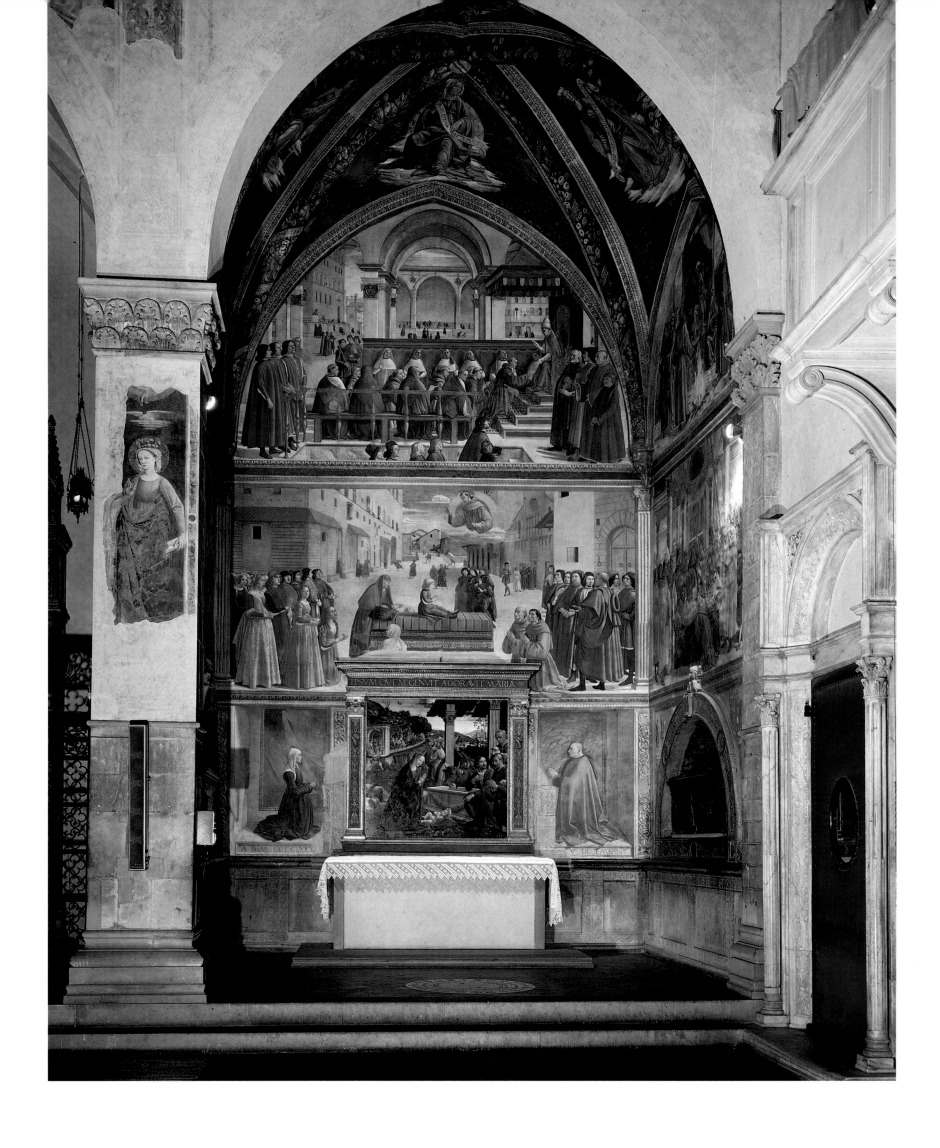

THE MOST BEAUTIFUL CHAPEL: THE SASSETTI CHAPEL IN SANTA TRINITÀ

Francesco Sassetti had gained his wealth as a partner in the French branches of the Medici bank in Avignon and Lyon. He also spent over ten years representing the Medici bank in Genoa and occasionally in Geneva. But he was not always successful later on in his role as the chairman of the bank, and in 1484 was replaced by Giovanni Tornabuoni. By the end of the 1470s, Sassetti had already acquired the rights of patronage to a small side chapel, the second to the right of the choir in the Florentine church of Santa Trinità. It was probable at this time that Ghirlandaio was commissioned to paint the chapel, which he decorated with frescoes between 1482 and 1485.

The donor and his wife had themselves portrayed as life-sized figures kneeling in prayer (ills. 33, 34) at the side of the altarpiece the *Adoration of the Shepherds* (ill. 59). The donors are adoring the Christ Child, just like the shepherds in the panel painting. An incomplete inscription under their portraits names the day on which the chapel was consecrated, 25 December 1485, hence

also the date by which it would have been completed. This year corresponds with the complete inscription on the altarpiece. In the Sassetti Chapel the artist combined secular, religious, and classical themes to produce a unique masterpiece (ill. 36).

In the scenes from the life of Saint Francis of Assisi, Ghirlandaio incorporated portraits of contemporaries and views of Florence: he recreated religious events to the Florence of his day. In contrast to the newly built Saint Fina Chapel, the Sassetti Chapel was old and in the Gothic style. On each of its three walls Ghirlandaio painted two scenes from the life of Saint Francis, completed by a seventh fresco in the tympanum over the arched entrance to the chapel. At the crown of the entrance arch, the Sassetti coat of arms is surrounded by a garland of fruit, a sculptural work made of terracotta. The fresco in the tympanum above shows a sibyl prophesying Christ's dominion over the world to Emperor Augustus (ill. 37). The fresco idealizes the classical period as the precursor to the Christian age, and this provides a link with the chapel's high point, the altarpiece, which depicts the birth of Christ. The grisaille figure of David outside the chapel can also be interpreted in this way (ill. 38).

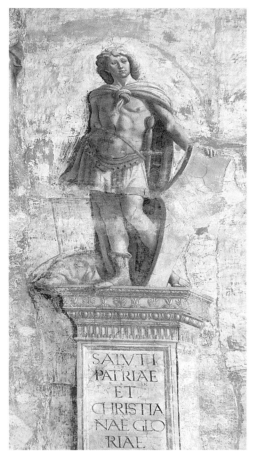

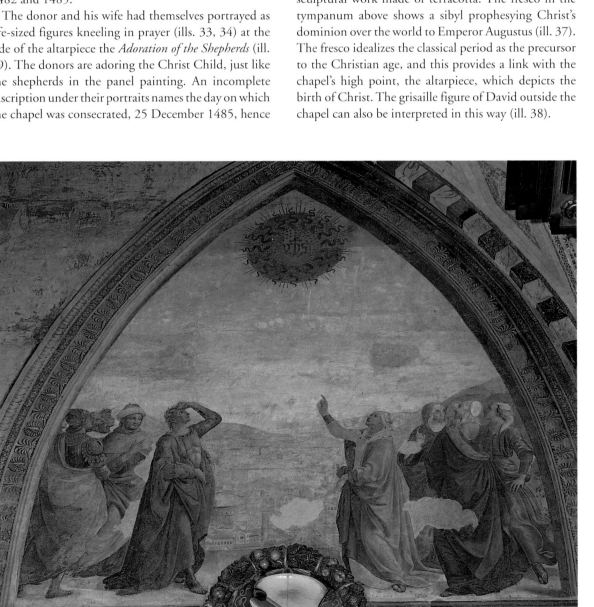

38 (above) *David*, ca. 1485
Fresco
Santa Trinità, Florence

The youth David, who, armed only with a catapult, vanquished the giant Goliath, was a symbol of the pride and power of the republic of Florence. He was also linked to the name of the donor: the catapult was part of the Sassetti family's coat of arms because their name was similar to the Italian word for throwing stones (*sassata*). The donor's coat of arms can be seen on David's shield. Catapults also flank the coat of arms above the chapel and are depicted in the sculptural ornamentation in the tomb niches in the chapel.

37 (left) *Meeting of Augustus and the Sibyl*, ca. 1485
Fresco
Santa Trinità, Cappella Sassetti, Florence

The Tiburtine Sibyl shows the Roman Emperor Augustus the shining gold vision of the name of Jesus abbreviated to "IHS". This prophecy to the pagan emperor is fulfilled in the altar painting in the chapel: the Birth of Christ. The figures are in a raised position with a view over classical Rome in which the Pantheon and Trajan's Column can be seen.

36 (opposite) View of the Sassetti Chapel, ca. 1485
Santa Trinità, Cappella Sassetti, Florence

After his protracted attempts to secure a much longed-for mortuary chapel for his family, Francesco Sassetti could not have wished for anything better than this superbly decorated chapel in the church of Santa Trinità. With its frescoes, altar painting, tombs and sculptural ornamentation, there is scarcely another Renaissance chapel by a major artist that has been preserved so completely.

40 (opposite) *Renunciation of Worldly Goods* (detail ill. 39), ca. 1485

In the background, a town wall with towers guides our eyes right into the distance. It is thought this is Genoa, where the donor spent ten years directing the local branch of the Medici bank. The shore is populated by many figures in groups, diminishing in size to create a sense of distance.

39 (below) *Renunciation of Worldly Goods*, ca. 1485
Fresco
Santa Trinità, Cappella Sassetti, Florence

The young Saint Francis renounced the world by laying aside his expensive clothes and placing himself naked into the care of the Church. A churchman is taking him into protection under his cloak – the same gesture used by a Madonna of Mercy. Spectators are restraining the horrified father carrying his son's clothes across his arm.

On the two side walls of the chapel are the black marble sarcophagi of Francesco Sassetti and his wife Nera Corsi, set into niches with round arches. Here the sculptural decorations are dominated by classical motifs; the sculptor Giuliano da Sangallo is sometimes identified as the artist. The tomb niches are framed by grisaille frescoes, in which Ghirlandaio cites motifs from classical coins. Above each are two monumental frescoes by Ghirlandaio, which clearly owe a debt to traditional images. There are still echoes of the pictorial order established by Giotto in Assisi over 160 years earlier. Ghirlandaio studied Giotto's frescoes in the Bardi Chapel, dating from about 1325, in the Franciscan church of Santa Croce in Florence, and made direct use of them.

In the Sassetti Chapel, the Saint Francis cycle starts in the tympanum on the left wall with the *Renunciation of Worldly Goods* (ill. 39), the scene in which the saint leaves his father and renounces his inheritance. It is perhaps surprising that this should be chosen as the theme for the mortuary chapel of a rich banker, but there were other bankers who considered the theme of poverty in response to God's call suitable for their funeral monuments – an example is Giotto's Saint Francis cycle in the Bardi Chapel, which was also commissioned by a banker. Underneath this tympanum is the fresco the *Stigmata of Saint Francis* (ill. 41). This event, the most important in the saint's life, encouraged his followers to raise him to messianic heights, for the miracle of the

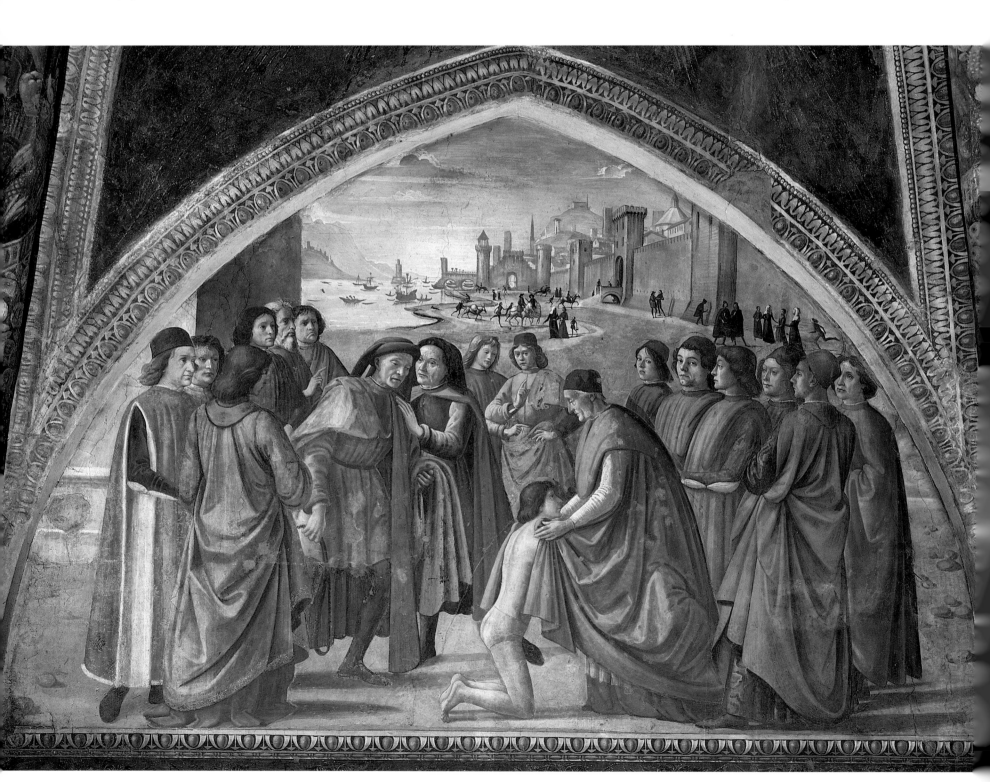

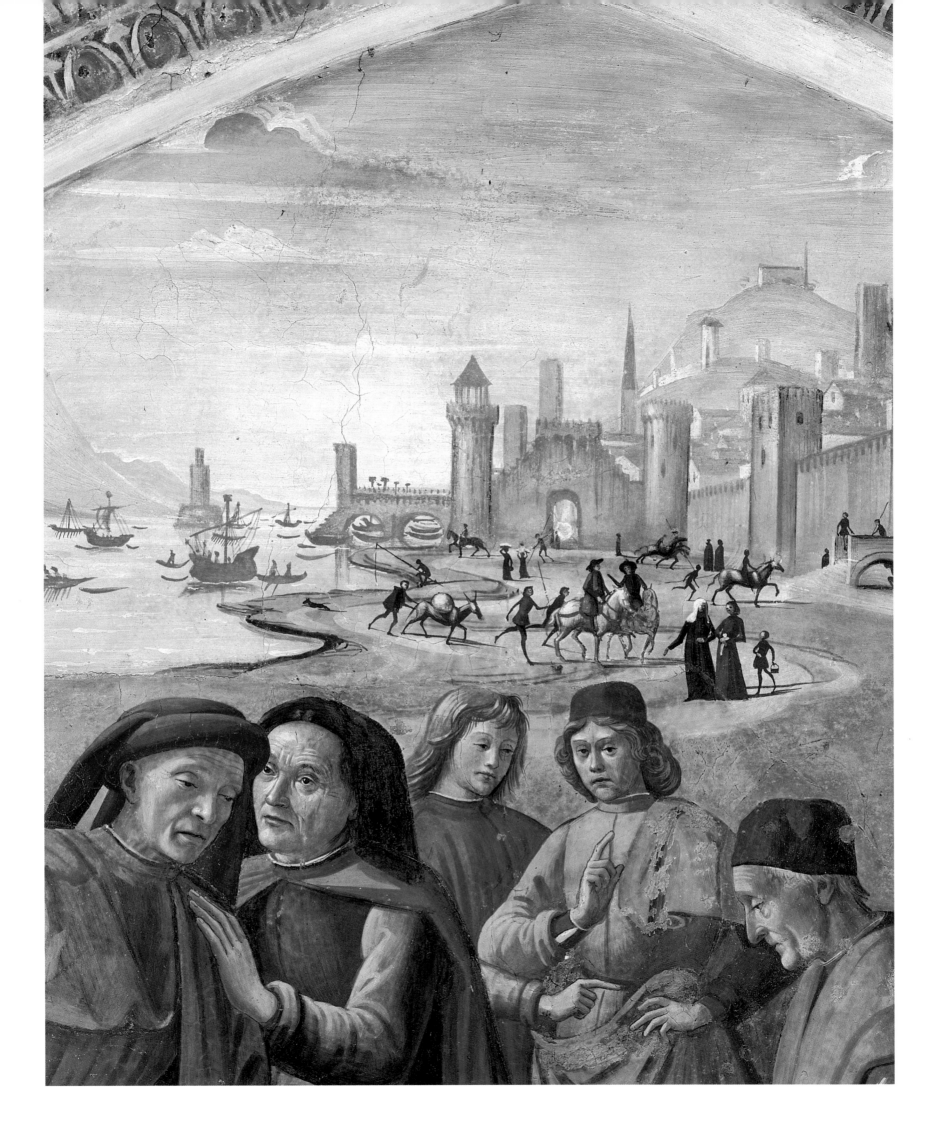

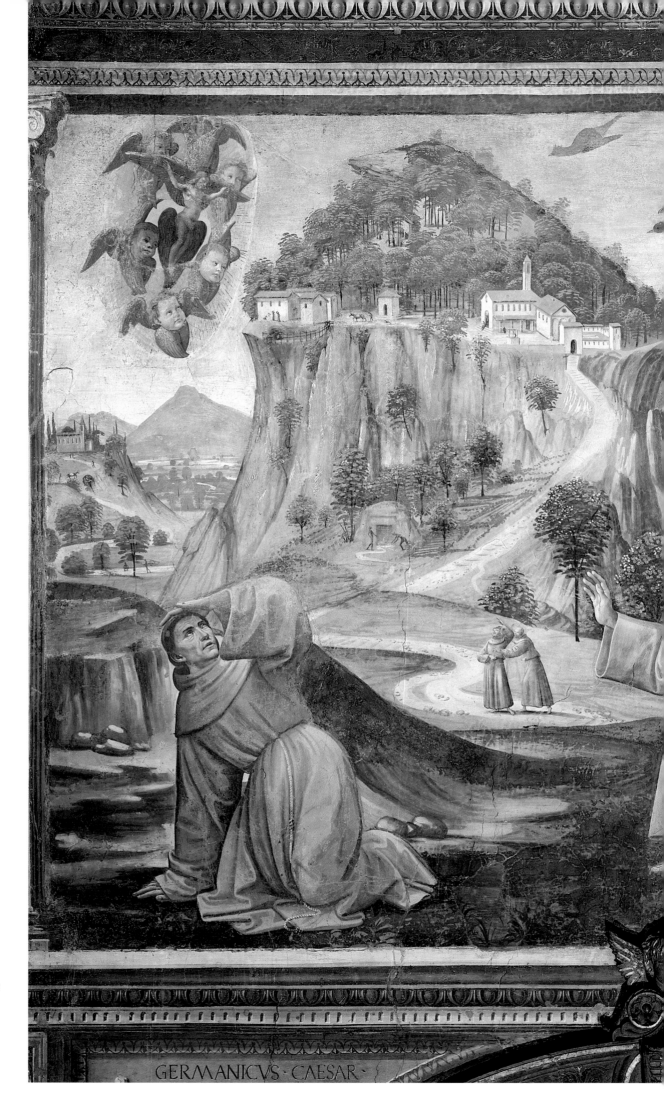

41 *The Stigmata of Saint Francis*, ca. 1485
Fresco
Santa Trinità, Cappella Sassetti, Florence

Saint Francis led his life entirely according to the example
of Christ. Two years before his death in 1224, he was
miraculously marked with the wounds of the crucified
Christ. This climax in the saint's life took place on the
slopes of the La Verna mountain, where seraphim
appeared to him bearing a vision of the crucified Christ
and he received the wounds produced by the nails and
lance.

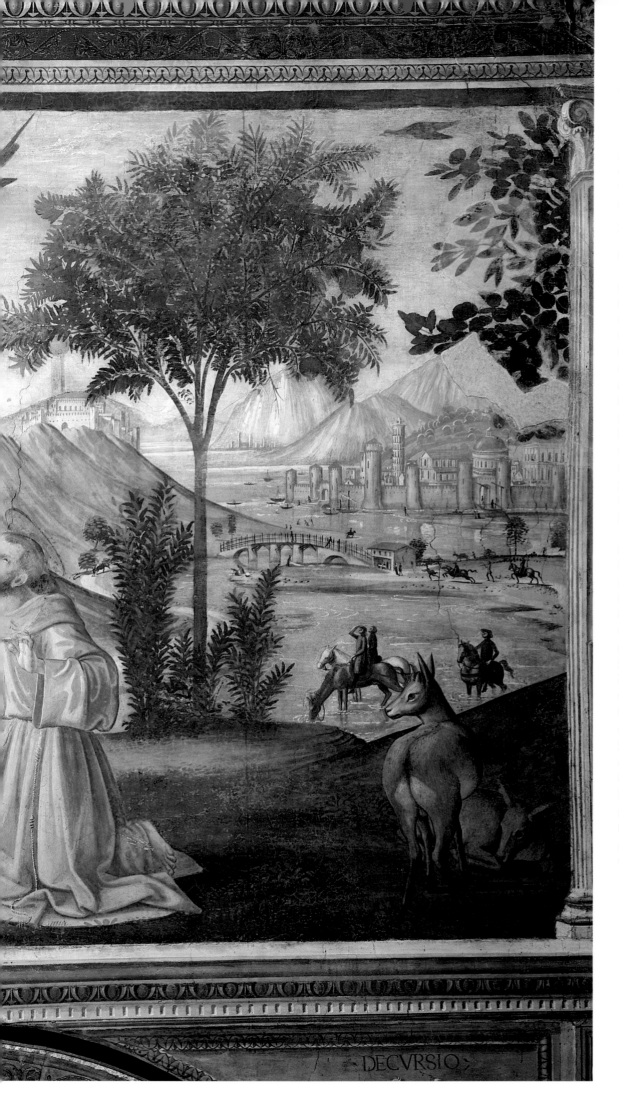

DECVRSIO

stigmata was the climax of his *imitato Christ* – his imitation of Christ. Legend tells how Saint Francis was transformed into the very image of the crucified Christ by receiving bleeding wounds on his hands, feet, and side. It is noticeable that this central event is not depicted in a prominent location in the chapel. Within the individual scenes, Ghirlandaio follows the compositional structure and postures of the main figures in Giotto's work, still his compulsory model. But the background proves that the frescoes belong to a new artistic era.

At roughly the same time, in about 1485, a Florentine sculptor of the same age created this scene showing the stigmatization in marble for the pulpit of the Franciscan church of S. Croce in Florence: his name was Benedetto da Maiano, and he had, like Ghirlandaio, been commissioned by the wealthy banker Pietro Mellini to create a funeral monument in the form of a pulpit. The similarity between the two scenes is so great that one is forced to assume that one of the two artists copied the other in his own medium. The remaining scenes about St. Francis on Benedetto's pulpit are also in part comparable with Ghirlandaio's frescoes. This raises the question whether the sculptor was influenced by the painter, or the reverse, or whether both of them made use of the same models. Here the two artistic genres of painting and sculpture were competing with each other.

The other two chapel walls have the same structure: a triangular area within an arch that is set above a rectangular area. On the right there is the *Test of Fire before the Sultan* (ill. 44), once again owing much to Giotto's frescoes in the Bardi Chapel. Beneath it, Ghirlandaio painted the *Obsequies of Saint Francis* (ill. 45). Here a priest is celebrating the funeral mass wearing a pair of spectacles on his nose – still an unusual motif, for Canon van der Paele in Jan van Eyck's Bruges Madonna of 1436 is still holding his spectacles, together with his book, in his hand. Vasari took such a liking to Ghirlandaio's priest that he wrote that he "is so real that only the absence of sound proves him to be a painted image". The distribution of the groups of figures is another variation – as is the *Obsequies* in the Saint Fina Chapel – of the composition created by Filippo Lippi in his *Obsequies of Saint Stephen* in Prato Cathedral. The sacred architecture is also derived from Lippi's fresco; Ghirlandaio, however, opens up his imaginary architecture at both sides, as he does in San Gimignano, with views onto a landscape.

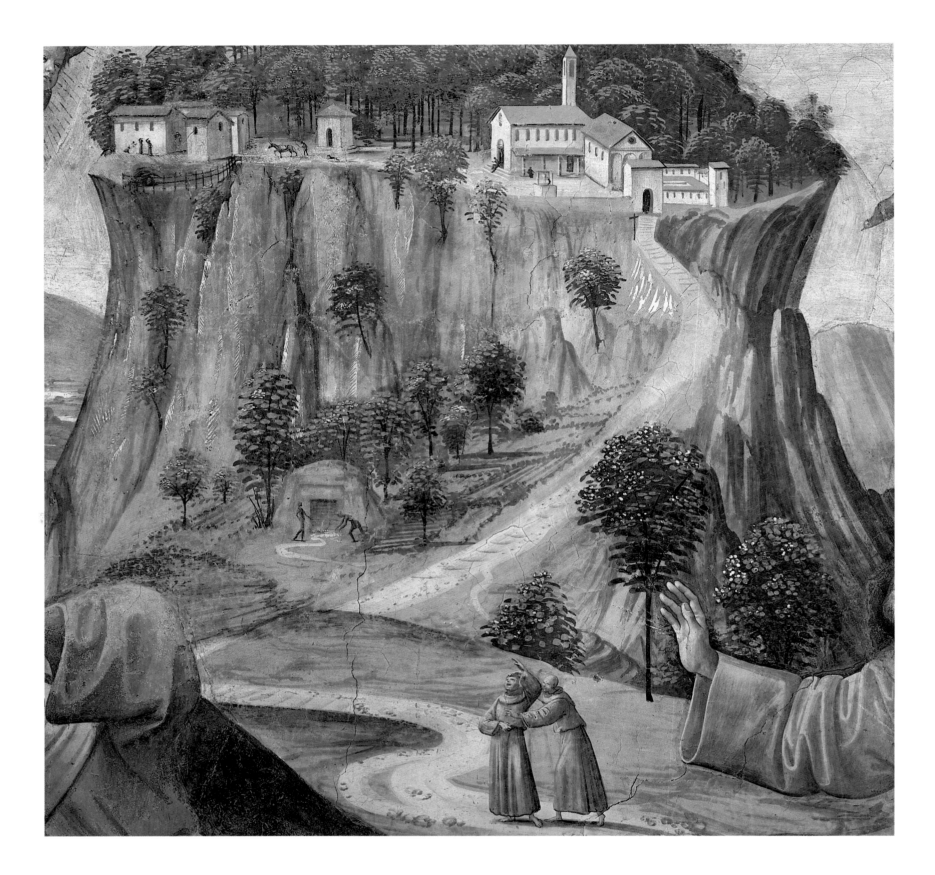

42 *Stigmata of Saint Francis* (detail ill. 41), ca. 1485

On mount La Verna in the Tuscan province of Arezzo,
1,128 metres above sea level, is a famous monastery
founded by Saint Francis. Ghirlandaio shows a path that
leads over a ramp to the gate of this monastery. Beyond
the gate we can clearly make out the monastery church
and a courtyard and well. To the left of the church, a
monk and his ass are on their way to a cluster of
monastery buildings. At the bottom of the hill, two
figures are busy by a grotto from which a spring is
flowing. Much in Ghirlandaio's picture is reminiscent of
real, topographical conditions.

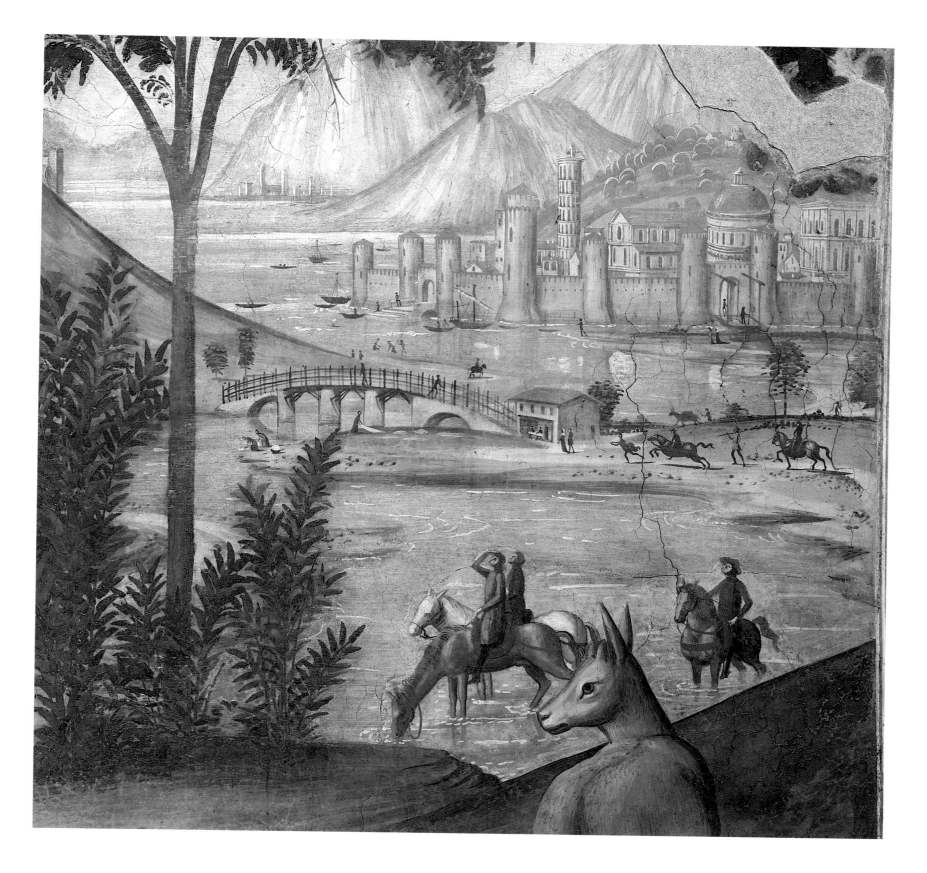

43 *Stigmata of Saint Francis* (detail ill. 41), ca. 1485

Three riders have stopped by a river in order to let their horses drink. They appear to be seeing the vision of Saint Francis in the distance. In the previous detail (ill. 42), two monks are also witnessing the manifestation. This contradicts the legend, which stated that there were no witnesses. In the background is an idealized view of the city of Pisa, which had been conquered by Florence in 1406.

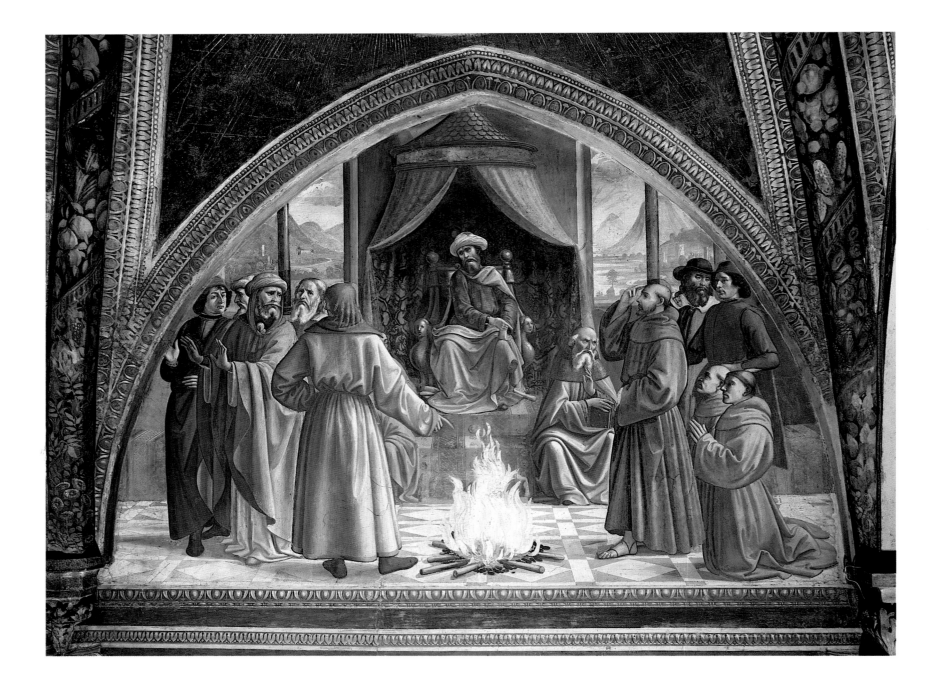

44 *Test of Fire before the Sultan*, ca. 1485
Fresco
Santa Trinità, Cappella Sassetti, Florence

Saint Francis has appeared before the Sultan in order to
prove the strength of his faith and the power of his God.
He is prepared to walk barefoot through a blazing fire for
his faith. The bearded Muslim scholars or religious leaders
on the left do not appear to be prepared to venture the
same for their faith.

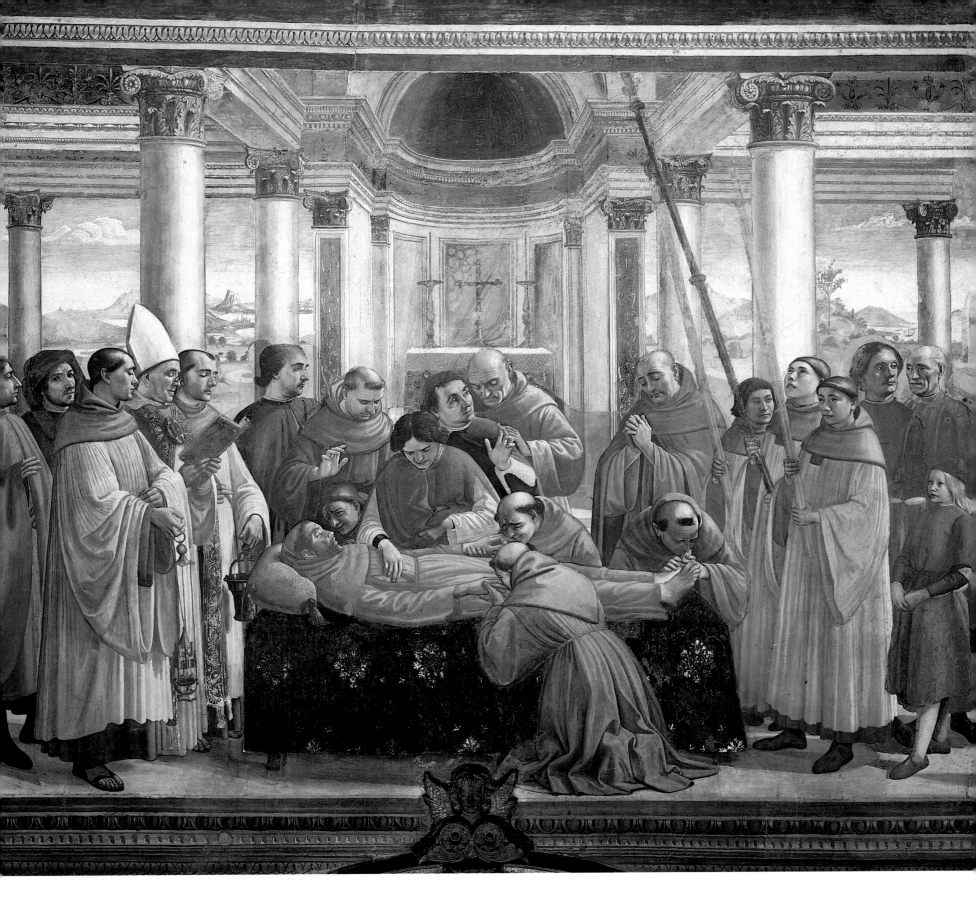

45 *Obsequies of Saint Francis*, ca. 1485
Fresco
Santa Trinità, Cappella Sassetti, Florence

As in Giotto's fresco in the Bardi Chapel in Florence,
grieving Franciscan brothers encircle the dead founder
of their order. Some are kneeling in order to kiss the
stigmata on his hands and feet. A figure dressed in red is
bending over the dead body in order to examine the
wound in the saint's side. This is Girolamo who, like the
doubting Thomas with Christ, doubted the stigmatization
of Saint Francis until he was able to touch the wound.

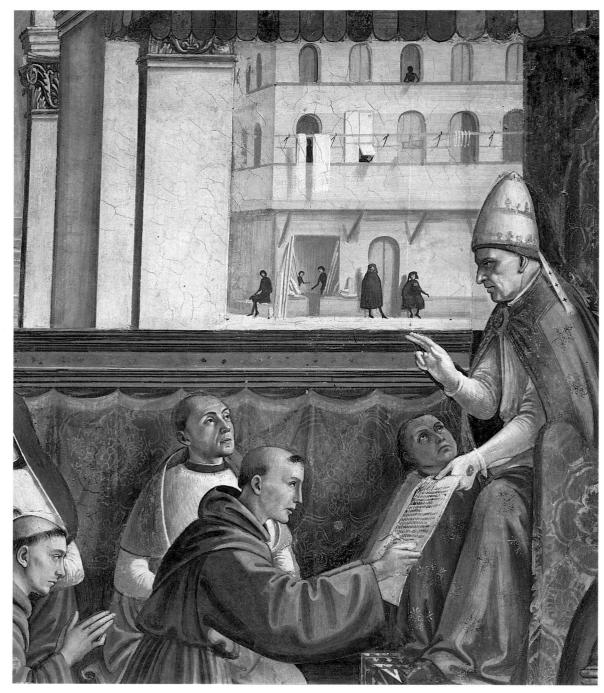

47 (right) *Confirmation of the Rule* (detail ill. 48), ca. 1485

Pope Honorius III, enthroned on high, is lifting his hand in blessing as he hands the scroll bearing the rule for the new Franciscan order to Saint Francis, who is kneeling before him. The everyday life of the city is going on in the background, paying little attention to the solemn ceremony – washing is hanging out to dry in the sun, and a small shop is open.

46 (below) *The Palazzo Vecchio and Loggia dei Lanzi*

The secular center of Florence, the Piazza della Signoria, is dominated by the Palazzo Vecchio, which was begun in 1299 and finished by the mid fourteenth century. In the interior, Ghirlandaio covered a wall in the Sala dei Gigli with frescoes. Famous statues are now on display in the so-called Loggia dei Lanzi (actually the Loggia della Signoria, built about 1374–1381). Both buildings were constructed using money raised by taxes and were meant to express the power of the city of Florence.

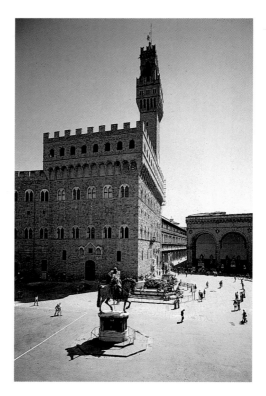

48 (opposite, above) *Confirmation of the Rule* ca. 1485
Fresco
Santa Trinità, Cappella Sassetti, Florence

Set between two lines of important Roman churchmen, several Franciscan brothers are kneeling behind the founder of their order, Saint Francis of Assisi. In the middle distance, Ghirlandaio does not conceal what he owes to Giotto, but the foreground and background give the scene a new interpretation. On the left, dressed in red, stand the sons of the donor: Galeazzo, Cosimo, and also Teodoro, who had already died in 1478.

49 (opposite, below) *Confirmation of the Rule* (detail ill. 48), ca. 1485

The Loggia dei Lanzi in the middle distance was used for official ceremonies and government announcements. The Palazzo Vecchio on the left, as the seat of government, was the pride of the Republic of Florence and is an emblem of the city to this day.

At the best site in the chapel, highly visible above the altar, are the most famous scenes in this group of frescoes, though they are not in any way the most important stages of the story of Saint Francis. In these scenes on the back wall of the chapel, Ghirlandaio succeeded in creating his own independent and unique images. The most remarkable example is immediately above the fresco the *Resurrection of the Boy*: it is the *Confirmation of the Rule* (ill. 48). Ghirlandaio moves the scene of both events from Rome, where they took place, to Florence. The events in the *Confirmation of the Rule* are taking place on the most important square in Florence, the Piazza della Signoria (ills. 46, 49). This expresses the civic pride of the Florentines, who considered their city to be the new Rome.

1478 was a fateful year for Florence and for the donor Francesco Sassetti. It was the time when the opponents of the Medici – led by the Pazzi family and supported by the Pope – attempted to murder Lorenzo de' Medici. The plotters attacked the Medici during mass in the cathedral. Lorenzo escaped wounded, but his brother Giuliano de' Medici was killed. Lorenzo took bloody revenge on his opponents and was able to use his power, which was now extended, to banish or kill his enemies. While appearing to uphold republican institutions, he secured the power of the Medici in Florence's affairs. Many citizens, led by wealthy families such as the Sassetti and the Tornabuoni, supported the consolidation of his power. Expecting to gain the protection of their own interests, they expressed their loyalty to the Medici through grand gestures, and art was a very suitable means. So the donor Francesco Sassetti, for example, had himself depicted standing peacefully next to his secular lord (ill. 50). Lorenzo de'

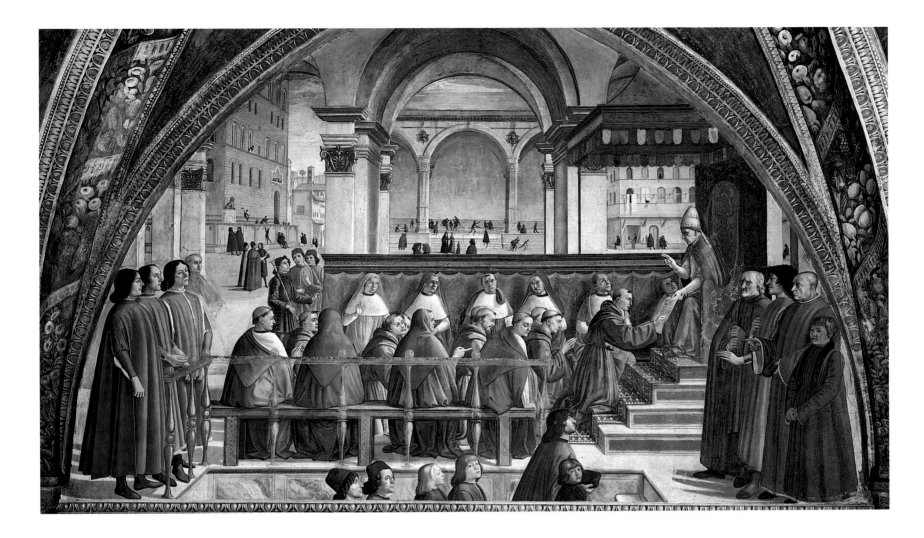

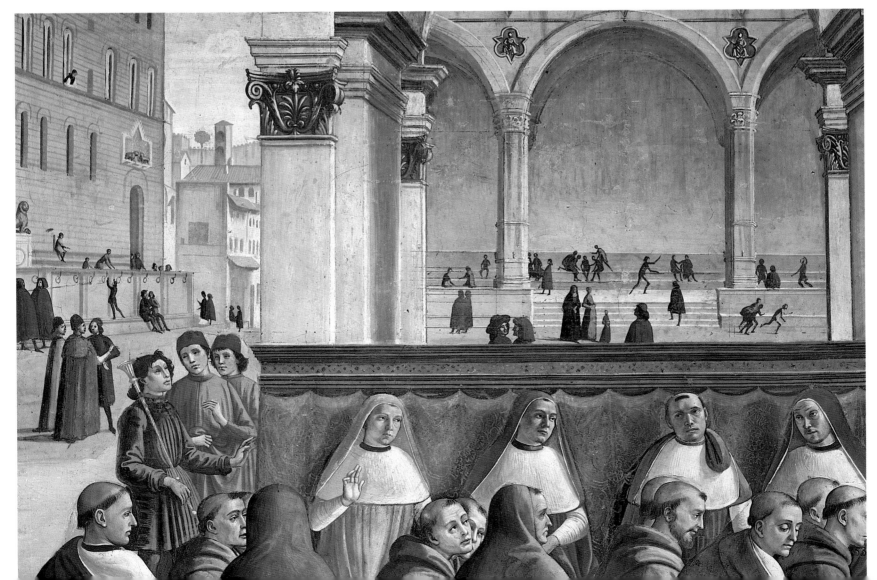

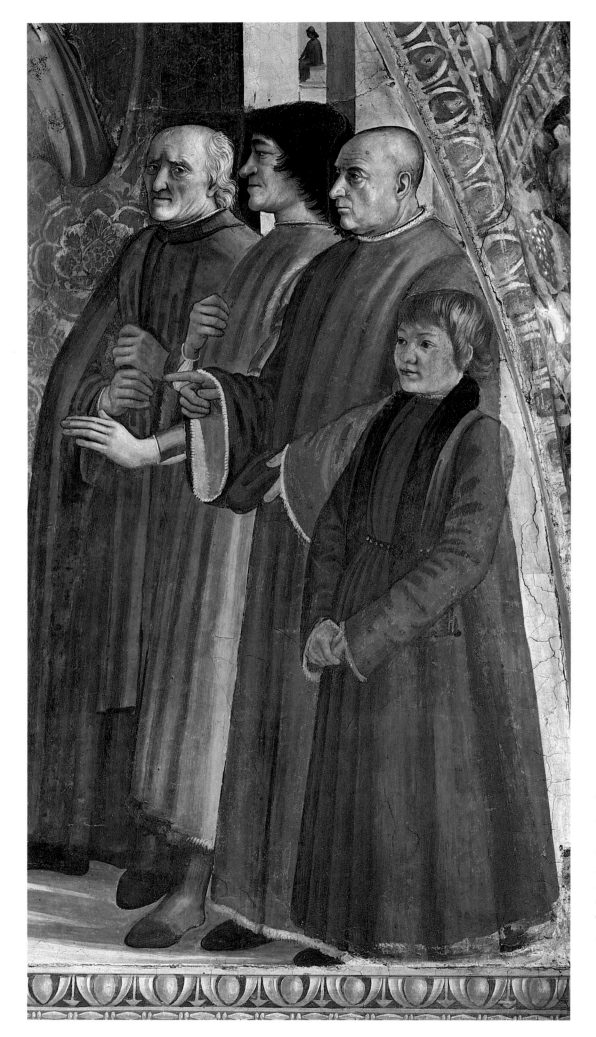

Medici, known as *il Magnifico* (the Magnificent), can easily be recognized by his profile. The fact that this is one of the few authentic portraits of him means that this picture an inestimable value. Contemporary writers all agree in their descriptions of the grotesque shortcomings in his external appearance. He was said to have a flattened nose that hung down at the tip, a nose that was not even gifted with the sense of smell. Like his mother, Lucrezia Tornabuoni, he had an impaired sense of taste, and he always spoke in a hoarse tone of voice. He had an unusually large mouth, sunken cheeks and a pale skin color, all of which might have been repulsive, though it was probably countered by the superior charm of dignified humanity that Lorenzo is said to have exuded. Lorenzo de' Medici was the intellectual center of the greatest artistic flowering of the city, and at the same time a tyrant. Under his level-headed leadership, Florence achieved an exceptionally high cultural level, but its economy stagnated. Skilled diplomacy enabled him to make the influence of his state felt in the power struggles between Venice, Milan, Naples and the Papal State.

According to Sassetti's wishes, the fresco the *Confirmation of the Rule* would show not only his own sons, but also those of the "Prince", together with Lorenzo's most important advisors. In order to be able to fit all the figures into the picture, some of the figures that had already been painted in the fresco had to be scratched off the wall. Thus, on the left side next to the donor's sons, there appears a monk without a body: he had been overpainted, but can now be seen again shining through the insufficiently thick layer of color that was painted over him.

Ghirlandaio had to make use of an artistic trick in order to do justice to the many portraits he needed to fit into the all too small pictorial space. He solved the problem skillfully by making some figures appear to be climbing a flight of steps, which meant that they did not take up as much space. An early preliminary drawing confirms that the portrayed figures were indeed not intended to be in the picture when work began (ill. 51). When the fresco was executed, the pictorial theme was altered by the presence of the powerful prince. This important change reflects the political and social status of the donor. The client's need to portray himself and his circle is so strong that the religious events are forced into the background. The donor's proud consciousness of his own greatness and power makes a piquant contrast with the obedient submission of Saint Francis to the rules of the Church.

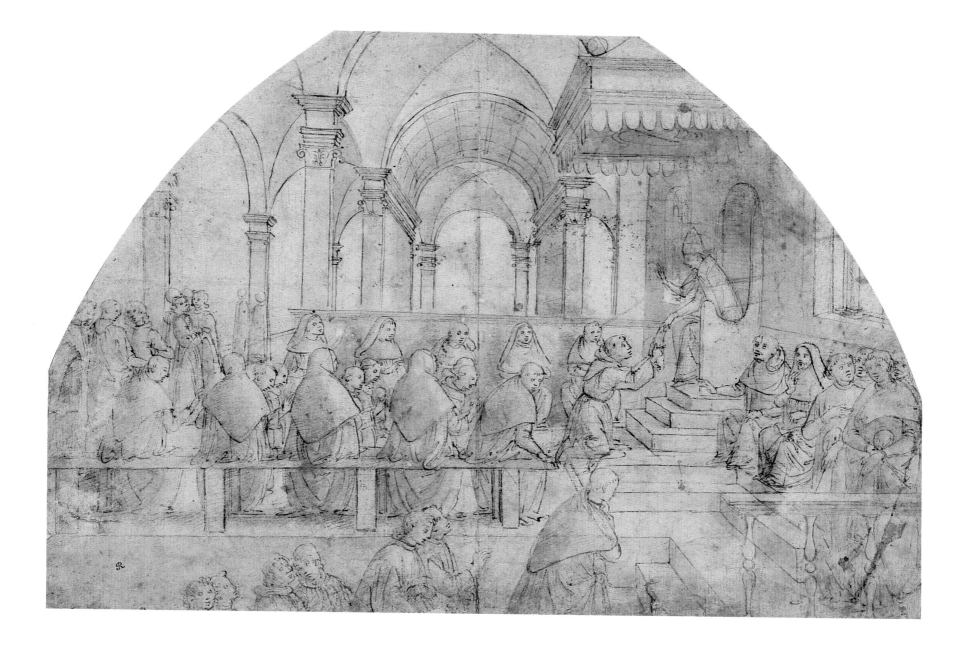

50 (opposite) *Confirmation of the Rule* (detail ill. 48), ca. 1485

The donor, Francesco Sassetti, is depicted in the foreground on the right as an equal and loyal partner to Lorenzo de' Medici, who stands next to him. On Francesco's left is his son Federigo, who like one of the Medici sons was destined to follow a career in the Church. The old man behind Lorenzo is Antonio Pucci, a powerful supporter of the Medici. Between 1480 and 1482, he carried out successful peace negotiations with the Pope. In 1483, his son Alessandro married Sibilla Sassetti, the daughter of Francesco.

51 *Confirmation of the Rule*, ca. 1483
Ink drawing on paper, 24.9 x 37 cm
Staatliche Museen Preußischer Kulturbesitz,
Kupferstichkabinett, Berlin

When Ghirlandaio planned this scene, he left out the contemporary background and the portrait figures. It is likely that he had to prepare such studies so that the donor could make such alterations or additions as he desired. When Ghirlandaio came to paint the fresco, he changed the character of the narrative: the depiction of ecclesiastical matters became less important than the exhibition of secular power.

So who is coming up the steps one by one and pushing the religious narrative into the background? It is the children of Lorenzo de' Medici, led by the poet Agnolo Poliziano (also known as Politian), who was their teacher and one of the most important humanists of the age (ill. 52). Poliziano frequently, and against his will, had to enter service as an occasional court poet. His poetry was so popular that he even complained about it in 1490. He lamented that everyone who wanted a short line for his sword, an epigram for his ring, a verse for his bed, or motto for his earthenware, would "run straight to Politian, and right away all the walls in the rooms will be covered with the washes of my ideas and inscriptions.

Lorenzo de' Medici provided the very best education for his children. He showed wise foresight in his planning of his son Giovanni's ecclesiastical career. The latter was given his spiritual tonsure as early as 1483, but in the fresco his hair is not yet cropped, so it is likely that this picture was completed before that date. It is certain that the tonsure – the sign of sacred dignity that his father so greatly desired – would not have been omitted. Giovanni was ordained a cardinal in 1489, at the age of 13, and in 1513 ascended the Holy See as Pope Leo X. After long diplomatic efforts and setbacks, the Medici finally succeeded in gaining power in Rome.

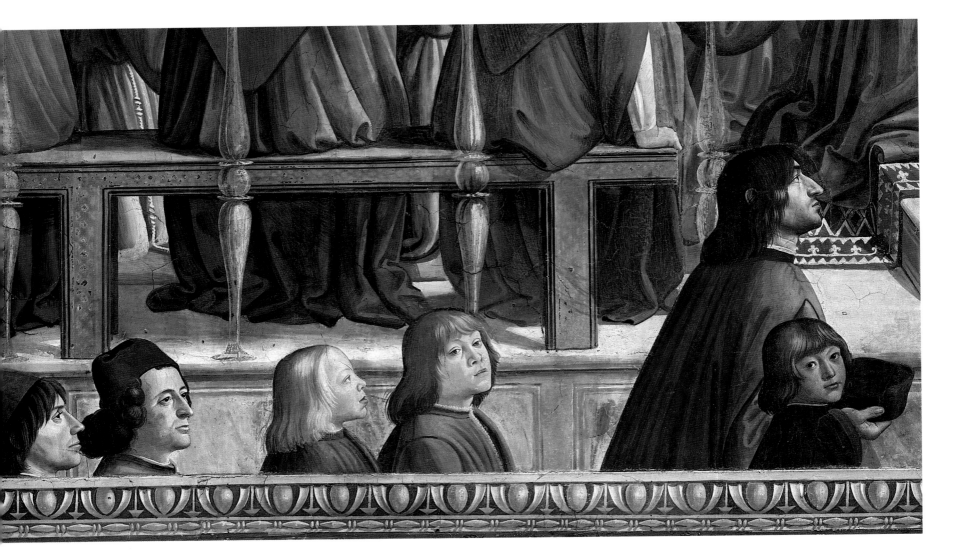

52 *Confirmation of the Rule* (detail ill. 48), ca. 1485

The sons of Lorenzo de' Medici are climbing a flight of steps. Giuliano, Piero and Giovanni de' Medici are led by their teacher, the poet Agnolo Poliziano. Lorenzo intended that the small blond Giovanni, with a stub nose and pale skin, should follow a career in the Church. He entered the history books as Pope Leo X (1513–1521). Following at the end are the well-known men of letters, Matteo Franco and Luigi Pulci, who were personal friends of the prince and competed with one another for Lorenzo's favor.

One person wants me to produce funny ideas for the carnival, a second wants pious, edifying speeches for conventicles, a third wants mournful tunes for a sad song, a fourth, in contrast, wants lewd lines for a serenade; one simpleton tells me (the even greater one) about his love affairs and would like a mysterious epigram which only his beloved would understand, but which would lead the uninitiated to make all sorts of fruitless assumptions." Ghirlandaio integrated a second portrait of this famous humanist on the very left of the *Obsequies of Saint Francis* (ill. 45).

Behind the children Matteo Franco, a close friend of Poliziano, is climbing the steps. He was a confidant of Lorenzo's and at the same time his children's elementary teacher. In a letter dating from 1485, he describes them just as Ghirlandaio depicts them in their portraits: the charming Giuliano was lively and as fresh as a rose. The prettiest one, Piero, was like an angel, the purest beauty. Giovanni was also handsome, not very fresh in his coloring but lively and natural.

At the rear is Luigi Pulci, another confidant of Lorenzo's, who wrote "Morgante", the first Italian

53 *Resurrection of the Boy* (detail ill. 54), ca. 1485

While playing, a boy falls out of the window of the
Palazzo Spini. A red ball is falling to the street below him.
Some passers-by see the falling child, rush up to help, but
it is too late: the child is dead. The depicted palace and
the Ponte Trinità over the Arno still stand today, though
they now look different from the outside.

chivalric poem, in 1483. He courted the favor of
Lorenzo the Magnificent in competition with his rival
Matteo Franco, and the two men fought poetic duels.
Their sonnets are pearls of courtly abusive poetry that
amused Lorenzo so greatly that his sons had to learn and
say these poems by heart.

The official prestige value of this upper picture on the
main chapel wall is clear. In contrast, the fresco beneath
it, directly above the altarpiece, is devoted to the Sassetti
family's private history. In 1478, the year of the Pazzi
plot, their son Teodoro died; but a few months later

Nera Corsi Sassetti gave birth to a second son. As they
felt him to be a gift from God, they made yet another
change in the plans for the altar wall in their mortuary
chapel. Ghirlandaio had to abandon his design for a
scene showing the appearance of Saint Francis in Arles,
for which preliminary drawings still exist, and paint the
Resurrection of the Boy. This was how the Sassetti
intended to express their gratitude for their new-bon son
Teodoro II (ills. 53 – 57).

The Sassetti Chapel is consecrated to the birth of
Christ, and as a result much in the chapel is conceived

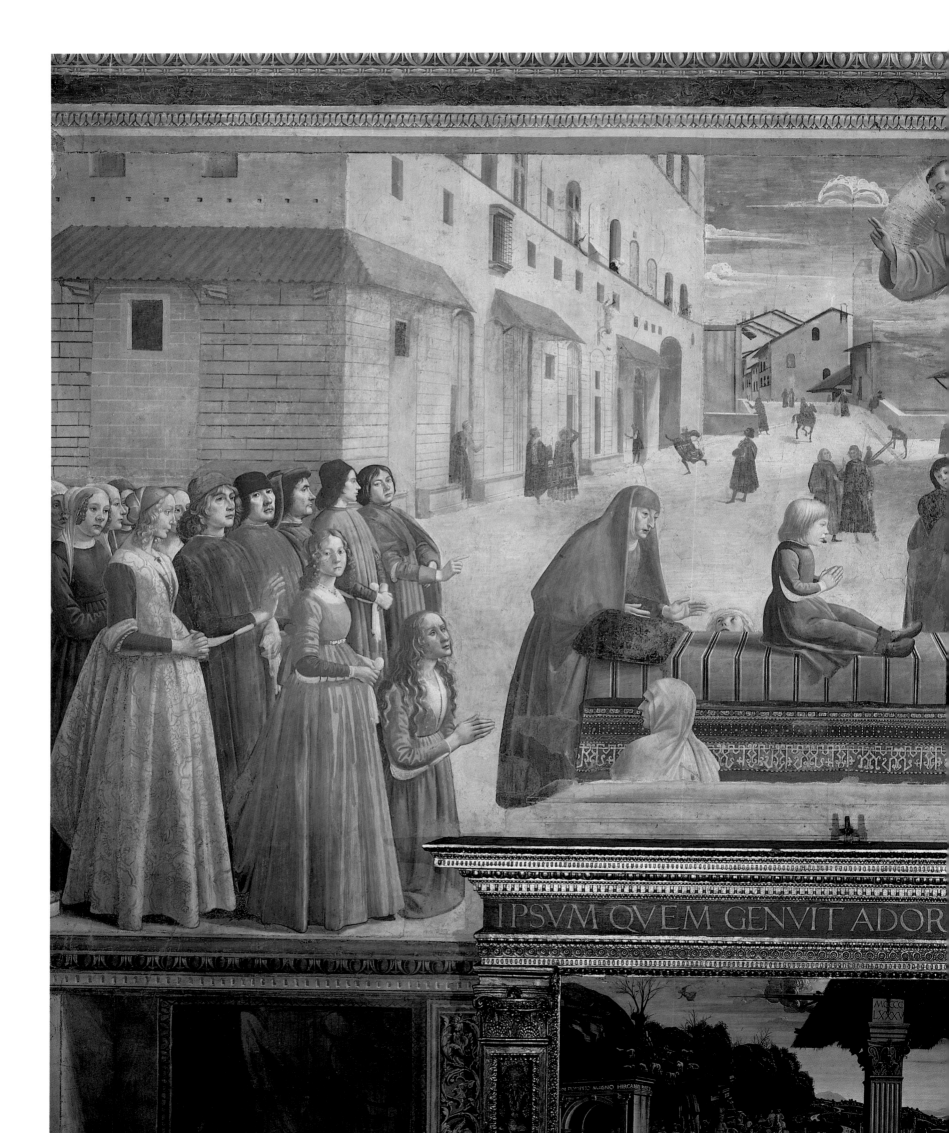

IPSVM QVEM GENVIT ADOR

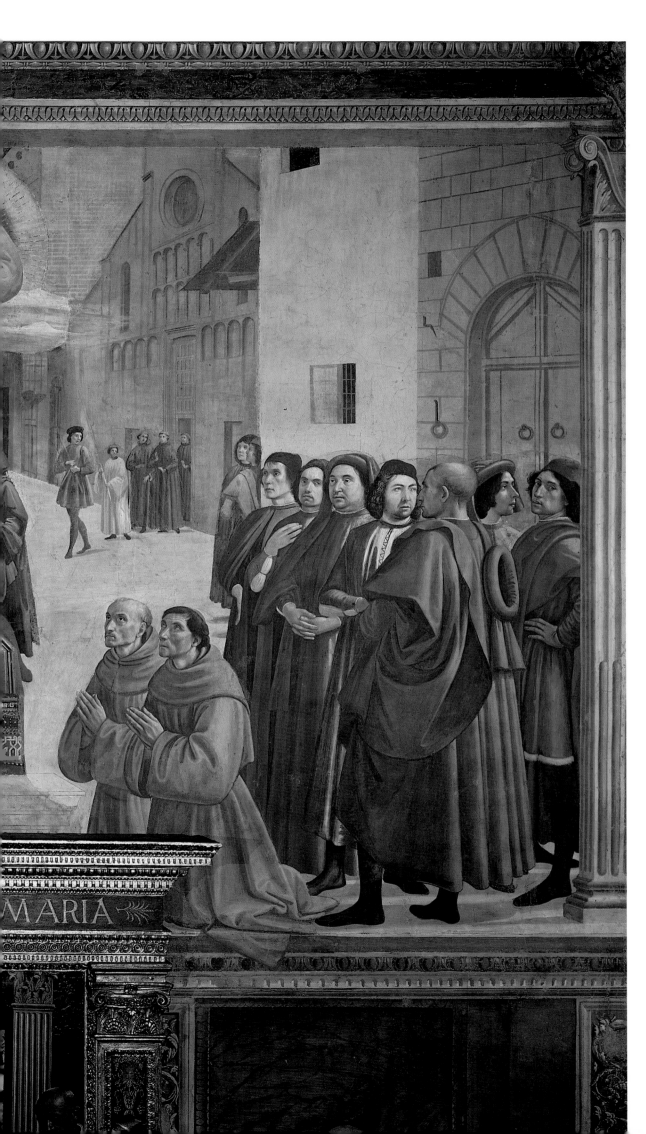

54 *Resurrection of the Boy*, ca. 1485
Fresco
Santa Trinità, Cappella Sassetti, Florence

The boy who met with the fatal accident is already lying
on a bier surrounded by mourners. Then, however, two
Franciscans succeed in interceding with Saint Francis on
their behalf, and the child is brought back to life. The
artist also moved this miracle from Rome, where it
actually took place, to Florence – just outside the church
of Santa Trinità in which the picture is painted – in order
to be able to incorporate many of the portraits requested
by the donor in the groups of onlookers. This scene,
seldom depicted, was the way the Sassetti couple
expressed their gratitude for the birth of a second son so
shortly after the death of their son Teodoro, a birth that
seemed like a miracle to them.

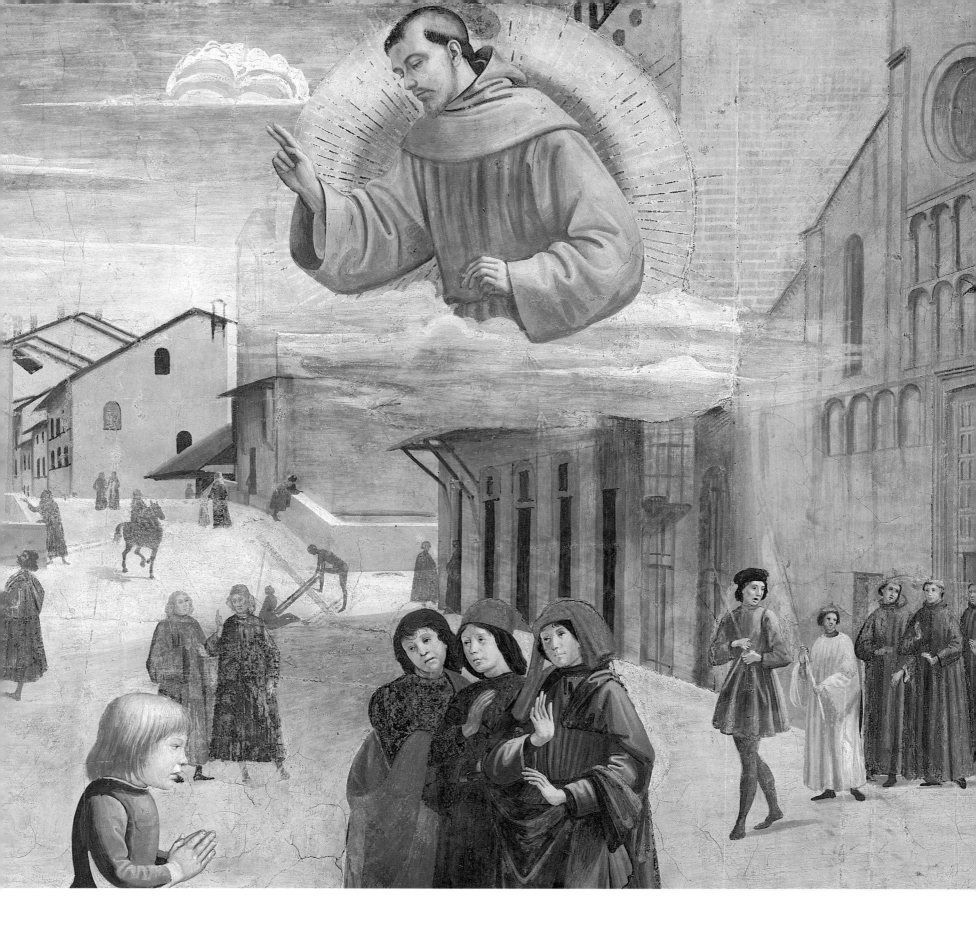

55 *Resurrection of the Boy* (detail ill. 54), ca. 1485

Ghirlandaio depicted the façade of the church of Santa
Trinità as it looked until about 1593. The Romanesque
façade used to be structured using blind arches, remnants
of which still exist today behind the new façade. Some
monks are leaving the church's portal in a procession. It
will pass along the street across the river, past the passers-
by, a rider and two working carpenters.

56 *Resurrection of the Boy* (detail ill. 54), ca. 1485

Curious onlookers have hurried up from all around in order to witness the miracle of the resurrection. In the crowd in front of the Palazzo Spini, the donor's daughters and some of his friends are portrayed. They probably included Maso degli Albizzi, Agnolo Acciaioli, Filippo (Palla) Strozzi the Elder and their wives and children – all of them loyal supporters of the Medici.

57 *Resurrection of the Boy* (detail ill. 54), ca. 1485

Other Florentine citizens are standing together on the right side. On the far right, Ghirlandaio self-confidently included himself in the scene, looking out of the picture. Next to him we see the profile of his brother-in-law Sebastiano Mainardi, who also worked on the frescoes. A similar family portrait exists in the later Tornabuoni Chapel (cf. ill. 2), where the figure seen from behind has the features of his brother Davide. Here the figure seen from behind is Neri di Gino Capponi; an impressive bust of him is on exhibition in Florence's Bargello.

with that event in mind. Even the sibyls painted on the chapel's roof vaulting are holding banderoles prophesying the coming of Christ (ill. 58). The prophecy in the *Meeting of Augustus and the Sibyl* on the first fresco outside the chapel is fulfilled in the altarpiece, where the promised Christ Child is being worshipped.

This altarpiece the *Adoration of the Shepherds* is the chapel's key work not only in subject, but also in artistic merit (ill. 59). This composition was so successful that other artists frequently repeated it. For example, several copies exist painted by a Maestro di Santa Lucia sul Prato. Ghirlandaio himself appears in scene, dressed as a shepherd. He is even allowed to come closer to the Christ Child than the donors, who appear in frescoes to the right and left, praying outside the confines of the panel. The artist, who is leading the shepherds, is

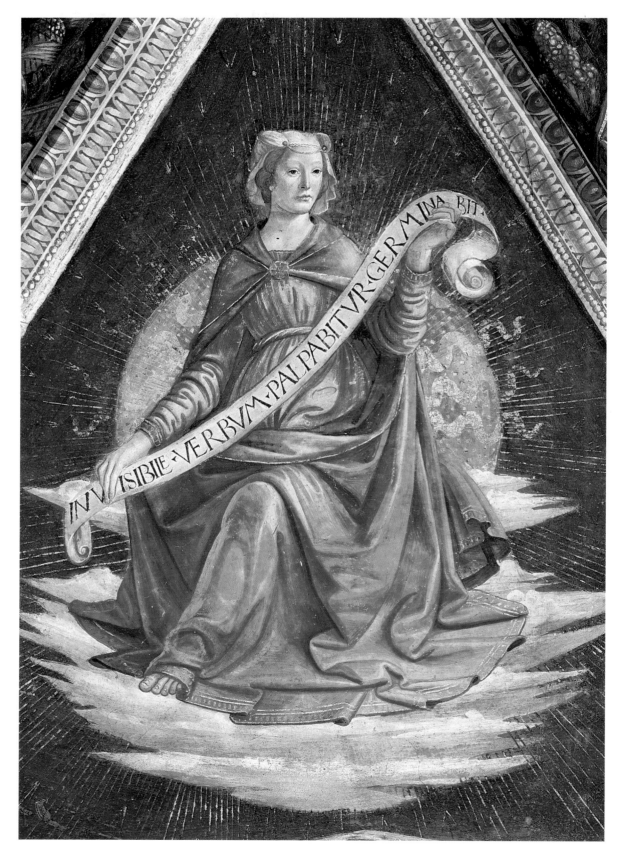

58 *Sibyls*, ca. 1485
Fresco
Santa Trinità, Cappella Sassetti, Florence

Four female prophets are depicted in the vaulting of the chapel. They are enthroned on clouds in front of a sky-blue background and are holding out their prophecies on banderoles. They are wearing marvelously colored garments and dresses with high waistlines. The ribs of the Gothic vault are magnificently decorated with painted garlands of fruit symbolizing the wealth, prosperity and fertility of both the donor family and the city of Florence.

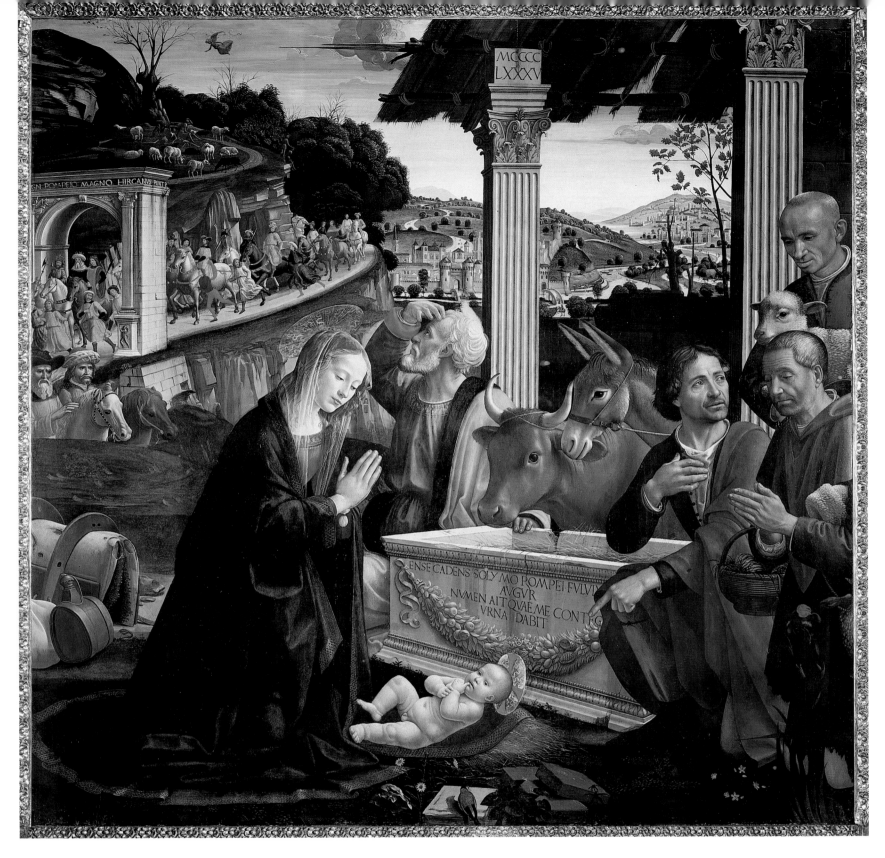

kneeling and bringing the miracle of the birth of Christ to the attention of both the shepherds and the observers of the picture. His left hand, with which he is pointing to the Christ Child, is finely drawn and is superbly modelled in three dimensions. With his right hand, his painting hand, he is pointing to his chest, as he does in a later fresco in the Tornabuoni Chapel (ill. 63). As Ghirlandaio is pointing both at the child and the garlands on the Roman marble sarcophagus, it is possible that the gesture is saying: "This holy child was painted for you by me, the garland-maker Ghirlandaio."

The classical sarcophagus in the picture is not just a manger for the ox and ass. It also has an iconographical significance indicated by the Latin inscription along its front: "The urn that conceals my body will produce a god." This is an ancient prophecy by Fulvius. The animals' manger will serve as a crib for the Christ Child. In his *Adoration of the Shepherds*, Ghirlandaio combines this reference to the Roman classical age with knowledge of Flemish art and turns them into an integrated whole.

An historic event that took place a few years before this work was painted clearly left its mark behind on

59 *Adoration of the Shepherds*, 1485
Panel, 167 x 167 cm
Santa Trinità, Cappella Sassetti, Florence

The wonderfully gentle Mary is kneeling in silent adoration in front of her son, who is lying naked on a corner of her cloak, which has been spread over straw. Like a real baby, the Christ Child is kicking his feet and sucking his thumb. Joseph is turning and in the distance he can already see the train of the Three Kings approaching, and on the right three shepherds are already moving into the picture in order to adore the child. The first shepherd bears Ghirlandaio's features: it is an another self-portrait.

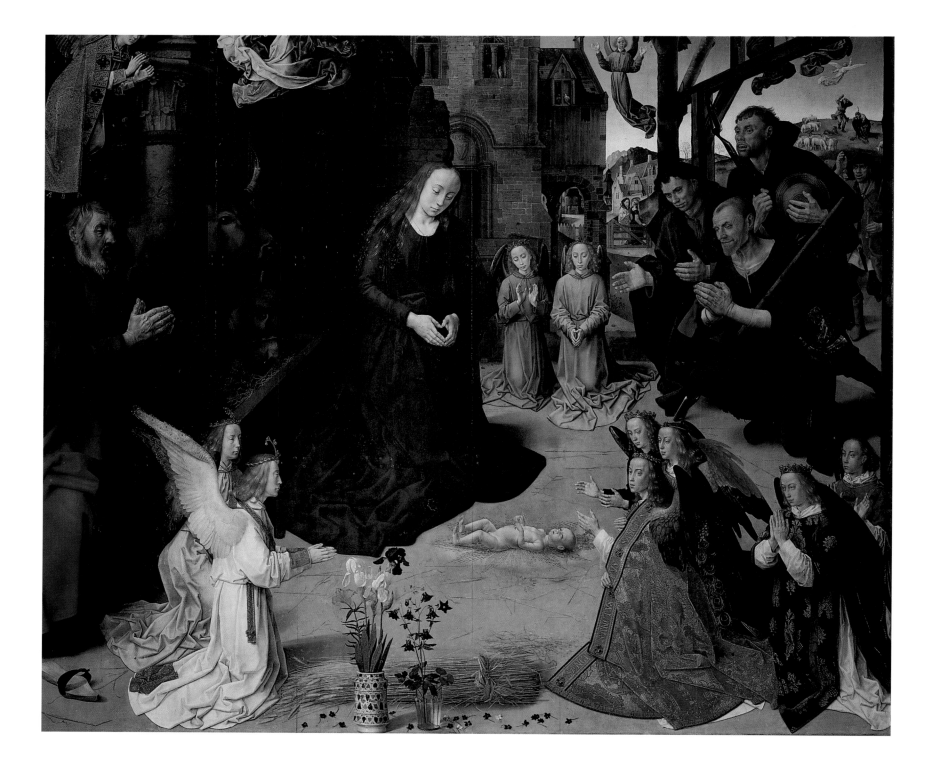

60 Hugo van der Goes
Adoration of the Shepherds, central panel of the *Portinari Altar*, before 1476
Panel, 253 x 304 cm
Galleria degli Uffizi, Florence

This gigantic oil painting, produced in the Netherlands, exerted considerable influence on Florentine painting at the end of the Quattrocento. The work hung, visible to all, in the church of the hospital of Santa Maria Nuova, and is now one of the prized possessions of the Galleria degli Uffizi. Ghirlandaio's *Adoration* (ill. 59) would have been unthinkable if it were not for the direct influence of this *Adoration of the Shepherds*.

Ghirlandaio's work. An altarpiece ordered by Tommaso Portinari from Hugo van der Goes in Bruges reached Florence in May 1483. Florentine artists saw van der Goes' *Adoration of the Shepherds* as a shining comet showing new ways of painting (ill. 60). In Ghirlandaio's altarpiece, the shepherds pushing their way into the picture from the right, with their harsh, life-like features, are drawn directly from this Flemish model. Ghirlandaio's landscape in the background also displays features from north of the Alps. (ill. 61).

The unique ensemble of the Sassetti Chapel, preserved in its entirety, still shows that Saint Francis was being primarily honored here not as the head of an order,

but as the patron saint of a family. At the same time, the frescoes are depicting the relationships of the clients and their closeness to the Medici. Even the relations between Florence and papal Rome, which became increasingly important to the Florentine upper classes for political and economic reasons, are included in the frescoes. The Sassetti Chapel documents this diplomatic rapprochement of Rome and Florence after the unsuccessful Pazzi plot. Furthermore, Francesco Sassetti wanted to emphasize his loyalty to Lorenzo de' Medici. He had every reason to do this, for his rival for the right of patronage of the main chapel in Santa Maria Novella, Giovanni Tornabuoni, had not only taken that

chapel from him, he had also written a letter to Lorenzo de' Medici in 1483 complaining about Sassetti's mismanagement of the Medici bank, and claiming he had caused several branches of the bank to go bankrupt. We have Ghirlandaio to thank for making sure that these relations remain alive in the portraits. Without this wonderful masterpiece it is likely that the donor Sassetti would have long been forgotten.

61 *Adoration of the Shepherds* (detail ill. 59), 1485

A river is snaking through a gentle, hilly landscape, in which nestles a city with mighty walls and towers. Two bridges lead across the river to the city gates. The roads and bridges are populated with tiny figures, some on horseback. Farther in the background lie other cities, paler and bluer because of aerial perspective.

62 Leonardo da Vinci's circle
Bust of Flora, early 16th century
Wax, height 67.5 cm
Staatliche Museen Preußischer Kulturbesitz,
Skulpturengalerie, Berlin

The unusual bust presents us with the classical goddess of
flowers and the spring. Due to the heat-sensitive nature of
the material, few other equally high quality examples of
sculptures using this technique remain. While it is clearly
not a votive figure portraying a particular personality, this
example conveys a good impression of the high artistic
value of such lifelike wax figures. Like Ghirlandaio,
Leonardo da Vinci, to whom this work is attributed, had
also become familiar with the production of such figures
in Verrocchio's workshop.

WAXWORKS IN FLORENTINE CHURCHES

The biblical stories and saints' lives that Ghirlandaio
depicted in his frescoes included portraits of many of his
contemporaries who all too often distracted the observer's
attention from the religious elements of the picture. On
many occasions the portraits make more of an impression
than the events depicted. The paintings seem to have less
to do with pious worship than with the elevation of the
donors and their immediate circle. In a few earlier religious
pictures, the donors knelt humbly in a corner to worship the
events. Now they stood upright and proud in all their
grandeur: what presumption, one might think! But far from
it – because of a quite different concept of piety, there were
much more astonishing customs in Florence at that time.
The art historian Aby Warburg has written on the subject.

The Florentine church of Santissima Annunziata gave
the right to the powerful men of the city, as well as
distinguished foreigners, to erect in the church life-size
images of themselves in wax. These figures, called *voti*, were
dressed in real clothes and donated to the church as a votive
offering. In the workshop of Andrea del Verrocchio – where
Ghirlandaio may have worked for some time – such wax
figures were produced on a massive scale. The church must
have looked like a waxworks.

After he had barely escaped being murdered by the Pazzi
family in 1478, Lorenzo de' Medici had three figures of
himself made at the same time and placed in various
churches in Florence. One of the figures wore the clothes
he had been wearing on the day of the attack, when his
brother Giuliano was stabbed to death in the cathedral and

he himself was wounded. Many foreigners also left their
life-size visiting cards behind in order to express their respect
for the Santissima Annunciata (the Blessed Annunciation) –
they included King Christian of Denmark, who came to
Florence in 1471, and even a Muslim Turkish pasha. Famous
women were also present as wax figures. An example was
Isabella of Mantua, who in 1529, together with Pope
Alexander VI, is mentioned as having been in need of repair.

At the beginning of the 15th century, the *voti* figures had
got out of hand to such a degree that the city council felt
itself obliged to restrict their numbers. Despite this, by 1447
there were so many that it became necessary to stand the
figures in an orderly manner in the nave. There they
obstructed the view of those in the side chapels, particularly
because some wax figures were seated on horseback in full
armor. Soon the number of *voti* had swollen to such an
extent that there was no room left in the churches and the
figures of donors had to be hung from the ceiling by cords.
A document dating from 1488 shows that there was a
dangerous number of *voti* hanging above the heads of the
faithful. It was not until *voti* had fallen down on more than
one occasion, disrupting the services, that the waxworks
were banned from the churches. In 1630, one could still see
600 life-size figures and 22,000 *voti* made of papier-mâché
in the church of Santissima Annunziata, but soon
afterwards they were shunted off to a side courtyard. The
remains of this collection of waxworks were left there until
the end of the 18th century.

In Warburg's opinion, this fascination with *voti*, which
even then was mocked as a silly heathen custom, allows
us to see the contemporary figures who appear in
Ghirlandaio's frescoes in a completely new light.

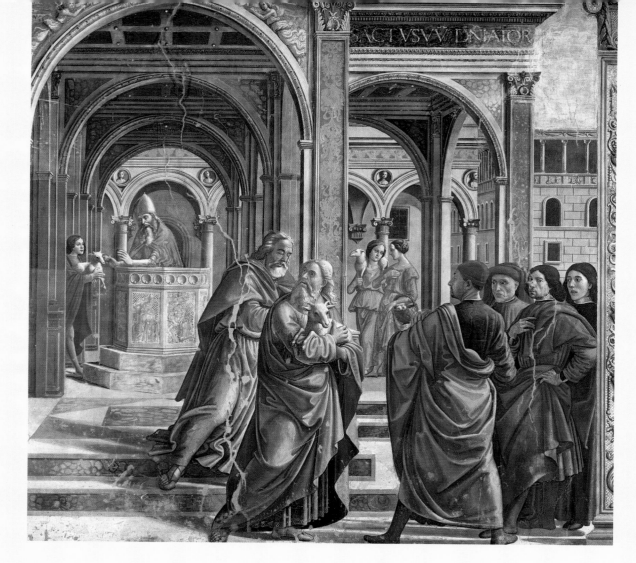

63 *Expulsion of Joachim from the Temple* (part of fresco), 1486–1490
Fresco
Santa Maria Novella, Cappella Tornabuoni, Florence

In the center of a loggia with broad round arches and built on a cross-shaped ground plan, a high priest is receiving sacrificial lambs at the altar where a fire is burning. As the old Joachim does not yet have any descendants, he is not allowed to take part in the sacrificial rite, and is sent away. Symmetrical groups of Florentine citizens frame this biblical scene, and in the group on the right, the artist has depicted himself and some members of his family (cf. ill. 2).

THE GREATEST COMMISSION: THE TORNABUONI CHAPEL IN SANTA MARIA NOVELLA

Even before Ghirlandaio had finished the ensemble in the Sasetti Chapel in Santa Trinità, it was already attracting members of the Florentine upper class, who were deeply impressed. So before work in the chapel was completed, Ghirlandaio was commissioned to carry out another large-scale project. His task now was to paint the apsidal chapel of Santa Maria Novella, the one Francesco Sassetti had been denied. On 1 September 1484, he and his brother Davide signed a contract that still exists with Giovanni Tornabuoni, a banker who, through astute management, had gained an immeasurable fortune. As the uncle of Lorenzo de' Medici and the director of the Roman branch of the Medici bank, he had even more influence than Francesco Sassetti, whom he replaced as the director of the branch in Florence in 1484.

In just four years, between 1486 and 1490, Ghirlandaio and his workshop completed a monumental work that was entirely to Tornabuoni's satisfaction. Using classical pilasters and entablatures, Ghirlandaio divided the two enormous walls under the wall rib in this Gothic chapel into six horizontally rectangular picture fields. They are placed above each other in three layers and are crowned by a pointed tympanum. The chapel's front wall, in contrast, has three high pointed arch windows that provide room on either side for three smaller, vertically rectangular pictures, as well as the large tympanum above them. Here Ghirlandaio designed not just the colorful stained glass windows, still at their original location, that illustrate scenes from the life of the Virgin Mary and Dominican saints; he also created the altarpiece and its back. These panel paintings, however, are no longer in their original location (unlike the one in the Sassetti Chapel), but are now in Munich and Berlin. So the decoration of the chapel was carried out according to an overall concept which included the architecture (windows), wall paintings and furnishings (altarpieces) – an enormous commission of monumental proportions.

It was only possible for Ghirlandaio to produce such an extensive work in the space of four years by using assistants from his large workshop. At this time his brothers, brother-in-law and several students were working there; the young Michelangelo Buonarroti is thought to have been working there as an assistant, though this cannot be proved. It is likely that Ghirlandaio produced all the plans, but painted only parts of the works himself. The magnificent portraits and the atmospheric, well-balanced spaces in the lower picture fields suggest that Ghirlandaio himself painted them. The upper pictures are of poorer quality; here – in the dizzy heights where pictures could be seen only from a distance – he allowed others to do the painting.

The frescoes on the chapel walls narrate the story of Mary and scenes from the life of Saint John the Baptist.

The narration of the story of Mary on the left wall of the chapel starts at the bottom at the entrance to the chapel with the *Expulsion of Joachim from the Temple* (ill. 63). This episode follows the traditional lines of composition. Of significance here is the architecture, which the artist obviously felt was more important than the events. In the upper half of the painting it takes up more space than the figures, who occupy only the bottom part of the picture. The most important figures – and not only the biblical ones – are standing at the front edge of the picture. All the other scenes follow this basic principle.

The overall conception of the chapel has been thought through carefully, right down to the direction of the light. As in the *Last Supper* in the church of Ognissanti, Ghirlandaio rigorously integrated into his scenes the way in which the interior was lit through the three windows: the scenes on the left wall are lit from the right, and those on the right wall from the left – as though from the real windows.

In the background of the *Expulsion of Joachim from the Temple*, Ghirlandaio's depiction of the widely spaced loggia and its medallions is a direct quotation of the Spedale degli Innocenti, the foundling hospital in Florence designed by Brunelleschi. Interestingly enough, there is a repetition of this façade, constructed shortly after Ghirlandaio's frescoes were painted, that can be seen when leaving the church of Santa Maria Novella at the other end of the piazza by the Spedale di San Paolo (built 1489–1498).

Above the portraits are two palaces whose lines run parallel with those of the temple. Comparable buildings, with rusticated lower stories and open upper stories, largely characterize the appearance of Florence to this day. This was one way in which Ghirlandaio repeatedly brought the city into his paintings.

Contemporaries of the artist and clients are present as spectators and witnesses of the expulsion of Joachim, and because of their fashionable clothing and shoes and their vain hairstyles they differ conspicuously from the biblical participants. It is thought that the noblemen on the left include the client's son, Lorenzo Tornabuoni, and his friend Piero, the son of Lorenzo de' Medici.

The second scene, the *Birth of Mary* (ill. 64), is one of the finest creations in the chapel. The space, which is skillfully constructed along perspective lines, opens up like a display case. It is opulently decorated, with a relief frieze in which putti are dancing a roundel. They appear to be delighting in the birth of the Virgin Mary, for as the Latin inscription at their feet proclaims: "Thy birth, O Virgin and Mother of God, brings joy to all the world." This frieze of putti was inspired by Florentine sculpture, being reminiscent of the two cantorias in the cathedral by Donatello and Luca della Robbia, created about 1435.

64 *Birth of Mary*, 1486–1490
Fresco
Santa Maria Novella, Cappella Tornabuoni, Florence

Here we feel that we are in the palace of a Florentine
patrician. The large space is divided by painted pillars. In
the larger bedchamber, on the right, the aged Anne is
lying exhausted in bed after giving birth, and the three
young nurses are taking care of the newborn. In the wall
panelling, the artist's signature can be read in gold –
GRILLANDAI – with the family name – BIGHORDI –
further to the left.

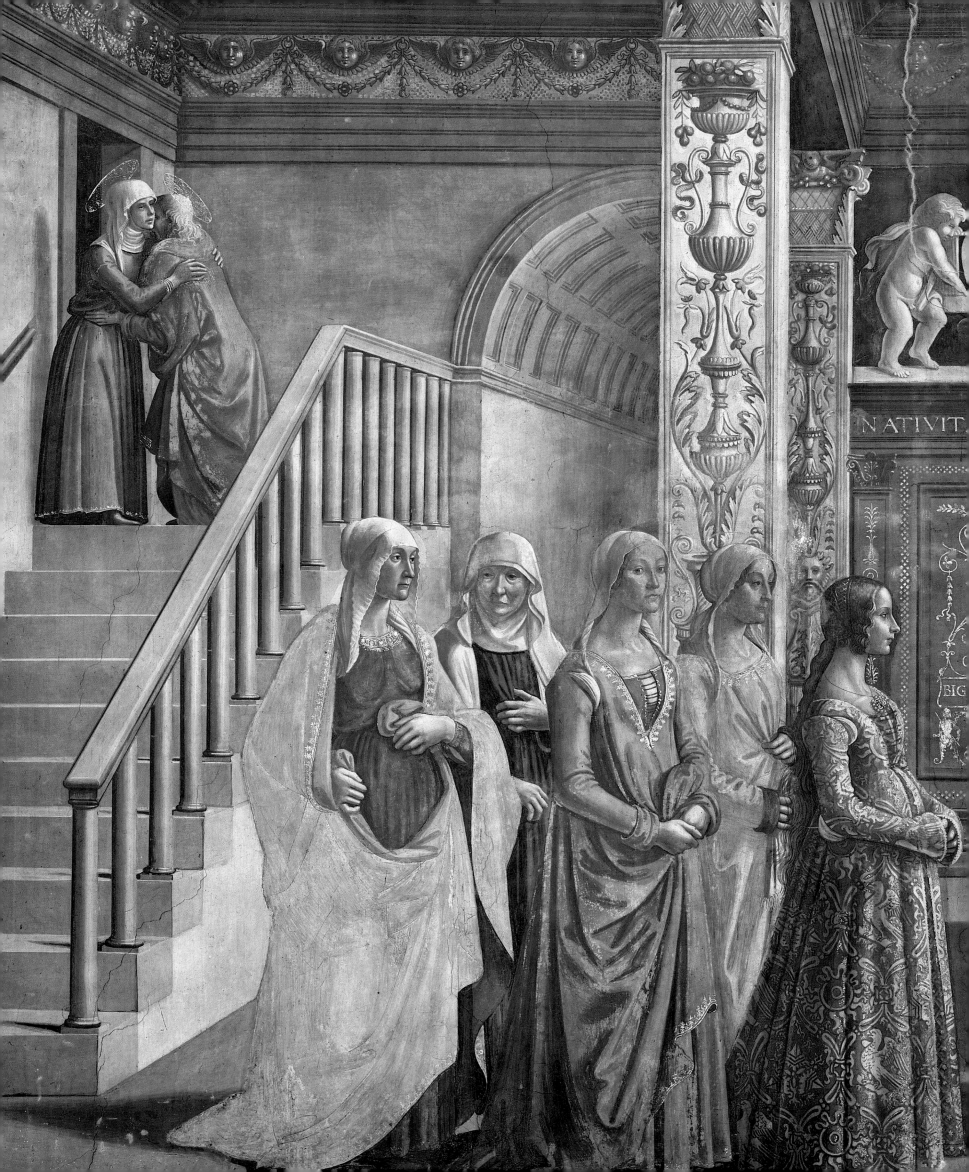

65 (opposite) *Birth of Mary* (detail ill. 64), 1486–1490

In the top left-hand corner, almost unnoticed on the steps, we see Anne and Joachim embrace. This represents the kiss at the Golden Gate, which, through the will of God, made Anne pregnant after years of being barren. Ludovica Tornabuoni, followed by four companions, is walking towards the bed in order to visit the woman who has just given birth. This young girl, who is depicted in profile, is wearing a magnificent brocade garment and standing very upright, like the pillar behind her, unmoving and proud.

67 (right) *Birth of Mary* (detail ill. 64), 1486–1490

Here Ghirlandaio succeeds in convincingly continuing the rear wall of the real chapel, which has windows, into the depth of the picture, where there is also a painted window. As a result, part of the frieze of dancing putti playing instruments is in the light, and part in shadow. The figures of the nurses are also captivatingly vivid – the joy of the lovely woman holding the child lights up her bright face. And the marvelous moving figure of the woman pouring water gives the picture a look of everyday life.

66 (below) Drawing, ca. 1486
Ink on paper, 22 x 17 cm
Galleria degli Uffizi Gabinetto dei Disegni e delle
Stampe, Disegno 289 E, Florence

The only figure in the fresco of the *Birth of Mary* who conveys any sense of movement is the servant pouring water into a brass basin for the child to bathe in. Ghirlandaio prepared for the painting by drawing this detailed individual study. The cloth fluttering behind her is lower in the fresco than here, in order not to obstruct our view of Anne. The sleeves were also altered at her elbows. The cross-hatching and the strong contours so typical of Ghirlandaio's style of drawing are clearly recognizable.

The daughter of the donor, Ludovica Tornabuoni, is entering the birth room from the left with her retinue. She is noticed by the kneeling nurse, who turns and looks at her – an action Ghirlandaio uses to forge a direct link between the biblical and the contemporary (ills. 65, 67). The stiff appearance of this young aristocrat forms a stark contrast to the graceful movements of the maid pouring water. There is an isolated preliminary study for this figure that tells us a great deal about Ghirlandaio's method of drawing using a network of parallel hatching (ill. 66).

Should the contrast between these two women be interpreted as the difference between the working population and the high society of the Florence of the period?

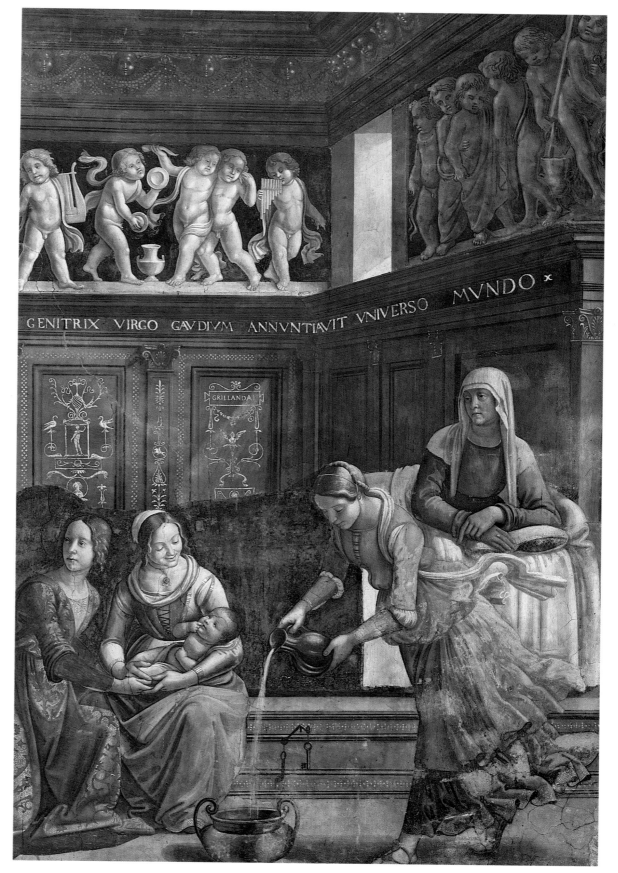

We can now move on to the opposite wall. Here we find a second equally successful birth scene, the *Birth of Saint John the Baptist* (ill. 68). Ghirlandaio once again created a room flooded with light and air. We can well imagine that the palace rooms of Ghirlandaio's patrons being similar to this. In this picture he makes use of contrasting complementary colors by placing the red bedspread in front of the green wall hanging. In front

It is not just the age of Elizabeth and her maid that contrast, but also their respective auras of stillness and movement. Nowadays it is astonishing to think that Savonarola, the severe preacher of repentance, could have taken exception to this superb maid. She corresponds to the nurse on the far left, who is stretching out her arms eagerly. The two figures form an exciting frame for the quiet scene taking place in-between.

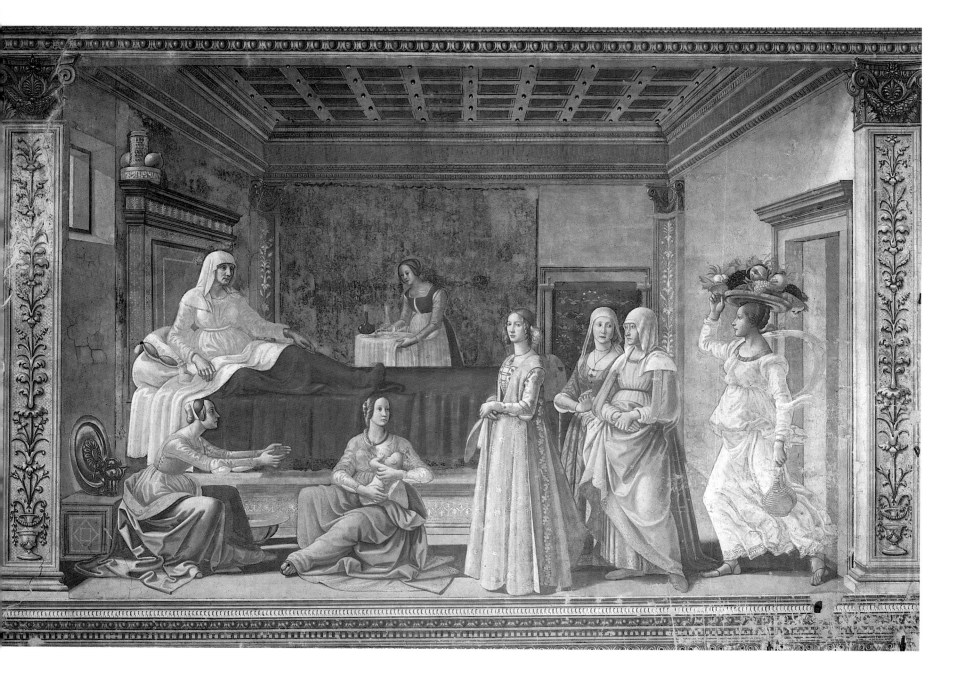

68 *Birth of Saint John the Baptist*, 1486–1490
Fresco
Santa Maria Novella, Cappella Tornabuoni, Florence

As in the *Birth of Mary* (ill. 64), here the bed of the woman who has just given birth is also standing against a wall with a window, in a somewhat less magnificent, but equally contemporary room, which reflects the atmosphere of a respectable Florentine house. Elizabeth is propped up in bed, as Anne was, but she is holding a small book in her left hand, probably a prayer book.

of the wall hanging, a maid dressed in red and green is carrying a tray with carafes of water and wine for the refreshment of the woman in childbed. The golden orange hues of the pilasters and entablatures form a complementary contrast with the light blue of aged Elizabeth and the young maid coming in from at the far right (ill. 69). Such color schemes help to create the captivating clarity that characterizes so much of Ghirlandaio's work.

The Berlin Gemäldegalerie owns a picture dating from 1489 of Judith and her maid, which has been attributed both to Ghirlandaio's brother Davide and also to his brother-in-law Mainardi. The maid in that painting is a mirror reflection of the maid carrying fruit, except that instead of fruit she is carrying the severed head of Holofernes. This repetition in a different context is a sign of a particularly good composition.

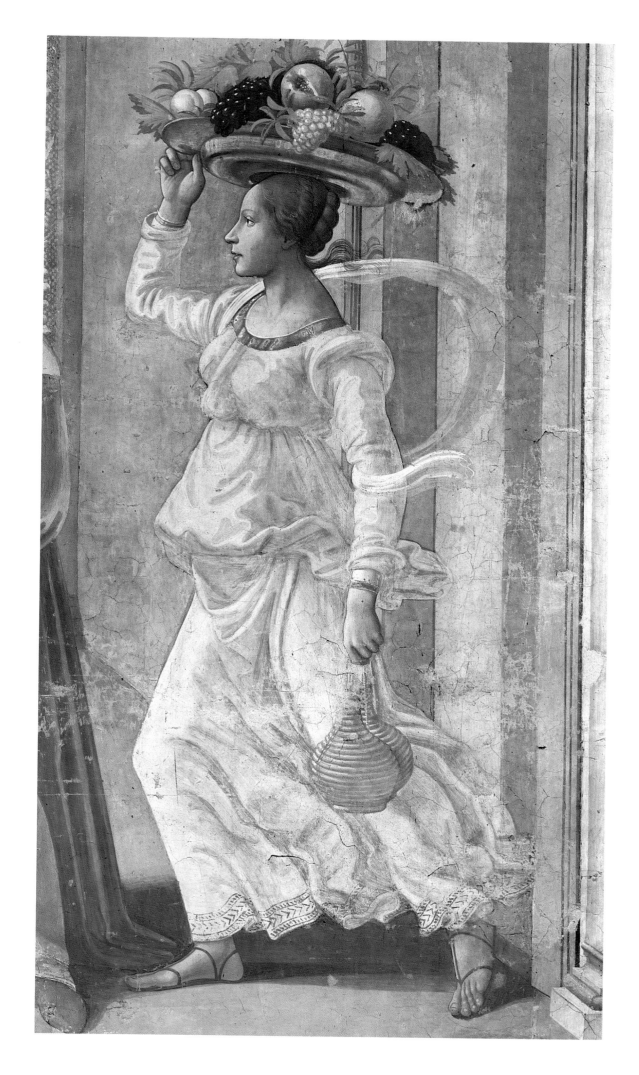

69 *Birth of Saint John the Baptist* (detail ill. 68), 1486–1490

A nimble servant carrying a large bowl of fruit on her head and a bottle of wine in her hand is hurrying in so that Elizabeth, exhausted by the birth, can fortify herself. In the overflowing bowl, delicious fruits are arranged like a still life. Because she is moving so rapidly, the servant's hair and her antiquated, double-belted garment are fluttering behind her. The sweeping arch created by her veil underlines her lively movement.

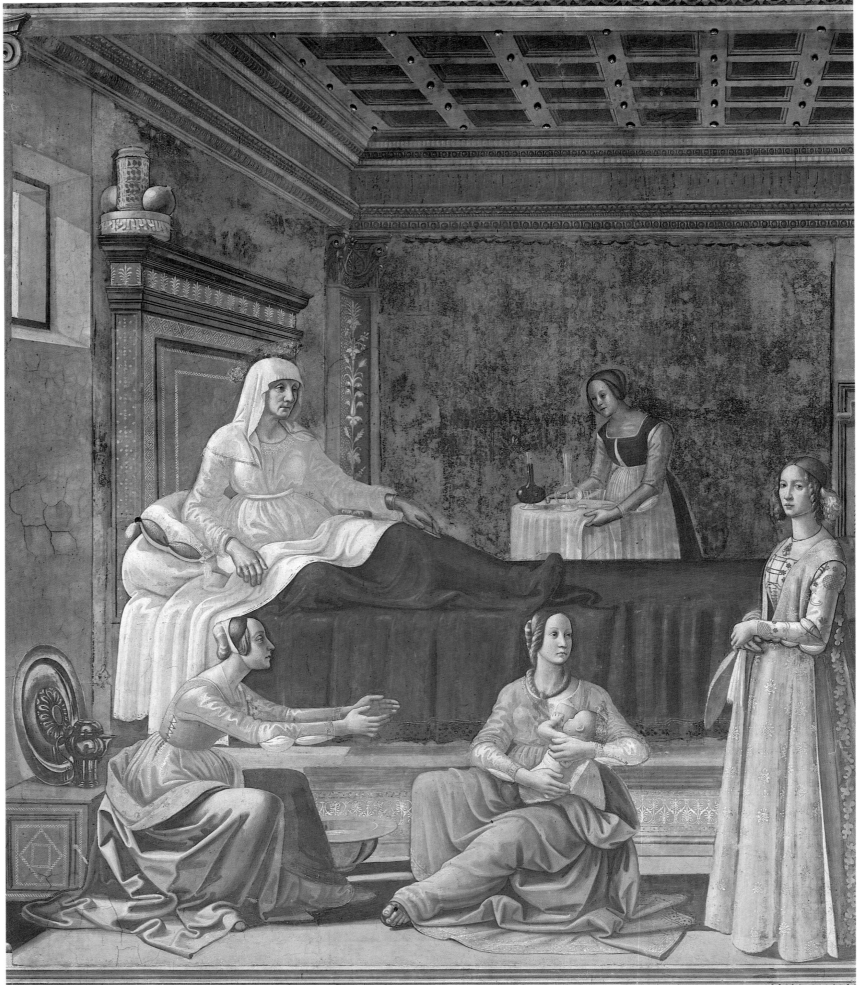

In the *Birth of John the Baptist*, Elizabeth is visited by female representatives of the donor family (ill. 71) – as is Anne in the birth scene on the opposite wall. The only figure that can be identified is that of the poet Lucrezia Tornabuoni, who was known for being very virtuous. She was the mother of Lorenzo de' Medici and a friend of the humanist Agnolo Poliziano and Luigi Pulci, portrayed in the Sassetti Chapel together with her son.

There is actually nothing in this scene to suggest that it is depicting an event from the story of Christ – with the sole exception of the severely weather-beaten halo surrounding Elizabeth's head. In this scene from everyday life, Ghirlandaio surpassed even his beautiful *Birth of Mary*. In addition to the marvelous basket of fruit, he added another two still lifes to the picture in order to make it appear more home-like and realistic. On the far left two objects, a brass jug and bowl, that we are already familiar with from the fresco the *Last Supper* in the church of Ognissanti, and from the frescoes in the Saint Fina Chapel. At the top of the bed's headboard, next to the window, there is a symmetrical arrangement of a box, two pomegranates and a vase, reminiscent of both Saint Jerome's study (ill. 20) and the frescoes in the Saint Fina Chapel. All these things once again bring Flemish painting to mind, which during this period made widespread use of everyday secular details as accessories. The miniature depicting the birth of Saint John the Baptist in the "Turin/Milan Book of Hours" is an outstanding example – a superb work that was most probably painted by Jan van Eyck himself, though its attribution is just as disputed as its date.

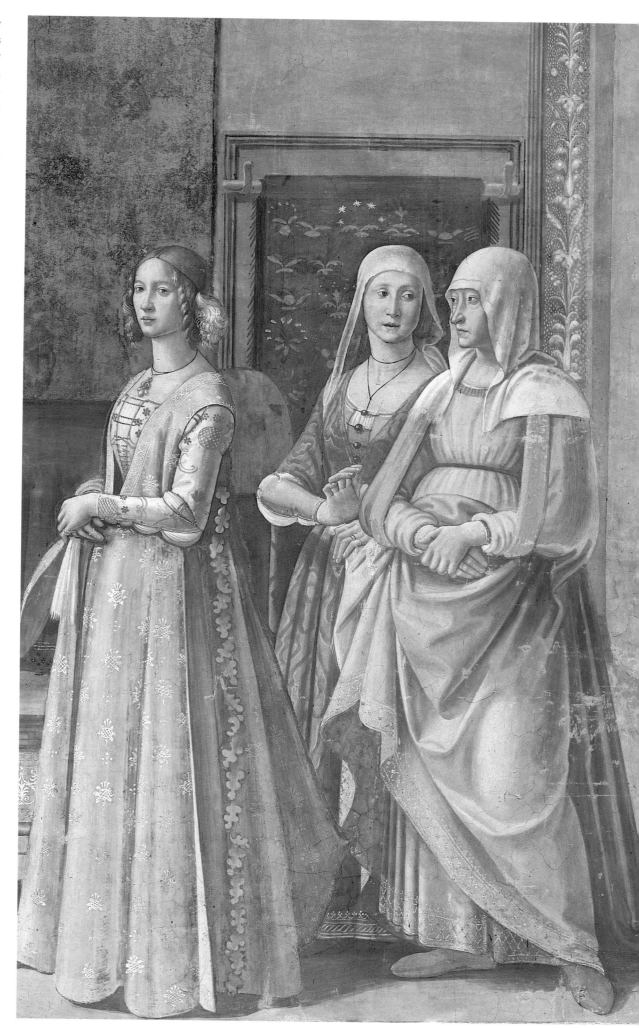

70 (opposite) *Birth of Saint John the Baptist* (detail ill. 68), 1486–1490

The small Saint John is being breast fed by a young nurse in the foreground, and a servant is already stretching her arms out energetically for him, in order to give the newborn a bath in a green bowl. Behind them, Ghirlandaio has clearly shown the position the mother is lying in under the blankets. Her bed is made in the same way that beds are made in Italy to this day – a white linen sheet turned down at the top end over a woollen blanket.

71 (right) *Birth of Saint John the Baptist* (detail ill. 68), 1486–1490

Here a beautiful unknown woman from the donor's immediate circle is looking at us. She is holding a small cloth in her hands, which are elegantly clasped in front of her stomach, and dressed in a gentle pink, a hue picked up in her cheeks. Two women wearing white head-dresses accompany her; the elder is probably the donor's sister, Lucrezia Tornabuoni, who died before the picture was painted.

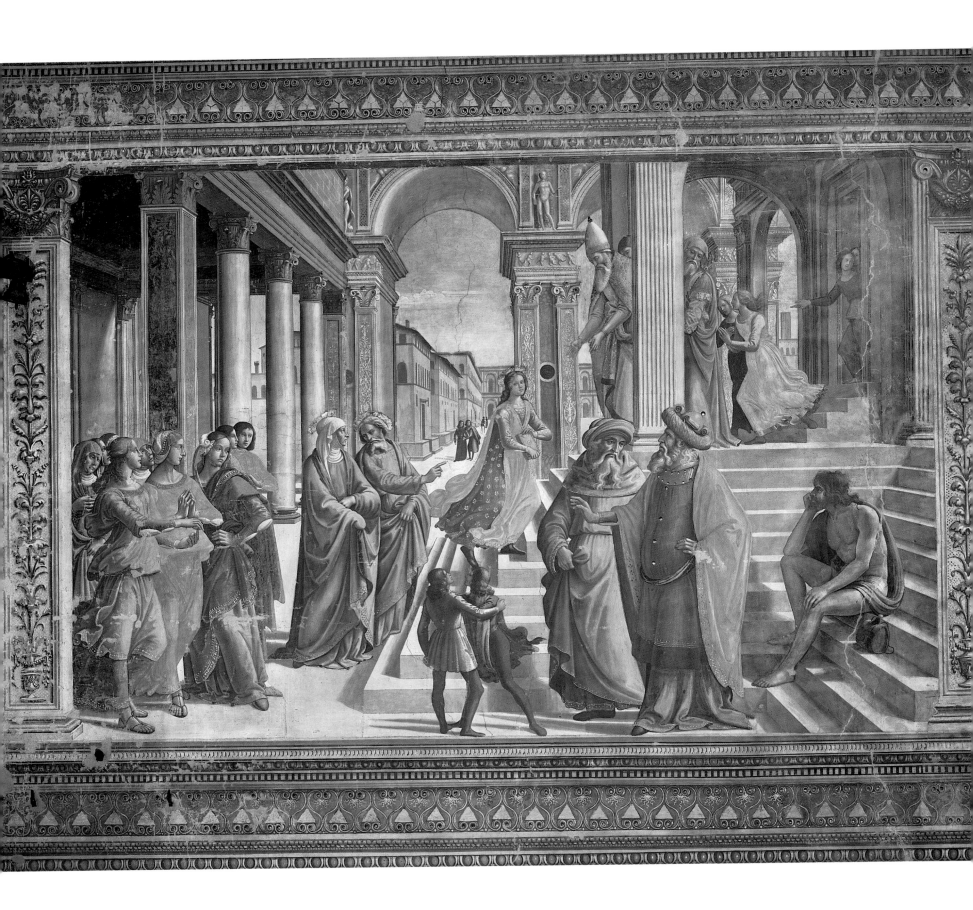

72 (above) *Presentation of the Virgin*, 1486–1490
Fresco
Santa Maria Novella, Cappella Tornabuoni, Florence

In the center of the painting, Mary as a girl is hurrying up
the steps of the Temple carrying a book, and at the top
the venerable high priest is waiting to welcome her with
open arms. Her elderly parents have accompanied her to
the bottom of the steps. Many old and young witnesses
are present.

73 (opposite) *Presentation of the Virgin* (detail ill. 72),
1486–1490

Ghirlandaio was more successful in his depiction of the
group of three young women on the left than in his
depiction of the main events. In them he demonstrated
various body postures and hand movements, and it is
possible that here he was inspired by classical reliefs
depicting dancers. The women's classical clothing reflects
the colors of Mary's garments and repeats the yellow, blue,
red, and green in the garments worn by the old men on
the right side.

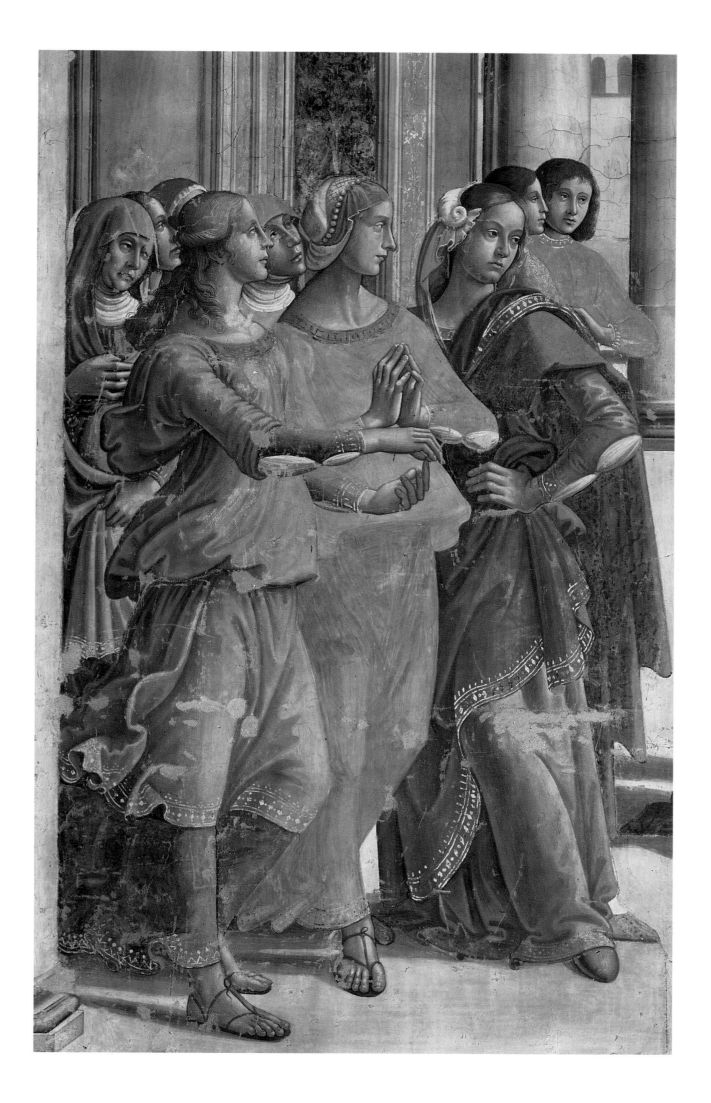

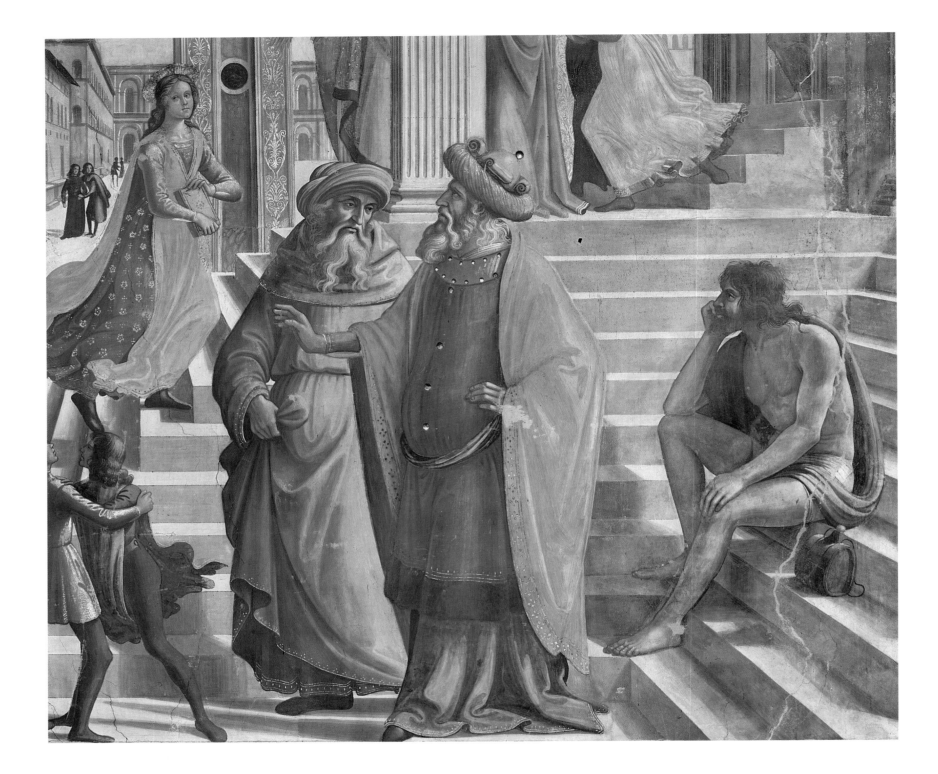

74 *Presentation of the Virgin* (detail ill. 72), 1486–1490

The two old men and the semi-naked seated figure on the right were used by Ghirlandaio to fill an empty space in the composition. But he used this weakness to present the observer with a successful depiction of a male nude who has nothing to do with the event depicted. The wooden flask on the elegantly lit flight of steps reappears in two panel paintings the artist produced of the *Adoration* (ills. 59 and 115).

Let us return to the cycle of the life of Mary on the left wall. On the second level, the *Presentation of the Virgin* and the *Marriage of Mary* stand side by side. With its many separate elements and its complex architecture, the composition of the *Presentation of the Virgin* (ill. 72) is somewhat confused. In contrast, the *Marriage of Mary* has an entirely symmetrical structure, which is created by an architectural setting that consists of a square space with three barrel vaults along each side (ill. 75). Though the architectural elements are comprehensibly arranged in the picture, the events themselves are not fully integrated with them. It seems as if the architecture and

figures were created independently of each other, a view supported by a preliminary study in which the architectural elements are not yet present (ill. 76). Looking as though it has been slotted in from above, the architecture does not really look inhabited by the figures. The most remarkable figures are themselves outside the main group, at the edges of the pictorial field (ills. 77, 78); it is thought that the women's figures on the left are most likely to be Ghirlandaio's own work.

At the same height – above the corner of the chapel and connecting with the rear wall of the chapel next to the Gothic window – there is the narrow fresco the

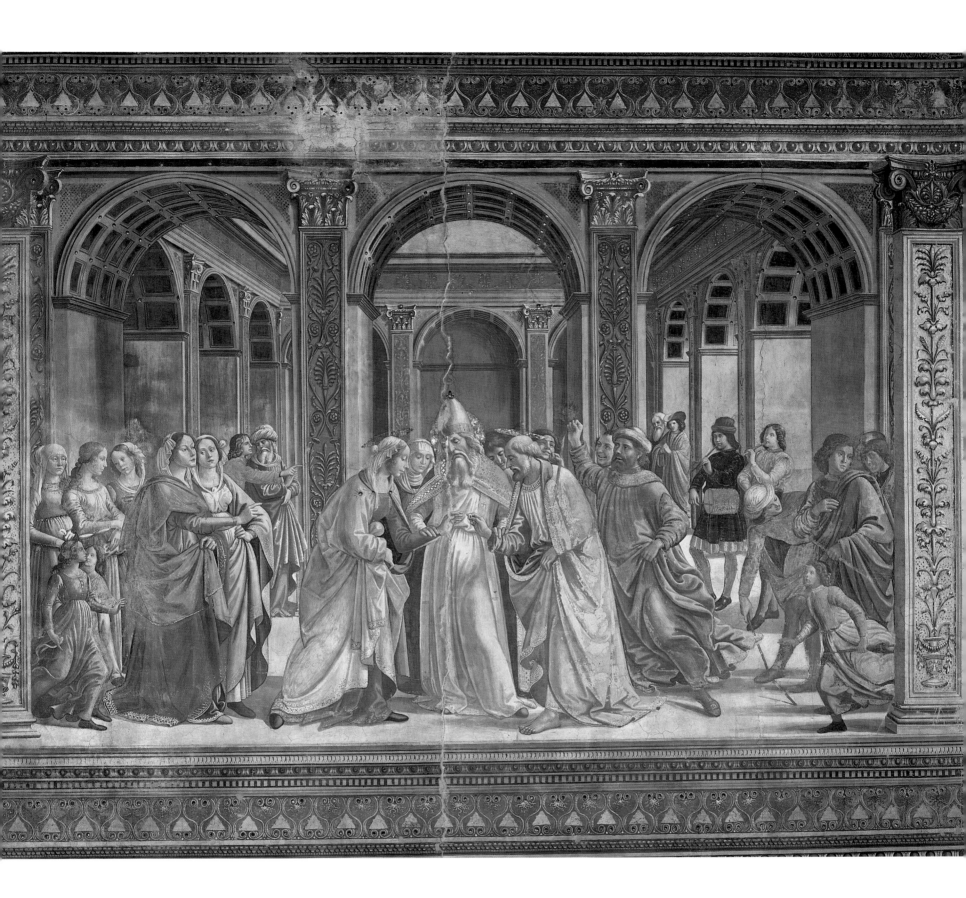

75 *The Marriage of Mary*, 1486–1490
Fresco
Santa Maria Novella, Cappella Tornabuoni, Florence

The venerable high priest, the same figure as in the
Presentation of the Virgin (ill. 72), is uniting the bride and
groom. Joseph is about to place the wedding ring on his
young bride's finger. The composition of the picture is
focused on this holy act: it is taking place in the center
of the picture, with the central round arch above it, and
composition emphasized by the pilasters in the
foreground and background.

76 (above) Drawing for the *Marriage of Mary*, ca. 1486
Ink on paper, 26 x 17 cm
Galleria degli Uffizi, Gabinetto dei Disegni e delle
Stampe, Disegno 292 E, Florence

The high priest is not yet drawn in this preliminary study
for the fresco of the *Marriage of Mary* (ill. 75). It seems
that Ghirlandaio tried drawing Mary in two different
positions and then decided in favor of the second version
on the left. There are also several studies of the male
figure with the raised fist on the sheet.

77 (center) *The Marriage of Mary* (detail ill. 75),
1486–1490

On the left stand mainly female observers of the
ceremony, discussing the event and pointing things out
to each other. Two playing girls are running into the
picture from the left: their pendant is the boy dressed in
blue coming in from the right. His color corresponds to
that of Mary, and the color of the girls to that of Joseph.
Ghirlandaio has here created a balanced composition
based on color and symmetry.

78 (far right) *The Marriage of Mary* (detail ill. 75),
1486–1490

The men whose rods did not blossom forth as Joseph's
did, are breaking their rods in anger and one of them is
shaking his fist. They are disappointed that old Joseph
of all people should have been chosen instead of them
to marry the Virgin. A different mood is created by the
laughing faces behind the groom, as well as the musicians
with drums and pipes, who are starting up the music for
the celebrations.

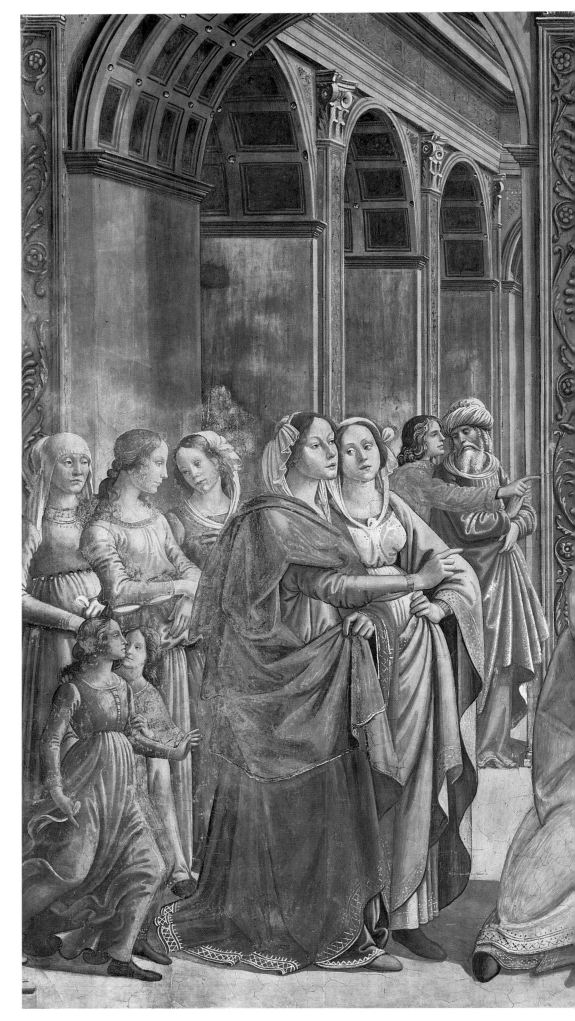

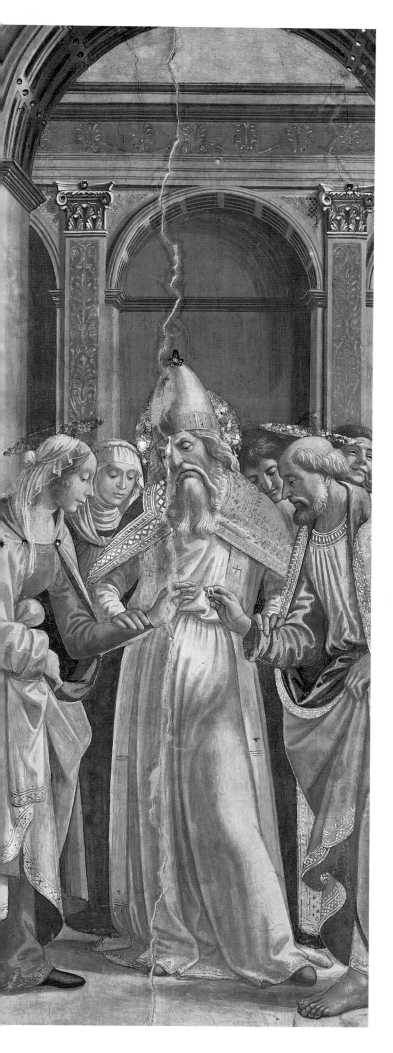
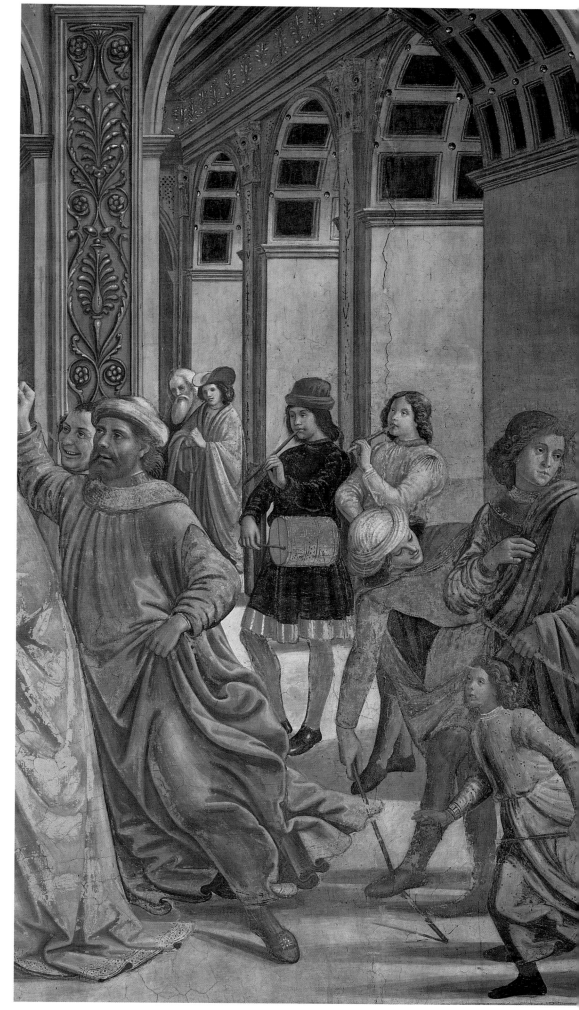

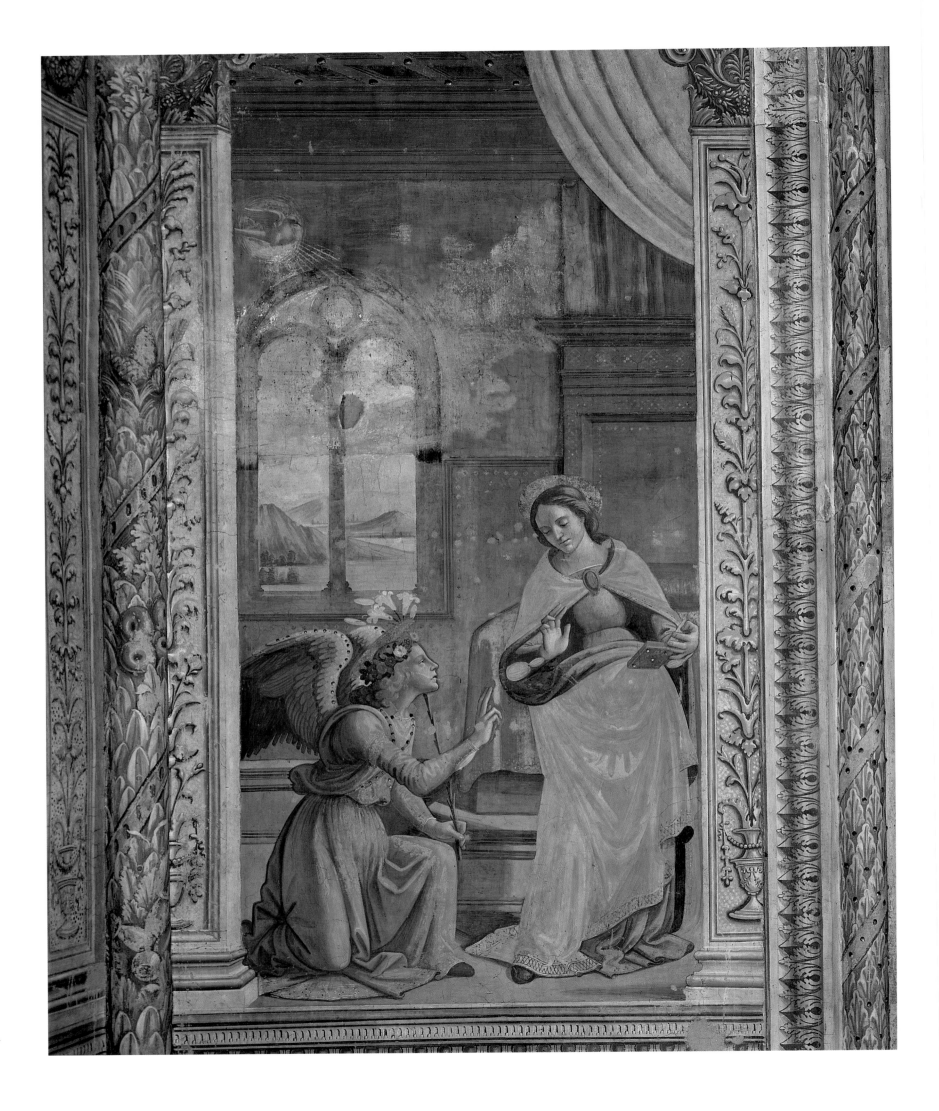

Annunciation (ill. 79). Again Ghirlandaio has moved the scene of this biblical event to Tuscany and his own era. He was able to find the traditional Renaissance form of a painted window with a view of a landscape in many Florentine palaces. They can still be seen today in Florentine, examples being the palaces of the Medici, Rucellai and Strozzi families. The angel is derived from the *Annunciation* painted by the young Leonardo da Vinci between 1472 and 1475, now on view in the Galleria degli Uffizi (ill. 80). Various authors such as Morelli, Cavalcaselli, Heydenreich and Calvi have suggested that Ghirlandaio or his son Ridolfo could have created this panel painting, though Verrocchio, Credi and others have also been proposed as they consider the "faults" in the painting to be incompatible with Leonardo's talent. They criticize the traditional compositional scheme with the two main figures on the left and right in the foreground, as well as the somewhat uncertain stance of the Virgin, with the traditionally rich folds of her garment.

The coldness of her beautiful face and the all too precisely drawn unruly curl above the angel's forehead

were also features that one felt could not be Leonardo's style. And indeed, the marvellous landscape with its indications of the presence of people – boats and the harbor town are visible – are unusual in Leonardo's work. But two surviving drawings by Leonardo support the authorship, first recognized by Liphart (1869), of Leonardo da Vinci: in Oxford we find a study of the right sleeve of the angel, and in the Louvre there is another of the Virgin's cloak.

In contrast to Leonardo's horizontal format, in Ghirlandaio's fresco in the predetermined vertical format his Virgin may be depicted facing the observer in an equally frontal view, but she is standing upright. She is therefore reminiscent of the beautiful picture on the same theme in the Uffizi by Lorenzo di Credi, an artist who was also taught by Verrocchio together with Leonardo and Ghirlandaio.

Two further pictures showing the Annunciation produced by Ghirlandaio's workshop show an even clearer relationship with Leonardo's work. It was probably Sebastiano Mainardi, using the designs of his brother-in-law, who painted a fresco of the

80 (above) Leonardo da Vinci
Annunciation, ca. 1472–1475
Panel, 98 x 217 cm
Galleria degli Uffizi, Florence

For a long time, this work was wrongly attributed to Ghirlandaio. Ghirlandaio in fact adopted the posture of the angel from Leonardo's *Annunciation* for his own *Annunciation* in the Tornabuoni Chapel (ill. 79). The shape of the altar lectern in Leonardo's picture also influenced Ghirlandaio in his depiction of the *Angel Appearing to Zacharias* (ill. 91). Leonardo's conception of space was also imitated in other works produced by Ghirlandaio's workshop.

79 (opposite) *Annunciation*, 1486–1490
Fresco
Santa Maria Novella, Cappella Tornabuoni, Florence

The angel of the Annunciation, Gabriel, has entered the Virgin's bedchamber from the left and is kneeling in front of her, his hand raised in blessing. Standing in front of her bed and holding a prayer book, she moves back hesitantly, her right hand raised in protection. At the same time, however, she is humbly turning towards the angel in order to receive the message. The dove of the Holy Spirit is floating down above the window.

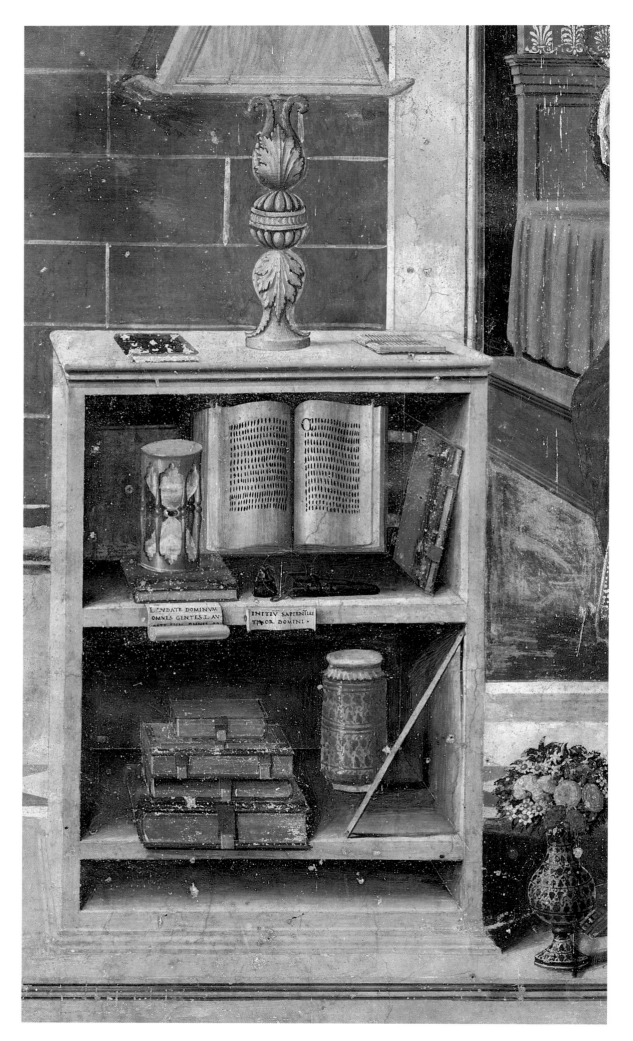

81 (previous double page) Sebastiano Mainardi (attributed)
Annunciation, ca. 1482
Fresco
Loggia del Comune, Collegiata San Gimignano

The composition omits the marvellous motif of the corner of the room used in Leonardo's painting in the Uffizi (ill. 81). In contrast to Leonardo's work, in this *Annunciation* the door giving us a view into the Mother of God's bedchamber is placed behind her. The angel, instead of kneeling on a meadow covered with flowers, is now kneeling on hard tiles. The landscape is little more than a mechanical copy of Leonardo's.

82 (left) *Annunciation* (detail ill. 81), ca. 1482

The Madonna's lectern is reminiscent of Ghirlandaio's still life in the fresco of *Saint Jerome* (ill. 20). Here the influence of Netherlandish panel paintings is clearly visible. This assortment of precisely reproduced books, notes, an hour-glass, container and flower vase bears comparison with Leonardo's classically influenced lectern in his *Annunciation* painting in the Uffizi (ill. 80).

Annunciation (ill. 81) about 1482 in his native town of San Gimignano. This is largely a poor imitation of Leonardo's *Annunciation*. Only the lectern, the details of which are reminiscent of Flemish still lifes, shows originality (ill. 82).

Ghirlandaio created another *Annunciation* between 1489 and 1490 using the ancient mosaic technique, which he had learnt from Alessio Baldovinetti (ill. 83) and which he had been able to employ when restoring a few old mosaics. There is no lectern in this mosaic

version of the Annunciation, though the influence of Leonardo's painting is still felt, particularly in the spatial arrangement – a building on the left behind Mary and a view over a wall to a landscape.

The *Annunciation* of the Tornabuoni Chapel is followed by two pictures side by side whose theme Ghirlandaio integrated into one panel at roughly the same time, on his altarpiece for the Spedale degli Innocenti. The *Adoration of the Magi* (ill. 84) is on the third level of the left wall of the chapel. It is next to the

83 *Annunciation*, 1489–1490
Mosaic
Duomo Santa Maria del Fiore, Porta della Mandorla, Florence

Above the Porta della Mandorla on Florence Cathedral there still exists one of Ghirlandaio's mosaics; his brother Davide probably executed most of it. Vasari wrote the following comment about this mosaic *Annunciation*: "Nothing better has been produced by modern masters. Domenico used to say that painting was design, but that the true painting for eternity was mosaic."

equally large fresco the *Slaughter of the Innocents* (ill. 85), which Vasari described as being the best painting in the entire cycle "because it was executed with good judgement, ingenuity, and great skill". It is surprising that this horrific event is given an individual monumental scene in the cycle of the life of Mary, and that the normally very popular Annunciation scene is pushed to one side. But the *Slaughter of the Innocents* provided Ghirlandaio with an opportunity to present a dramatic composition showing a lively crowd scene – scenes he had studied in classical models. It was not without reason that he placed a Roman triumphal arch covered with relief of classical battle scenes towering up behind the dramatic events. Once again the background of the picture acts as a backdrop, for the figures are

bunched together on a densely packed front stage and are not integrated into architecture. The *Slaughter of the Innocents* takes place amid a violent swirl of movements and gestures. There is a dramatic confusion of people's and horses' bodies, which fall upon each other all around. Ghirlandaio depicts the classical model for the scene at the top on the arch.

In the foreground on the right a desperately screaming mother, her red garment billowing in frantic folds, is tearing at the hair of one of the killers from behind. Pure horror is written on her face. The soldier, dressed in classical armor that has a blue leather body piece shaped to indicated the ribs, is bending right over backwards. The foreground of the picture is characterized by falling horses, bloody limbs and heads, streaming hair and

84 *Adoration of the Magi*, 1486–1490
Fresco
Santa Maria Novella, Cappella Tornabuoni, Florence

This scene, which has been severely damaged by damp, shows Mary and the Child in the center with an arch above them. The latter is part of the ruins of a classical triumphal arch, such as Ghirlandaio had seen in Rome. The youngest king on the left is reverently removing his crown and is about to kneel and present his gift to the child. In the background is the kings' retinue, which even includes a giraffe.

drawn swords. On the far right the fleeing mothers are bunched together, but they will not succeed in escaping Herod's order that all the children of the same age as Christ should be put to the sword.

In the final scene, painted in the large pointed tympanum on the left wall of the chapel, two events, the *Death and Assumption of the Virgin*, are depicted in one picture (ill. 86). The composition and execution of this poorly preserved fresco are poorer than in the other pictures in the chapel. In its solemn character the scene is comparable with the considerably better *Obsequies* in the Saint Fina and the Sassetti chapels. Above the windows of the rear wall of the chapel, where Ghirlandaio had a former round window bricked up at his own expense, there is a fresco that is difficult to see.

It shows the Coronation of the Virgin amid a circle of saints, and is painted according to a traditional formula. It is probable that Ghirlandaio had to abide by particularly strict iconographical prescriptions in this scene, as it depicted a central dogmatic belief of the Church and of the Dominicans in particular.

The right wall in the Tornabuoni Chapel tells the story of Saint John the Baptist in the same seven picture areas as the story of Mary is told on the wall opposite. The two stories meet in the fresco the *Visitation*, in which the two mothers-to-be, the young Mary and the aged Elizabeth (ill. 87) are depicted.

In the background of the *Visitation*, side by side, are features that reflect the two sources of Ghirlandaio's pictorial inspiration: classical art and Flemish painting.

85 *Slaughter of the Innocents*, 1486–1490
Fresco
Santa Maria Novella, Cappella Tornabuoni, Florence

The liveliest composition in the artist's entire range of works, this large crowd scene is reminiscent of classical battle reliefs. The mothers of Bethlehem are in a wild panic, trying to save their children from the killers' swords, which are flashing through the air. On the ground lie the mutilated bodies of the slaughtered innocents in pools of blood.

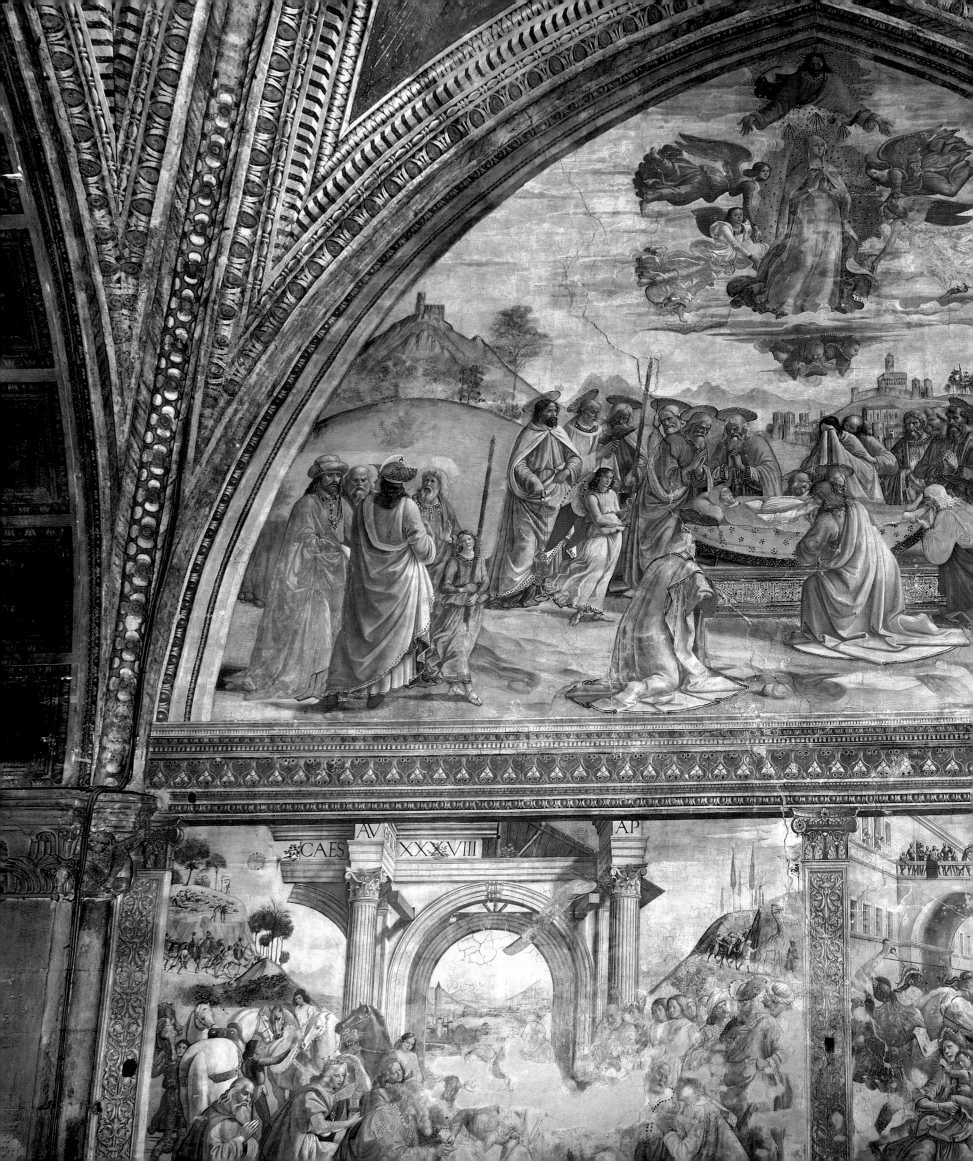

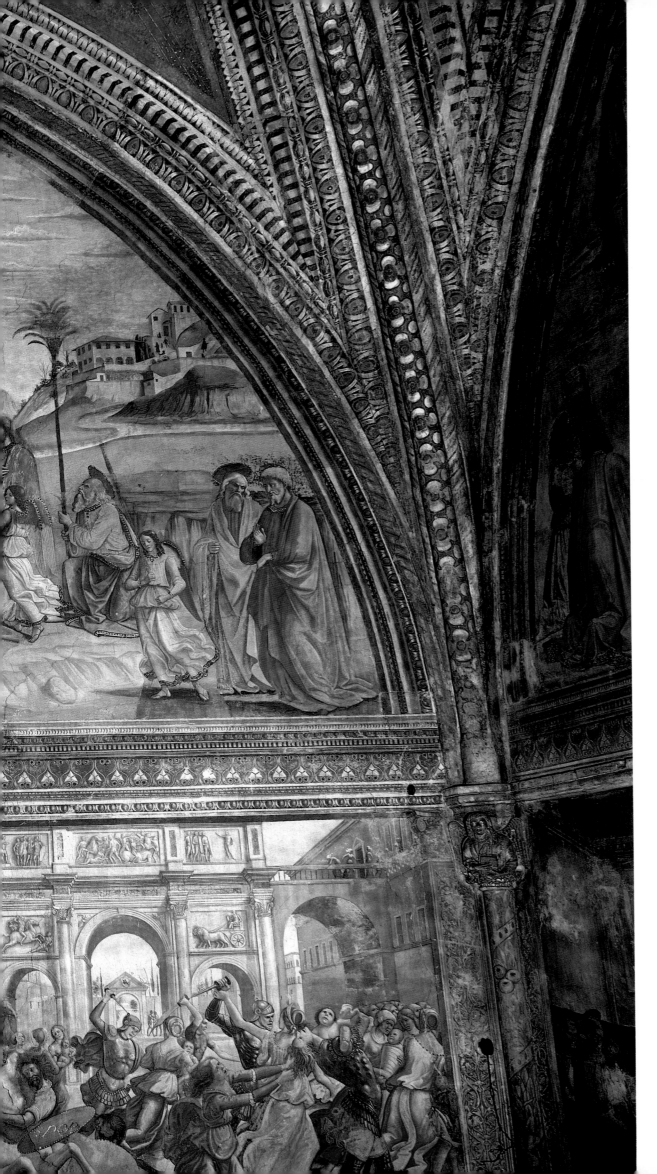

86 *Death and Assumption of the Virgin*, 1486–1490
Fresco
Santa Maria Novella, Cappella Tornabuoni, Florence

Mary's body is lying on a bier in an open space, mourned
by the grieving Apostles. Four angels are carrying long
candles or palm leaves. The dead Mary's pale face is old,
her cheeks sunken. But in a glory above her, a young and
beautiful Virgin with a rosy face is being carried up to
heaven by angels to meet her son.

87 *Visitation*, 1486–1490
Fresco
Santa Maria Novella, Cappella Tornabuoni, Florence

Along with the two birth scenes (ills. 64 and 68), this is
one of the most important pictures in the entire chapel.
The meeting of the Virgin Mary and Saint Elizabeth in
the center was painted quickly and easily. Ghirlandaio
then uses the remaining space to display a little of
everything that his brush is capable of producing and
that his donor stipulated in the contract: landscape and
cities, animals and plants, a bold use of perspective,
classical buildings and reliefs and, not least, portraits
of noble and beautiful women.

On the right, the classical era is represented by a building
with sculptural decorations, while the men seen from
behind, leaning over wall, are derived from superb
Flemish paintings – Jan van Eyck painted such figures
in the background of his so-called *Rolin Madonna* about
1436 (now in the Musée du Louvre), and Rogier van der
Weyden created a variation on this idea in his *Saint Luke
Painting the Virgin* (now in Boston).

Ghirlandaio uses the classical reliefs and the strong
horizontal line of the wall below them to establish a link
with the next scene, the *Angel Appearing to Zacharias* (ill.
91). In this fresco Ghirlandaio portrayed a considerable
number of contemporary political figures and members
of the donor families – such as Giuliano, Gian Francesco
and Giovanni Battista Tornabuoni on the right, together
with Giovanni Tornaquinci. Those portrayed are not
taking part in the biblical events; rather, it seems
important to them to be seen in this context. The artist

88 *Visitation* (detail ill. 87), 1486–1490

Ghirlandaio created a bold but convincing spatial situation in this detail of the *visitation*: a wall that follows converging lines of perspective conveys a vivid sense of spatial depth. On the left a paved road leads through a gateway into the lower part of the city by the waterside;

hurrying up the road is a servant carrying a bowl on her head, a figure reminiscent of the servant in the *Birth of Saint John* (ill. 68). Behind the two central figures, Mary and Elizabeth, a sandy path leads up to the wall. The group of women on the left, so typical of Ghirlandaio, is a variation of a single type seen from different points of view.

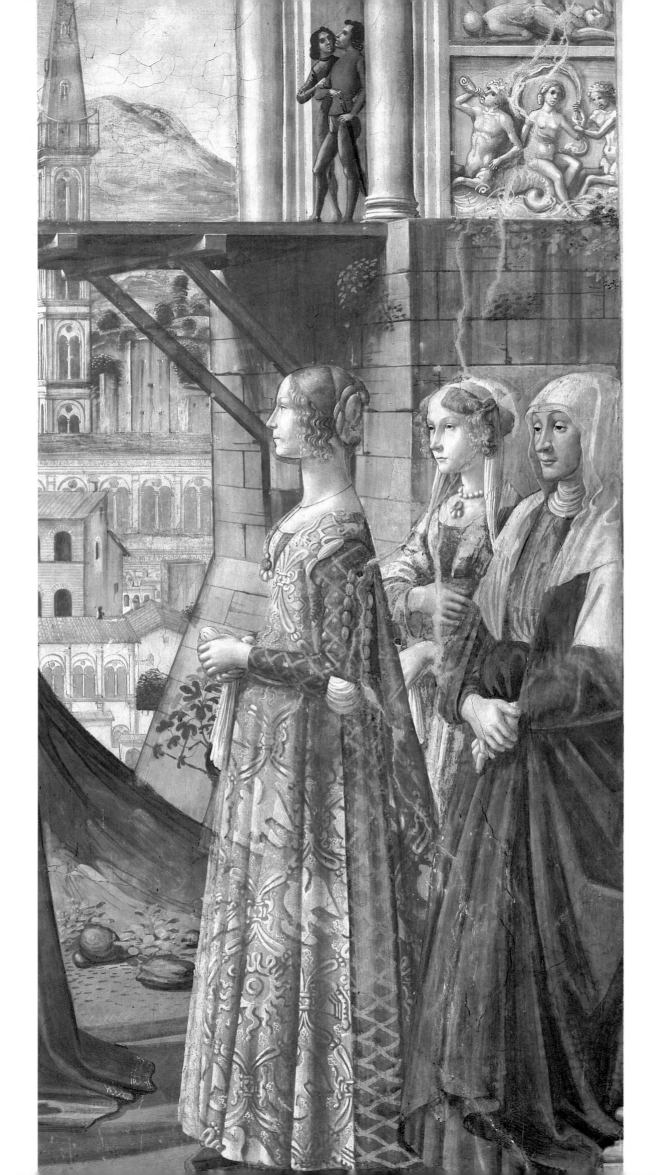

89 (opposite) *Visitation* (detail ill. 87), 1486–1490

In this detail Giovanna Albizzi-Tornabuoni is standing
directly underneath the arch of a classical triumphal
archway flanked by columns, just as if she were the main
figure in the painting. In 1486 she married Lorenzo, the
son of the donor. Vasari mistakenly thought she was
"Ginevra de' Benci, a most beautiful young girl living at
the time", whose portrait was painted by Leonardo da
Vinci about 1478, a work now in Washington. Giovanna,
who is standing stiff and rigid, is shown in sharp profile,
wearing a magnificent gleaming gown and has an elegant
hairstyle, unapproachable in front of her companions.

90 (below) *Visitation* (detail ill. 87), 1486–1490

In the background three men are leaning over the wall
and watching the activity in the city below, activities we
cannot see. The tower between the two trees is very
similar to that of Florence's Palazzo Vecchio. Two figures
stepping out through the classical gateway make it clear
just how monumentally large, and how far away, the
building behind them is.

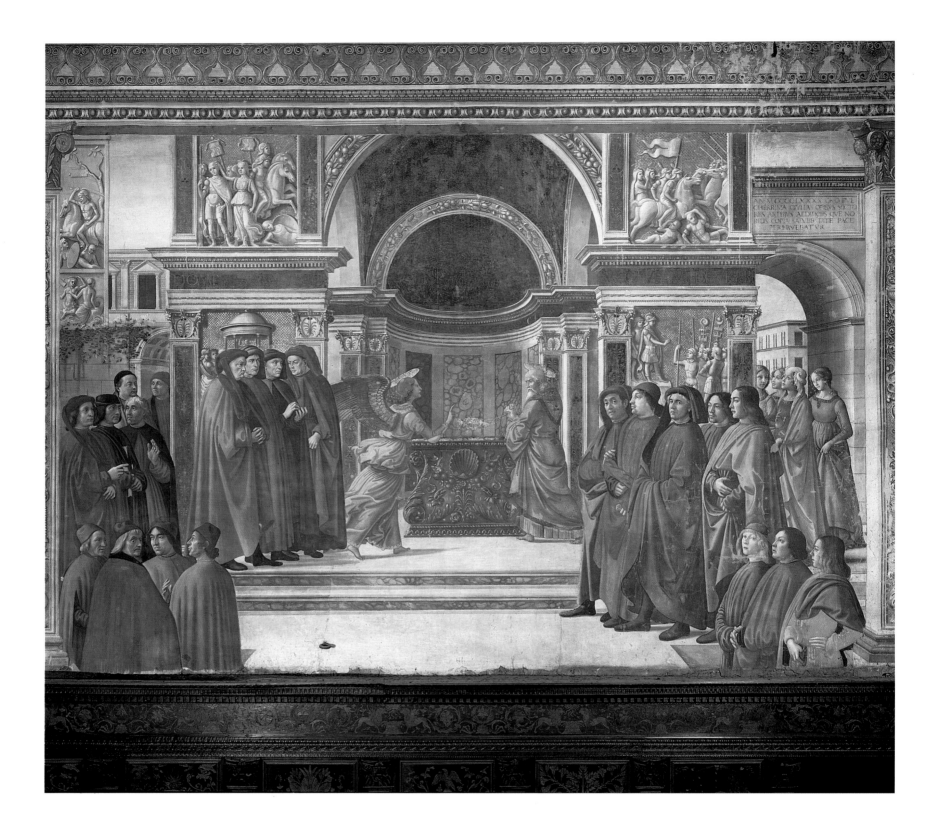

91 *Angel Appearing to Zacharias*, 1486–1490
Fresco
Santa Maria Novella, Cappella Tornabuoni, Florence

As the priest Zacharias swings a censer at the altar of a classical temple, an angel announces to him the coming birth of his son, St John. The form of the altar was influenced by Leonardo's lectern in the Uffizi *Annunciation* (ill. 80). Ghirlandaio grouped many important personalities of his age around the two biblical protagonists.

arranges them in groups of three, four and five figures on various ground levels, so that they do not overlap too much (ill. 92). As a result, the front groups are standing at the edges of the picture in rather absurd holes – an artistic device that Ghirlandaio employed with considerably more skill in the Sassetti Chapel by making the figures climb a flight of steps. It is likely that the artist had to accede to the wishes of his client and incorporate all these figures, relatives and friends, into the scene. In the process he once again showed himself to be a superb portrait painter with the talent to create character studies with a psychological profundity.

The two subsequent scenes, the *Birth of Saint John* (ill. 68) and *Zacharias Writes Down the Name of his Son* (ill. 93), had been united in one picture in the above-mentioned miniature in the "Milan/Turin Book of Hours" by Jan van Eyck. Ghirlandaio gave each episode its own picture. There the scene with the writing Zacharias takes place in the background, where another room is connected to the birth chamber that, as in Ghirlandaio's painting, is depicted as a genre scene. In contrast to Jan van Eyck, Ghirlandaio devotes separate pictorial fields to the two episodes and places the seated priest Zacharias in front of a magnificent loggia which

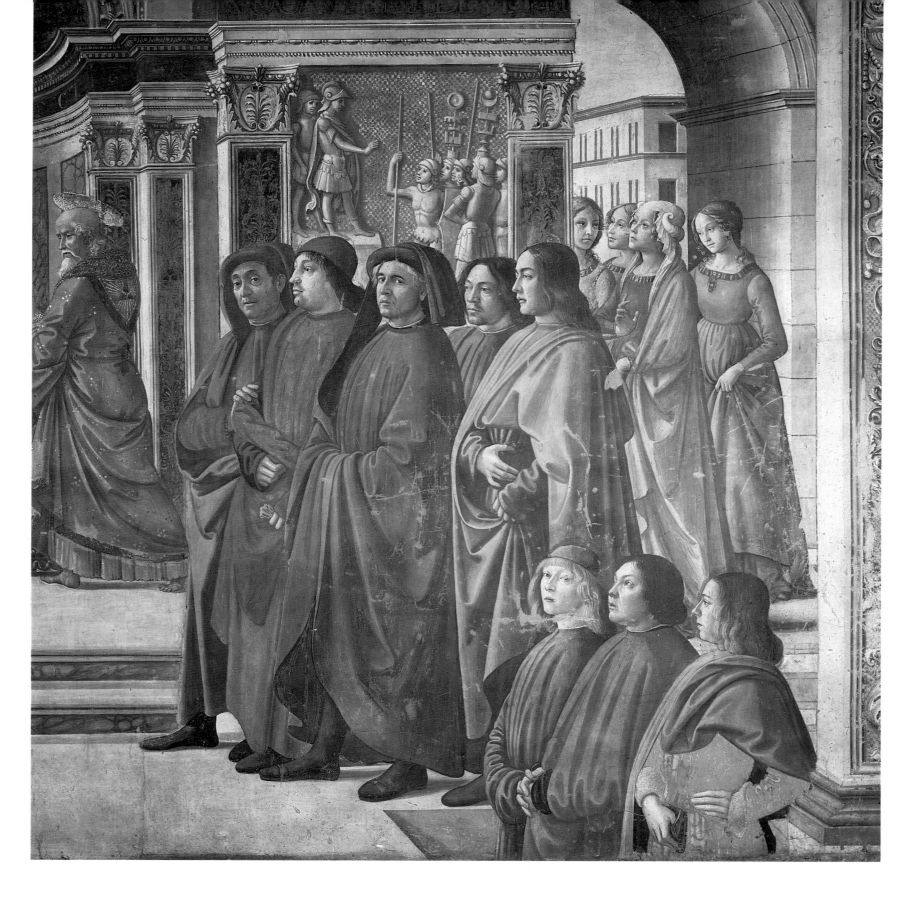

92 *Angel Appearing to Zacharias* (detail ill. 91),
1486–1490

Some women are standing a little to one side underneath
a tympanum on which are written words celebrating the
happy period in which this chapel was completed. The
words are those of Agnolo Poliziano: "In the year of 1490,
when the brilliant city, famed for its wealth, history,
vitality and its architecture, was living in peace and
prosperity." Above the heads of the men, the artist depicts
a classical relief, on a background of golden mosaic, that
depicts a military commander addressing his soldiers. The
same motif is depicted in grisaille in the Sassetti Chapel.

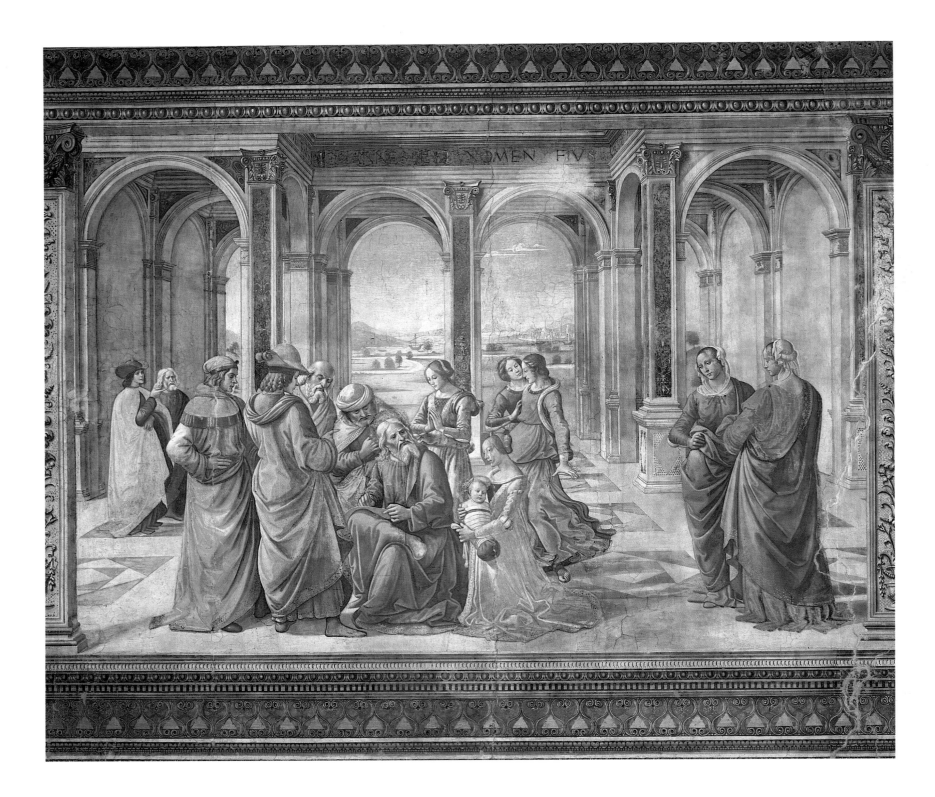

93 *Zacharias Writes Down the Name of his Son*,
1486–1490
Fresco
Santa Maria Novella, Cappella Tornabuoni, Florence

Ghirlandaio has made this composition animated by the
unusual device of placing the most important group of
people, who are standing around Zacharias, off center.
This means that the baby John is in the center directly
under the middle pilaster. The open loggia architecture
with a view onto a landscape in the background is not
connected with the events in the picture. It is possible
that it was added, as a backdrop, late in the production
of the work.

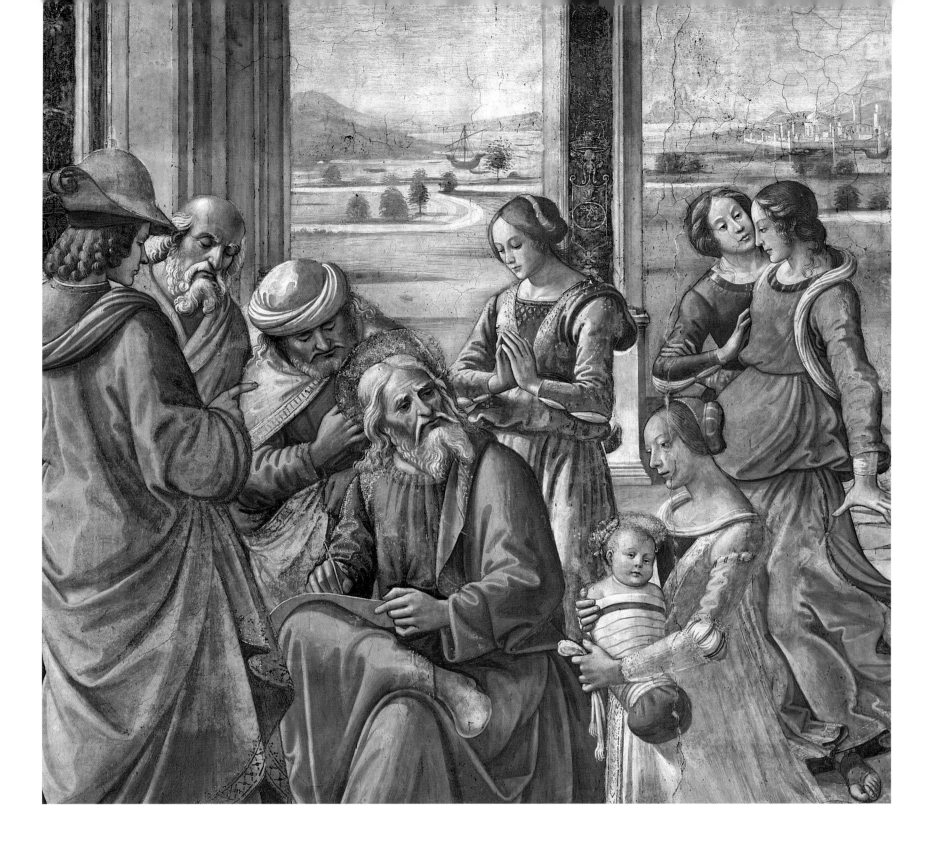

94 *Zacharias Writes Down the Name of his Son* (detail
ill. 93), 1486–1490

The bathed and swaddled baby John has been carried
by a young maid across to his old father, Zacharias, who
is forced to write down the name of his son as at the
Annunciation the angel struck him dumb until the birth
of his son. Old men are leaning forward in order to read
the name. The extensive landscape in the background
shows a town with a harbor in which a ship at anchor is
clearly visible. In accordance with the laws of aerial
perspective, the colors in the distance become paler and
lighter.

opens out onto an extensive landscape. Vasari writes how Zacharias, "whose spirit is undaunted although he is still mute, expresses amazement that a son has been born to him, and while they ask him what name to give his son, he writes on his knees – all the while staring at his son, who is held by a woman kneeling reverently before him – forming with a pen on paper the words 'His name will be John', to the astonishment of many of the other figures, who seem to be wondering whether this could be true or not." There exists a preparatory drawing for the scene showing St. John's naming, in which the two secondary female figures on the far right were sketched (ill. 95). Neither of them play a part in the narrative, but guide us via the figure seen from behind on the right, where this scene borders the birth scene, into the pictorial fields and, by means of the direction they are gazing in, draw the attention of the picture's observer to the central event taking place, the naming. At the same time, the two women exist as independent optical sensations. They decorate the pictorial field like a frame, a harmonious group that is pleasant to look at. Ghirlandaio drew the same young woman seen from two different points of view, from the front and behind, just as they then appeared on the fresco.

95 (left) A Study of Two Women (for *Zacharias Writes Down the Name of his Son*), ca. 1486
Ink on paper
Galleria degli Uffizi, Gabinetto dei Disegni e delle Stampe, Disegno 294 E, Florence

The preliminary study shows how carefully Ghirlandaio studied the play of light and shade in the folds of the garments. Clearly visible is his characteristic use cross-hatching in his drawings.

96 (opposite) *Zacharias Writes Down the Name of his Son* (detail ill. 93), 1486–1490

The two women standing to one side on the right are part of Ghirlandaio's typical wealth of figures. They are less "stopgaps" to balance the composition, than an opportunity for Ghirlandaio to present variations on the theme of "standing female figure". He carefully prepared these robed figures in a preparatory study.

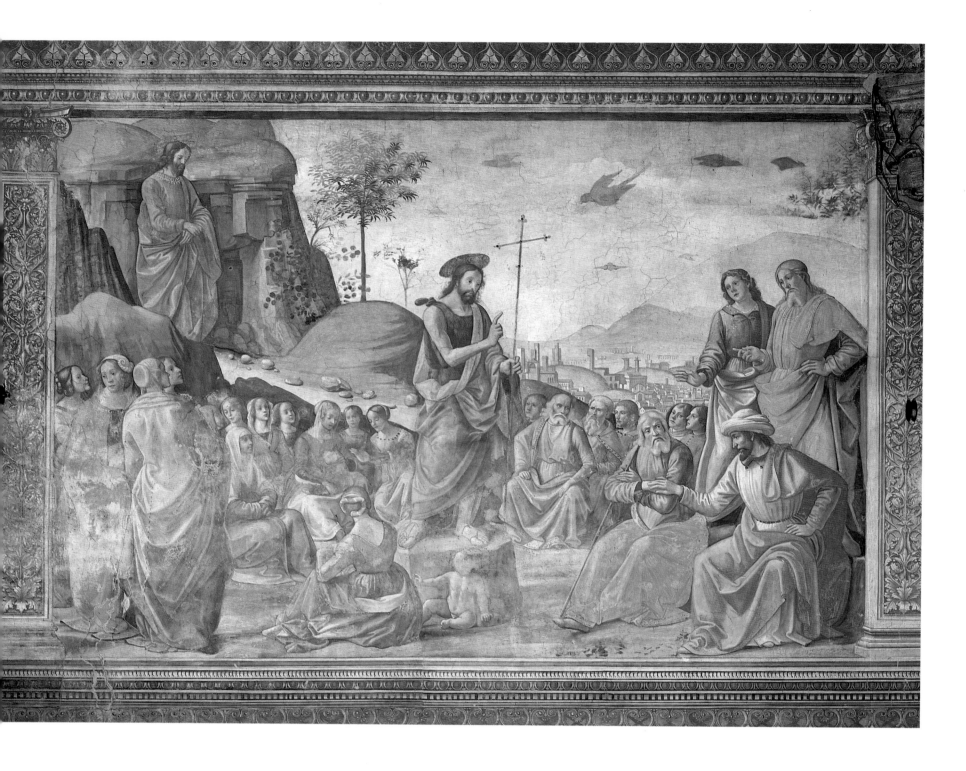

97 *The Preaching of Saint John the Baptist*, 1486–1490
Fresco
Santa Maria Novella, Cappella Tornabuoni, Florence

While Saint John in a fur robe is making didactic gestures
and preaching about the coming of the Messiah to an
intent group of listeners, Christ is already approaching.
Unnoticed by the Baptist, who is pointing to his cross
staff, Christ is stepping out of the background into the
scene between the rocks.

On the third level there are two frescoes, side by
side, that deal with the mission of Saint John the Baptist.
In the picture on the right he is preaching, and in
the next picture he is baptizing Christ (ills. 97, 98). The
same landscape is continued through both scenes,
linking them to one another. Worthy of note in
the preaching scene, and typical of Ghirlandaio, is the
group of women on the left, with a beautiful figure
seen from behind. Another figure seen from behind is
seated at the feet of the preaching Saint John. The naked
sitting child is Ghirlandaio's quotation of classical
sculpture.

The *Baptism of Christ* is an emulation of the already
mentioned painting by Verrocchio and Leonardo in the
Uffizi (ill. 12), though the angels and landscape are far
weaker. There is a very old-fashioned feeling about the

depiction of God the Father, who is giving His blessing
surrounded by angels.

In this painting the artist was interested less in
depicting the baptism than in displaying variation of
the nude figure. These were inspired both by Masaccio's
frescoes in the Brancacci Chapel and also by classical
sculpture. As early as the 1440s, in Piero della Francesca's
Baptism of Christ (now in London), a magnificent nude
figure had been depicted in the act of undressing.
Piero's arrangement of the main figures also influenced
of the version of the Baptism by Verrocchio and
Leonardo.

Many writers believe the young Michelangelo carried
out some of the work in these poorer paintings by
Ghirlandaio. They even believe that a narrow fresco on
the window wall may contain a portrait of the barely

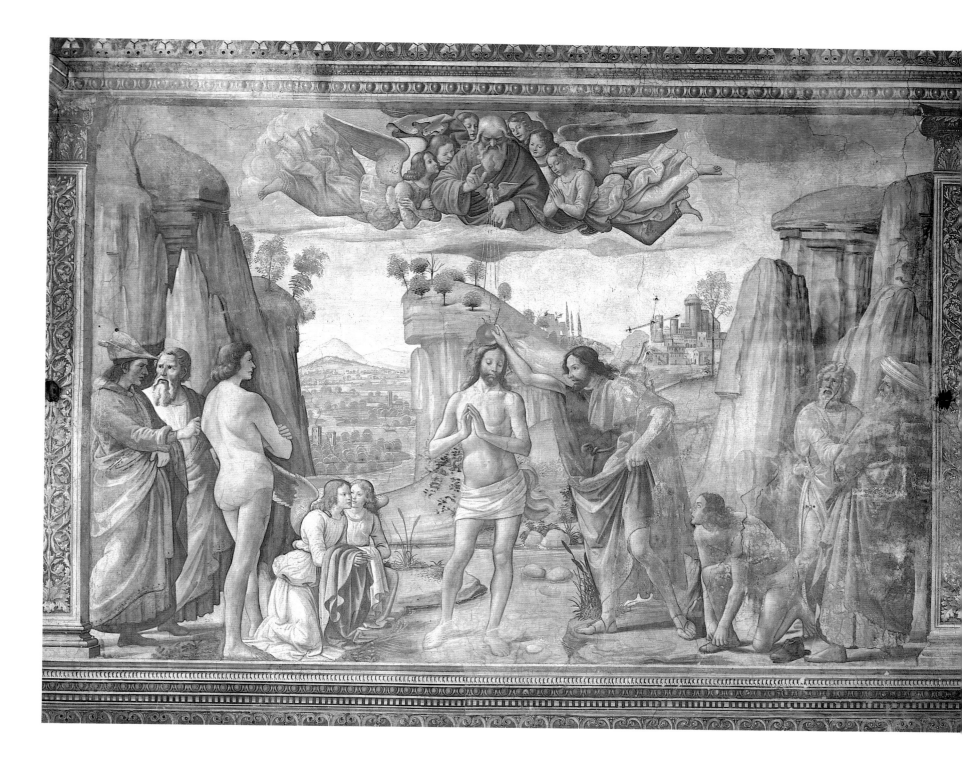

98 *Baptism of Christ*, 1486–1490
Fresco
Santa Maria Novella, Cappella Tornabuoni, Florence

The strict composition is based on a design that is
reminiscent of the early work in Sant' Andrea a Brozzi
(ill. 11) and derives from Verrocchio's famous *Baptism of
Christ* (ill. 12) in the Uffizi. Ghirlandaio made slight
changes to Christ's standing position and replaced the
angels on the right with a kneeling male nude, who is
already taking off his shoes in preparation for the
baptismal ceremony. On the left side we can see, from
behind, another naked man about to be baptized.

100 (right) *Herod's Banquet*, 1486–1490
Fresco
Santa Maria Novella, Cappella Tornabuoni, Florence

The landscape, which continues over two picture fields, can be made out very clearly beneath the banquet. In the center of the arched area, King Herod is feasting. He is sitting at a raised table, with a dome and several arches above him. In front of him stands a dwarfish court jester, guiding our eyes to the horrific detail on the left.

99 (below) *Saint John the Baptist in the Desert*, 1486–1490
Fresco
Santa Maria Novella, Cappella Tornabuoni, Florence

When he was a boy, Saint John went into the desert in order to do penance. He is depicted moving quickly, his cloak flapping behind him. He turns once more towards his parents, who he is now leaving. In the background, ocean-going ships are anchored in front of a town.

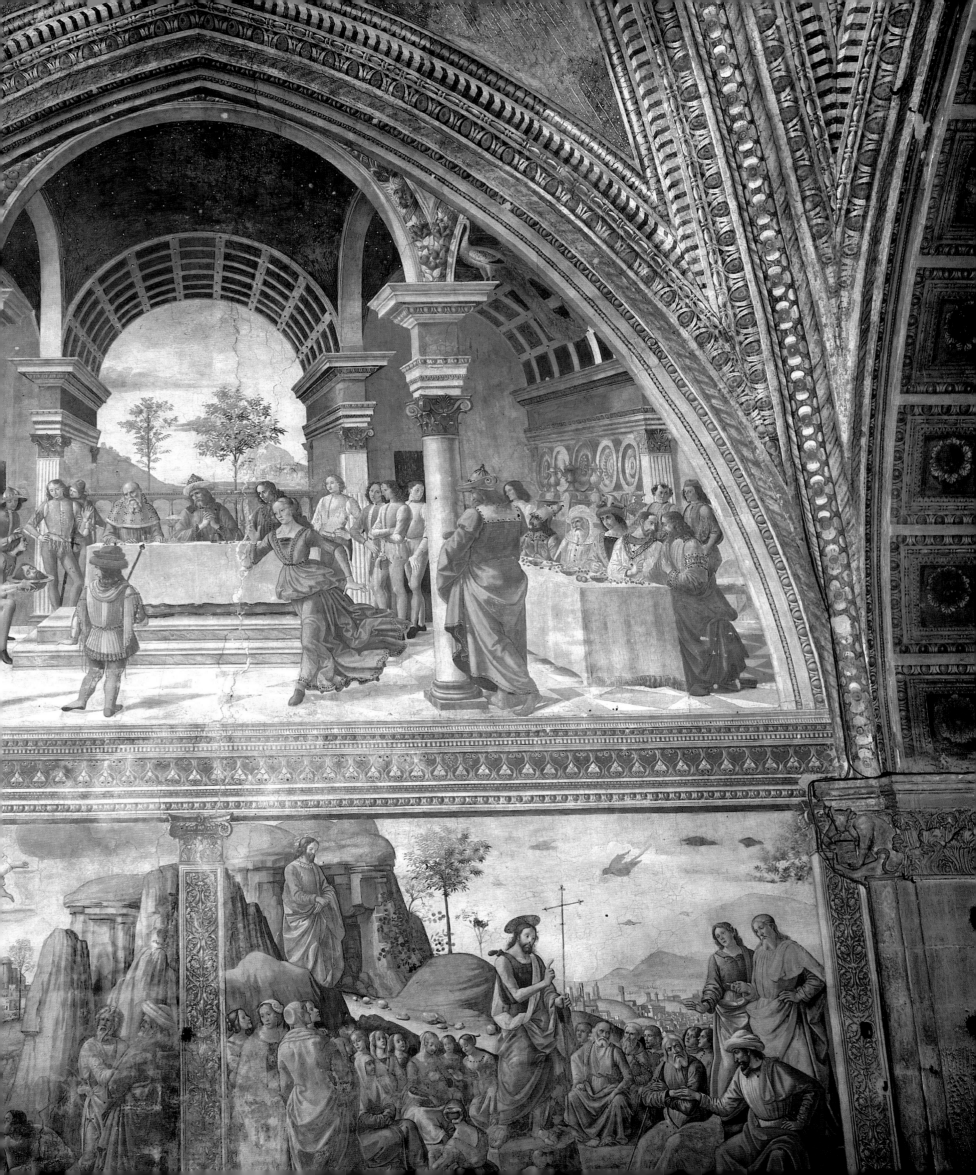

101 *Herod's Banquet* (detail ill. 100), 1486–1490

The beautiful Salome in the bluish shining dress is
dancing in so animatedly that her dress is flapping behind
her. Her moving arms are bent in an impetuous but still
gracious manner. This vision bewitched King Herod to
such a degree that he promised to fulfil her every desire.
She then requested the cut off head of Saint John the
Baptist, and this is already being presented to the
banqueters on a platter on the left.

fifteen year old artist, who is thought to have worked as an assistant in the Tornabuoni Chapel (ill. 99).

The cycle of the life of St. John concludes in the large tympanum with *Herod's Banquet* (ill. 100), about which Vasari wrote that: "The last scene, the one in the arch next to the vaulting, presents the sumptuous Banquet of Herod and the Dance of Herodias, along with countless servants performing various chores in the scene; the picture also contains a large building drawn in perspective which, together with the painted figures, clearly reveals Domenico's skill." A colossal palace architecture, carefully constructed according to the laws of perspective, rises up in the form of a series of enormous barrel and dome vaults, which in the foreground are supported by columns. Ghirlandaio was familiar with these columns with entablature blocks from Brunelleschi's Florentine churches of Santo Spirito and San Lorenzo, while the complex overall design of the building is reminiscent of the Maxentius Basilica in Rome. That classical building had been built by the Roman emperors Maxentius and Constantine as a monumental hall building with three aisles; the long central aisle was roofed by three huge groin vaults and the side aisles by coffered vaults.

In contrast to his more restrained depiction of Mary's death, here Ghirlandaio uses his powers to the full, both in the extravagant architecture and the vivid, though still somewhat stiff, figure of the dancing Salome (ill. 101). Ghirlandaio adopted and varied this dancing figure, together with the entire composition of the scene, from Filippo Lippi's depiction of the same scene in Prato Cathedral, painted between 1452 and 1466. That earlier painting already contains the musicians on the left, the row of pots on the right and the view out onto a landscape in the center. The arrangement of the figures was altered, but scarcely improved, by Ghirlandaio. Above all, and in the face of the festive and yet gruesome events, the figures lack all sense of drama. They display neither a lively party mood nor signs of horror or repulsion. The arrangement of the banqueters around the three long laid tables is reminiscent of Ghirlandaio's earlier depictions of the Last Supper. Here too, in addition to wine glasses and bowls, red cherries are arranged on the white table cloth.

The execution of Saint John is not depicted in the Tornabuoni Chapel. In its place, however, is a fresco on the window wall showing the martyrdom of the Dominican saint Peter Martyr. Perhaps the intention was to equate the Dominican saint with John the Baptist.

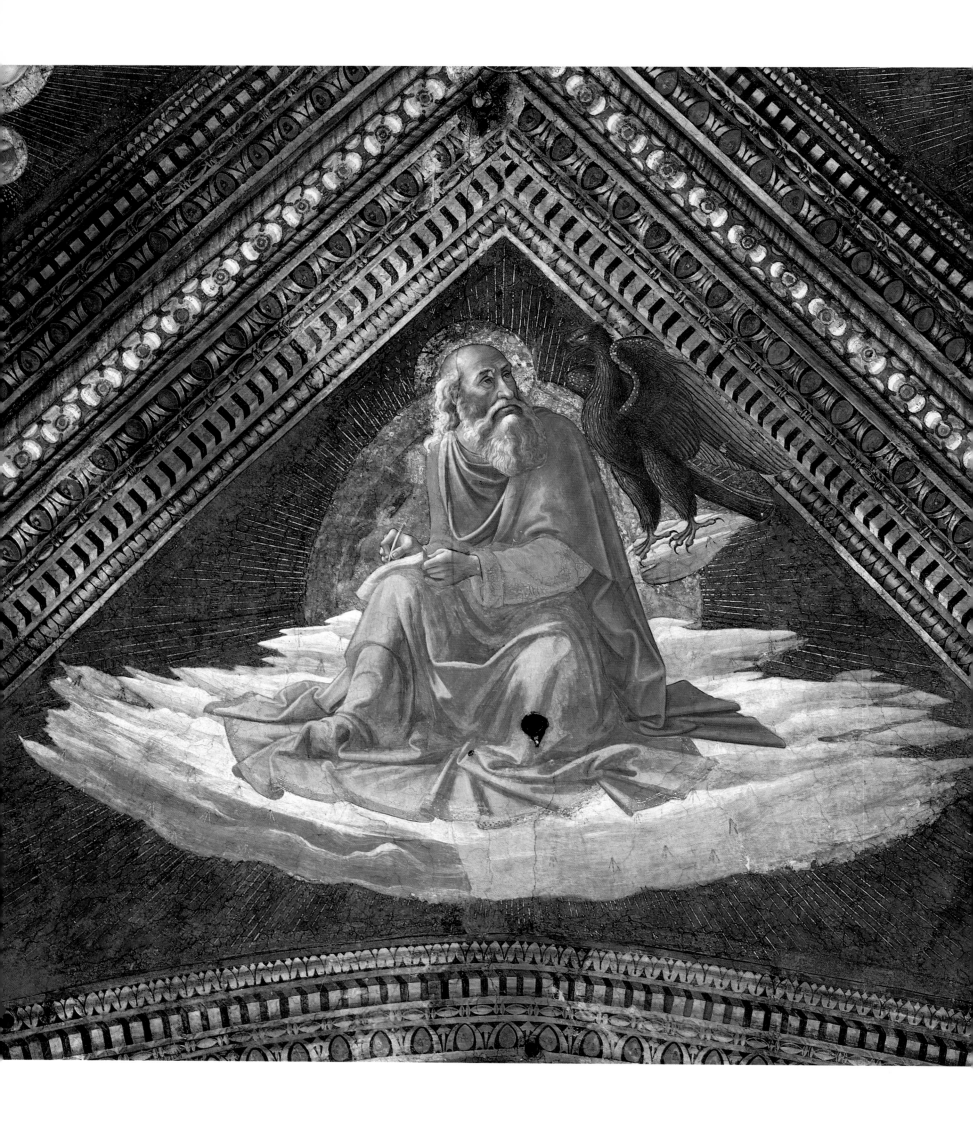

102 (opposite) *Saint Matthew the Evangelist*, 1486–1490
Vault fresco
Santa Maria Novella, Cappella Tornabuoni, Florence

Saint Matthew the Evangelist is writing down God's words, which are being conveyed to him by his symbolic animal, the eagle, on a piece of paper.

103 (above) *Mark the Evangelist*, 1486–1490
Vault fresco
Santa Maria Novella, Cappella Tornabuoni, Florence

Saint Mark the Evangelist is concentrating on sharpening his quill with a knife. The lion at his feet, his symbolic animal, is looking into the chapel with his large eyes.

In the Gothic vaults of the Tornabuoni Chapel the four Evangelists are floating on clouds (ills. 102–105). In addition, Ghirlandaio's workshop also produced three panel paintings to form part of the overall decoration of the chapel. The altarpiece on the rear wall of the chapel was lost during building work in 1804, but the front and rear panels of the main altarpiece are now in Munich and Berlin.

In the Tornabuoni Chapel, Ghirlandaio and his workshop created a superb ensemble just four years before he died. This was Ghirlandaio's greatest commission, almost as extensive in scope as the earlier projects such as Giotto's frescoes in Assisi and Padua, and later projects such as Michelangelo's frescoes in the Sistine Chapel. With his vault and wall frescoes, panel paintings and designs for the windows, Ghirlandaio created a magnificent composite work in Santa Maria Novella that has lost none of its power to impress. Together with the Sassetti Chapel and the Saint Fina Chapel, it is entitled to a permanent place in art history as a major example of chapel decoration at the end of the Quattrocento.

104 (left) *Saint John the Evangelist*, 1486–1490
Vault fresco
Santa Maria Novella, Cappella Tornabuoni, Florence

Saint John the Evangelist is holding the slate pencil in the
fingertips of his right hand, and with his left hand he is
holding out an open book for us to see. As he does so, he
is looking attentively at his symbol, the little angel. The
latter, wearing a fluttering garment, comes very close to
the Evangelist in order to convey to him the word of God.

105 (opposite) *Saint Luke the Evangelist*, 1486–1490
Vault fresco
Santa Maria Novella, Cappella Tornabuoni, Florence

Saint Luke the Evangelist, depicted as a young man with
brown hair and a beard, is looking at a little book on his
knee as he writes down the life of Christ. On his left a
very realistic ox, the Evangelist's symbol, is resting. The
reflections in its large black eye make it look quite good-
natured.

POWER, MONEY AND ART: THE FLORENTINE ARISTOCRACY AND THE WEALTHY BOURGEOISIE

It is necessary to qualify the repeatedly made claim that Ghirlandaio's monumental frescoes are an accurate image of the Florentine style of living during the Renaissance, that they provide a clear picture of everyday life in the 15th century. It is true that they capture the character and affected behavior of the Florentine high society, and that they convey the splendor of their fine clothes, and the magnificence of the rooms and the people who lived in them. But in their daily lives the people he depicted will not have behaved in the way they appear to us. Ghirlandaio was above all depicting the idealized public image of older, wealthy, educated men. The ordinary folk are normally kept well away.

Why this was the case is made clearer by a contract between Ghirlandaio and Giovanni Tornabuoni drawn up for the decoration of the apsidal chapel in Santa Maria Novella. It provides information about the relationship between the client and artist that to a large extent will have applied to other works as well. In the contract the donor demands that the chapel should be "decorated with noble, worthy, select and decorative wall paintings, both as an act of reverence and love of God, to raise the standing of his house and family, and to increase the reputation of the church and chapel." The contract also stipulates that a list of the colors to be used and the scenes to be painted should be drawn up: "And in all the above mentioned histories and pictures, on all the walls of the chapel, on the ceiling, the

106 *Portrait of the Donor Giovanni Tornabuoni,*
1486–1490
Fresco
Santa Maria Novella, Cappella Tornabuoni, Florence

His arms folded humbly across his chest, the rich banker is kneeling under arches that open onto a landscape. The landscape and architecture, shown in correct perspective, continue in the corresponding portrait of his wife. The row of columns behind him gives the painting a great sense of depth.

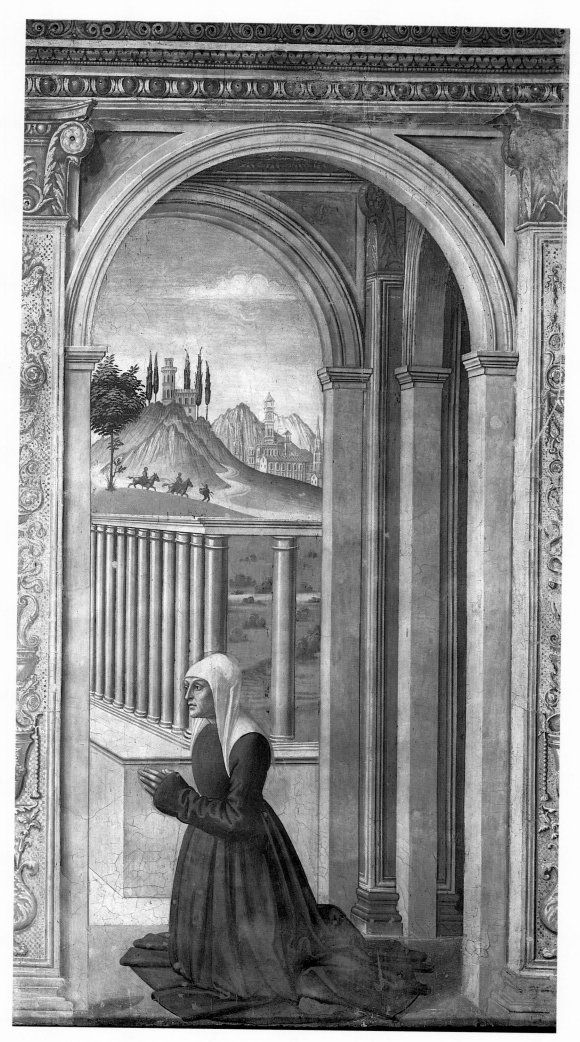

vaults, the columns, he [Ghirlandaio] should paint and depict figures, buildings, castles, towns, mountains, hills, plains, rocks, garments, animals, birds and livestock of all kind, just as Giovanni [the donor] sees fit." Such a requirement would guarantee the amount of effort needed to produce the work, but not its artistic quality. The portraits of the contemporaries Ghirlandaio integrated into the biblical scenes are not mentioned in the contract. But he has to deliver precise plans for each individual scene, and the donor reserves the right to demand changes of any kind in accordance with his wishes.

Ghirlandaio created an idealized image that complied fully with his client's intentions. Artists had to create the image that rulers desired to glorify themselves and justify their wealth. Sponsoring the arts was by no means as altruistic as the myth of patronage has sometimes led us to believe. Rich merchants, and bankers in particular, were frequently suspected of having broken the law against usury (making a profit on a loan). Legitimizing their own wealth by making pious donations was, therefore, one of the driving forces behind sponsoring the arts. Often donors wanted to be shown close to religious figures, and hence in a favorable light. For them, art was a means of representing power and displaying their piety. They wanted to be surrounded by princes, great minds and even artists in their pictures.

In this manner, some patrons have succeeded to the present day in linking themselves with the fame of the artist. A fascinating symbiosis of art, power and patronage developed from which artists were only gradually – and mainly in the century after Ghirlandaio – able to free themselves.

107 *Portrait of the Donor Francesca Pitti-Tornabuoni,* 1486–1490
Fresco
Santa Maria Novella, Cappella Tornabuoni, Florence

The donor's wife is kneeling in prayer on the right side, opposite her husband. By the time the fresco was created she had been dead for some years. It is possible that the pallor of her face indicates this.

113

INVICTA ANIMI VIRTVS·ET
VIRGINITATIS DECVS·ME
IN ETHERA SVBSTVLERVNT

DISCIPLI
NAM·ET
SAPIENTIA
DOCVIT EI
S·BEATVS
DOMINI
CVS

HL·KATHARINA VON SIENA

MARIA MIT DEM KINDE UND DEN HLN. DOMINIKUS/MICHAEL/JOHANNES D.T. UND IOHANNES EV.

PRESSVRAM FLAMME NON
TIMVI · ET INMEDIO IGNIS
NON SVM ESTVATVS ·

PANEL PAINTINGS

Ghirlandaio's greatest achievement was the decoration of mainly private chapels with monumental frescoes. That was what he was famous for and why he was in demand. But the furnishings of a chapel also included an altarpiece, and normally this would consist of an altar painting. The altarpieces normally found in Gothic art, consisting of several individual panels, with images painted on a gold background, had largely disappeared by Ghirlandaio's time. A new type of altarpiece had become common: the square panel.

Though many of Ghirlandaio's motifs were influenced by Flemish panel paintings, he did not adopt their new technique of painting with oils, but continued to work predominantly with tempera throughout his life. Two panel paintings by Ghirlandaio have already been described earlier: the *Madonna and Child* in Lucca (ill. 10), dating from about 1479; and the *Adoration of the Shepherds* in the Sassetti Chapel (ill. 59), painted in 1485.

Not just in the Sassetti Chapel, but also in the larger Tornabuoni Chapel, Ghirlandaio made sure that the painted furnishings were complete. Part of the entire extent of the Tornabuoni commission included a panel painting for the main altar in the church of Santa Maria Novella – the *Pala Tornabuoni* – and its rear panel facing the apsidal chapel. While the Sassetti *Adoration of the Shepherds* can still be worshipped in its original location between the donors depicted in fresco on either side, the ensemble in the Tornabuoni Chapel was dismembered in 1816. The main altar painting, which depicts the most important saints for this place, is now on show in Munich (ill. 108), while the rear panel, the *Resurrection of Christ* is now in Berlin (ill. 109). Both works were begun during the last years of Ghirlandaio's life and were probably not completed until after he had died. There has been much debate as to which parts were painted by Ghirlandaio himself, and which by his workshop.

108 *Madonna in Glory with Saints (Pala Tornabuoni)*,
ca. 1490–1496
Panel, 221 x 198 cm
Bayerische Staatsgemäldesammlung, Alte Pinakothek,
Munich

Mary, the main patron saint of the church, is floating in a glory with her child, surrounded by angels and above Saint Dominic, to whose order the monks of Santa Maria Novella belonged. Holding a book, Saint Dominic is kneeling in front of Archangel Michael. On the right, Saint John the Baptist is standing in front of the kneeling Saint John the Evangelist. The cycle of frescoes on the right wall of the chapel deals with the Baptist in more detail.

LET US PRAISE THE LORD: SCENES SHOWING THE ADORATION OF THE MAGI

Given his large-scale projects, Ghirlandaio could scarcely be expected to carry out such altar paintings in person. This was also realized by his donors, for some of them wrote into the contracts that the works they were paying for had to be painted by him in person. For example, on 28 October 1485, the prior of an orphanage ordered a panel painting of the *Adoration of the Magi* (ill. 110) from Ghirlandaio. The picture was intended for the main altar of the Ospedale degli Innocenti, a foundling hospital. Fra Bernardo acted as

the middleman and drew up a contract which made the following requirements: Ghirlandaio had to "color the aforementioned panel himself, in the manner that can be seen on a paper drawing, with the figures and in the manner as depicted there, and in all details in accordance with what I, Fra Bernardo, consider to be best: he must not deviate from the manner and composition of the mentioned drawing." In addition, the artist had to color the panel at his own expense and use good quality paints. Even the quality of the particularly expensive blue color was precisely laid down in the contract: the artist had to use "ultramarine costing 4 florins per ounce". Ghirlandaio had to deliver the panel paintings after thirty months and would receive 115 large florins for it

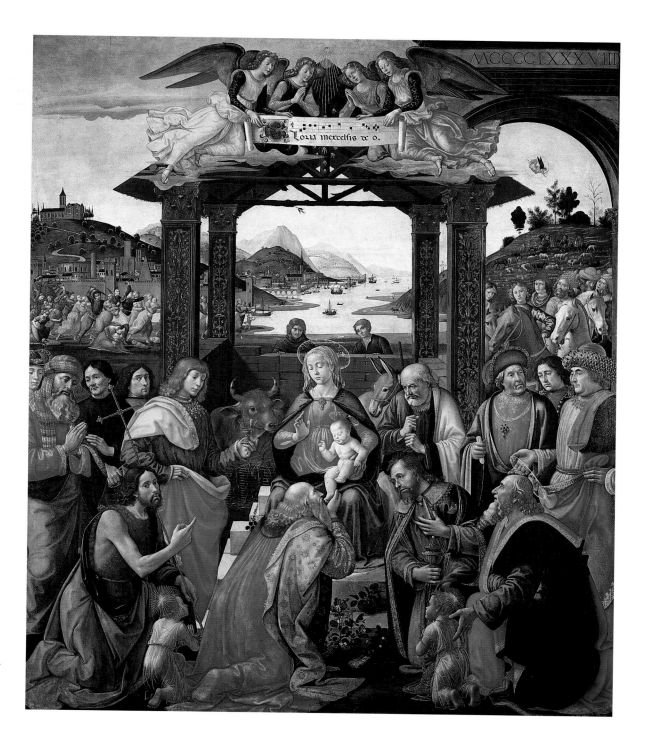

109 (opposite) The *Resurrection*, ca. 1490–1496
Panel, 221 x 199 cm
Staatliche Museen Preußischer Kulturbesitz, Gemäldegalerie, Berlin

The tomb guards are fleeing in panic from the risen Christ, who is rising up to heaven above a classical sarcophagus. Their armor, shields and helmets are depicted in rich detail, and the soldiers' frightened faces are shown with great skill. In the background on the left, the three Marys are approaching, soon to discover that Christ's tomb is empty.

110 (right) *Adoration of the Magi*, 1488
Panel, 285 x 243 cm
Ospedale degli Innocenti, Florence

There are so many saints in this *Adoration* that it is not easy to make out the three Magi. On the left, Saint John the Baptist is kneeling and pointing to the Madonna. The orphans of the Ospedale are represented by two of the innocent boys who were killed during the Slaughter of the Innocents in Bethlehem, kneeling in the foreground. There are gaping bloody wounds to their faces, arms and necks.

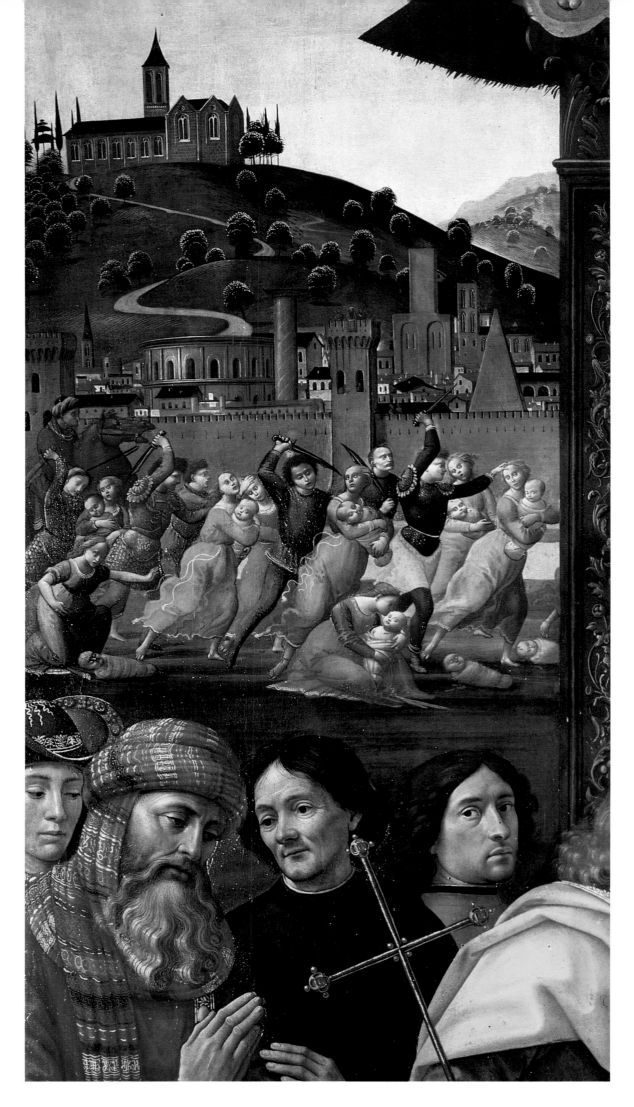

111 (left) *Adoration of the Magi* (detail ill. 110), 1488

Ghirlandaio gazes out at us from this picture, more modestly than in his other self-portraits (cf. ills. 2 and 57). It is thought that the churchman dressed in black in front of him is the man who commissioned the panel painting, Francesco di Giovanni Tesori. Above these two portraits, the *Slaughter of the Innocents* in Bethlehem is shown. The town beyond this, in which we can see monuments such as the Colosseum, Trajan's Column, the Torre delle Milizie, and a pyramid, is meant to be reminiscent of Rome.

112 (opposite) *Adoration of the Magi* (detail ill. 110), 1488

Here Ghirlandaio displays his interest in fine head-dresses and lavish jewelry, such as were depicted in extreme detail and variety in Flemish paintings. The three men's heads appear to be portraits, but can no longer be identified.

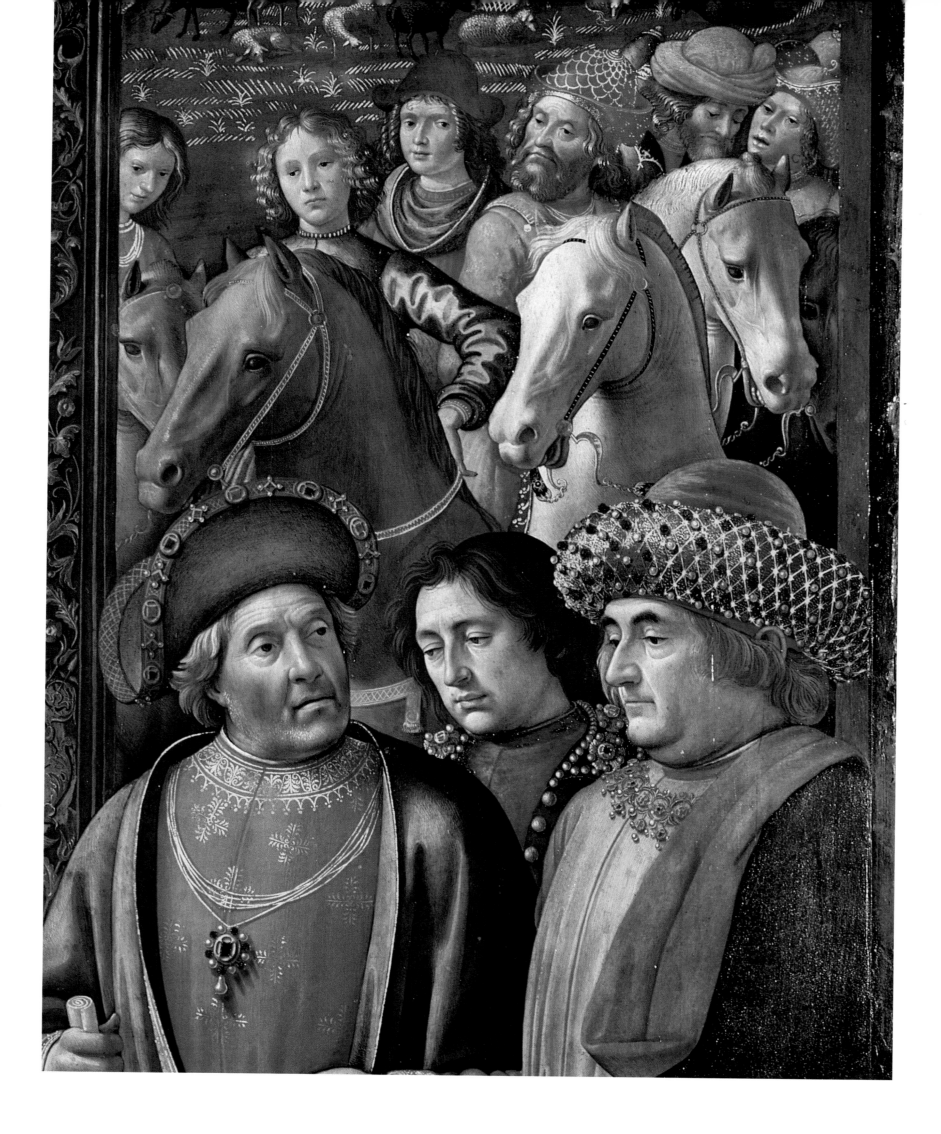

113 (above) *Adoration of the Magi* (detail ill. 110), 1488

Four angels float above the scenes holding a banderole on which there are the words "Gloria in excelsis deo", set to music. Already singing, the angels are pointedly holding the notes out for the observer to see, as an invitation to take part in the song of praise to God.

114 (opposite) *Adoration of the Magi* (detail ill. 110), 1488

The very successful landscape is filled with many figures. Ships of all sorts are sailing across the water, some of them with billowing sails. From behind a wall, two simply dressed men are watching the Adoration.

if the panel turned out to be worth the sum. The decision in that respect was in the hands of the contract's middleman, and as he assured himself in the text: "I can obtain an opinion as to its value or artistic merit from whomever I please, and if it does not appear to be worth the fixed price, he [Ghirlandaio] will receive as much less as I, Fra Bernardo, consider to be appropriate."

Completed in 1488, the work, which delighted the middleman and client, is one of Ghirlandaio's finest panel paintings. The artist received the agreed fee, together with additional funds for a predella.

In this *Adoration of the Magi*, Ghirlandaio's carefully thought out use of color is particularly impressive. Ghirlandaio distributes the glowing colors evenly. Mary in the center is wearing a blue cloak over a red dress. The oldest king kneeling in front of her is wearing a variation of these colors combined with yellow. To the left of Mary, the youngest king holding the valuable goblet in

his hand – he almost looks like Saint John the Evangelist – is also dressed in blue, yellow and red. The figure standing on the right edge of the picture wearing an expensive hat repeats this combination of colors, though now the blue and yellow are reversed. In the second figure from the right, wearing the blue hat, the Madonna's colors of red and blue are visible again, and they are repeated in clothes of the bearded man wearing a turban on the left edge of the picture. Between the Madonna and the man with the blue hat on the right, the artist creates a yellow highlight, though with a weaker blue accent, in the figure of Joseph. This row of figures alone produces a rhythm of color from left to right: red and blue; yellow, blue and red; red and blue; yellow and blue; red and blue; yellow, blue and red.

In 1487, Ghirlandaio painted another *Adoration of the Magi* (ill. 115), a large circular painting for the Tornabuoni family. Such tondos were particularly

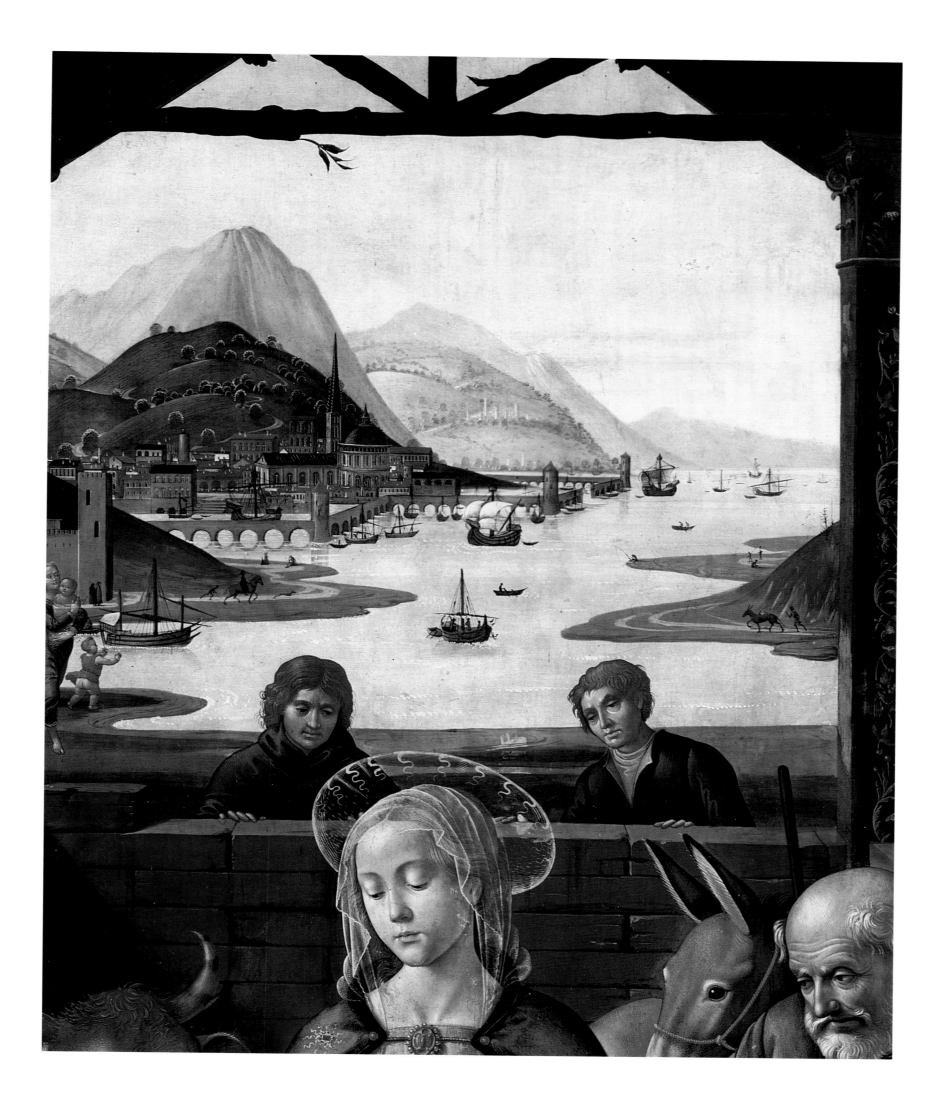

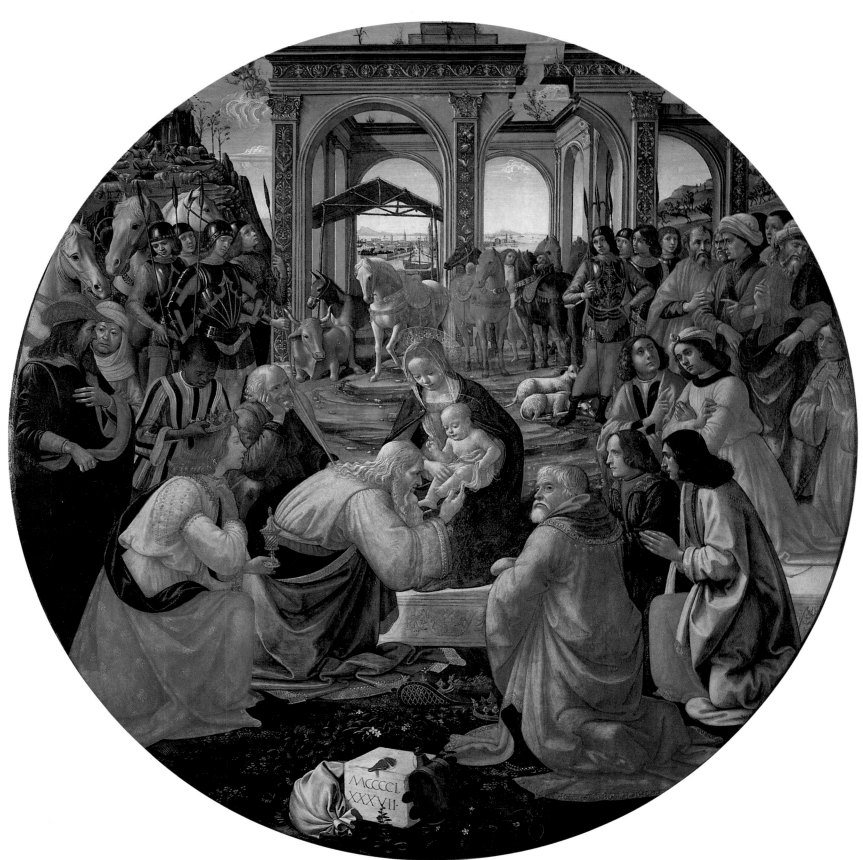

115 *Adoration of the Magi*, 1487
Panel, ø 172 cm
Galleria degli Uffizi, Florence

In order to receive the three kings, Mary has stepped out
of the stable with her child onto an open space. She is
sitting on a stone that is probably part of the classical ruin
in the background. The older kings have already taken
off their crowns in front of the Savior so that they can
worship him. A black servant is just taking the crown off
the youngest king: in this version of the Adoration, the
dark skin color of the king has been transferred to his
page.

popular as decorative items in private rooms, and their circular form required a particularly skillful composition. In the center the childlike Mary is enthroned with her child. In the background, behind the ruined arcades of a classical building, is a simple hut that provides the ox and ass with a stable and the holy family with shelter. The kings' large retinues are lined up right to the ruin, and only behind the Madonna is there a circle of empty space. In other words the composition is influenced by the form of the panel.

On the left is a lovely group of four soldiers with helmets and lances, looking in various directions. The soldiers have four horses that are also looking in different directions. Their pendant on the right, further back, is a group of four other soldiers in magnificent contemporary armor. The horses in front of the ruin are also very successful, and in them Ghirlandaio showed that he was also capable of depicting animals with strong foreshortening and from various angles. The contrast between the magnificent gray stallion and the darker gray ass is surely intentional. Above these animals the observer's gaze wanders through the open arched architecture of the classical ruin out into the far distance. There, painted in an atmospheric paleness, is a city surrounded by water and reminiscent of Venice.

The composition of both *Adorations* by Ghirlandaio contains allusions to the unique panel created in 1481 by Leonardo da Vinci, now in the Galleria degli Uffizi. Though Leonardo never completed this work, it had an enormous influence on the artists of his age. Ghirlandaio adopted the pyramidal composition of the main figures, with Mary at the top, in both his pictures. The inquisitive spectators behind the wall in Ghirlandaio's Innocenti *Adoration* are probably derived from Leonardo's unfinished painting. The circular empty space behind Mary in the tondo might also have been inspired by Leonardo's picture.

Another circular painting of the *Adoration* (ill. 116), produced by Ghirlandaio's immediate circle, is now in Milan. It is likely that his workshop produced an entire series of such paintings, only a few of which have survived.

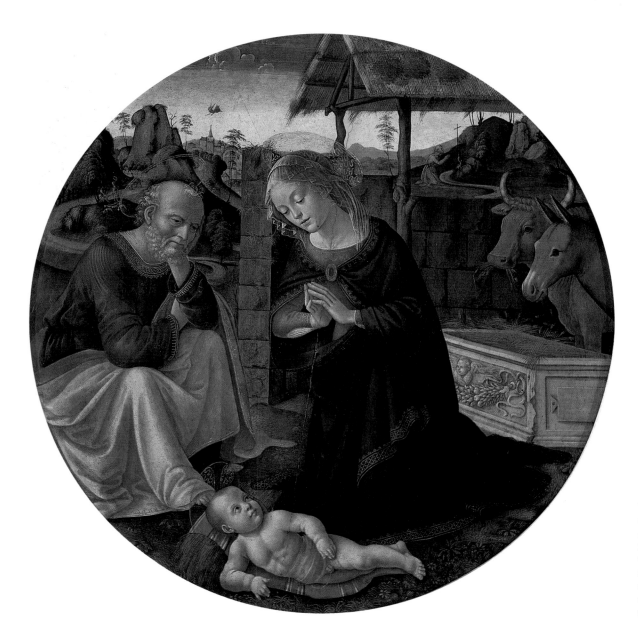

116 *Adoration* (by Ghirlandaio's workshop?)
Panel, ø 90 cm
Pinacoteca Ambrosiana, Milan

This tondo was attributed to Ghirlandaio, as some details in it are derived from his successful *Adoration of the Shepherds* in the Sassetti Chapel (ill. 59). The Madonna, for example, is a mirror image. The ox and ass, together with their marble crib, have been moved to the edge of the picture. Joseph and the Christ Child at the front edge of the picture are adapted to the shape of the frame. The child's unusual posture is reminiscent of classical depictions of river gods.

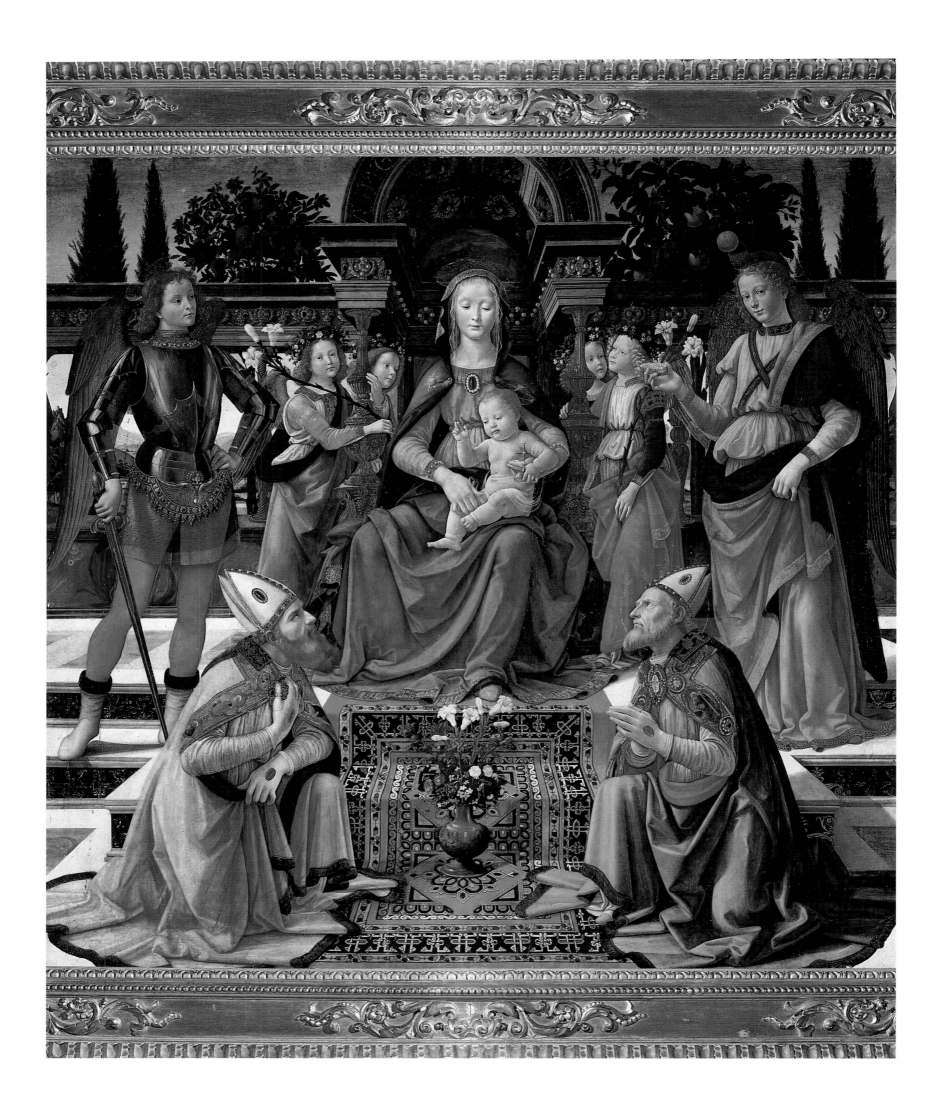

ALTAR PAINTINGS WITH SAINTS

Altar paintings depicting the Virgin Mary and Christ together with several saints were common in Ghirlandaio's day. In Renaissance Italy, enthroned Madonnas, surrounded by saints, were extremely popular. In such a picture, which was called a *Sacra Conversazione*, or "holy conversation", it was possible to combine various saints in accordance with the requirements of the individual donors and church representatives. The donor's patron saint would, for example, be depicted next to the main patron saint of the church or altar, or the founder of an order. It is frequently possible to tell, by looking at the depicted saints, which church a painting was in and to which order the church belonged. This was a way of avoiding conflicts such as the one Francesco Sassetti faced when he was refused permission to depict his patron saint, Francis of Assisi, in Santa Maria Novella. The choice of

saints could in effect be extended to include, for example, the patron saints of a town or guild.

Two such works by Ghirlandaio are now in the Galleria degli Uffizi in Florence (ills. 117, 118). In both pictures the Christ Child is depicted in a similar posture, his hand raised in blessing. In the earlier painting with the tied back curtain, in Lucca Cathedral (ill. 10), Ghirlandaio depicted all the saints in a standing position. But in the later works the two saints at the front are kneeling. This makes a better use of the surface of the picture and at the same time achieves a more interesting arrangement of figures by creating a pyramidal composition formed by the kneeling saints and the Madonna. The panels in the Uffizi are filled with decorative accessories, such as the carpets on the steps leading up to the throne and the flower vases, and these were surely influenced by Flemish works. The depictions of the Madonna are, however, still in keeping with Verrocchio's models.

117 (opposite) *Madonna and Child Enthroned with Saints*, ca. 1483
Panel, 191 x 200 cm
Galleria degli Uffizi, Florence

This picture is composed in a strictly symmetrical manner. The archangel Michael in shining armor is similar to Saint Julian in Ghirlandaio's earliest *Sacra Conversazione* in Sant' Andrea a Brozzi (ill. 9). The trees are a quotation of the *Last Supper* in Ognissanti (ill. 24), and the carpet is similar to the table covering in the Ognissanti *Saint Jerome* (ill. 20).

118 (below) *Madonna and Child Enthroned between Angels and Saints*, ca. 1486
Panel, 168 x 197 cm
Galleria degli Uffizi, Florence

At the front right, Pope Clement is kneeling. He has laid down his papal tiara in front of him and appears to be urging the observer to take part in a humble worship of the Madonna. Saint Dominic, the founder of the order of the Dominicans, is kneeling next to him, and on the right the Church Father Saint Thomas Aquinas, is holding out a valuable book.

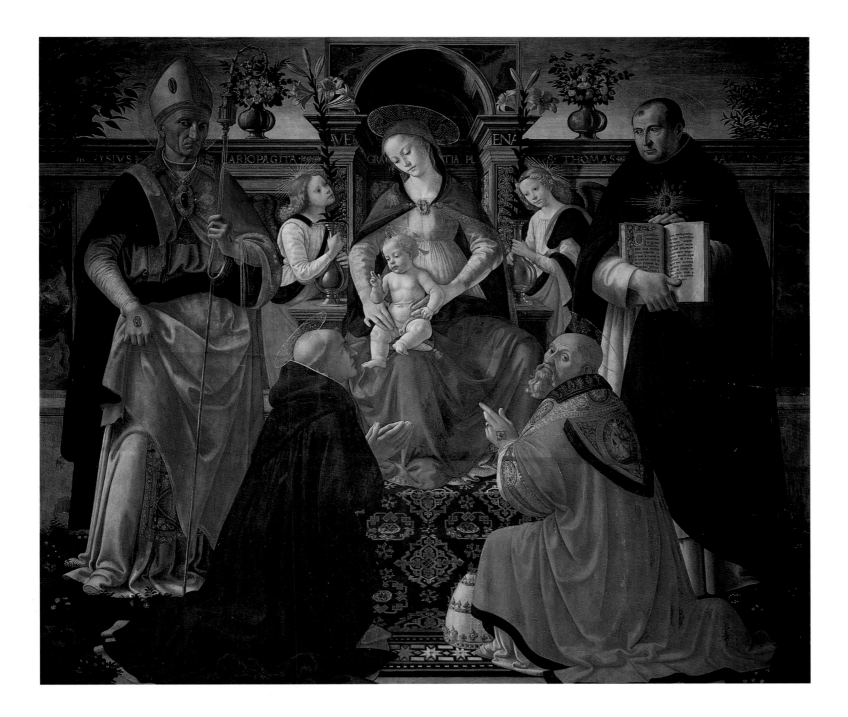

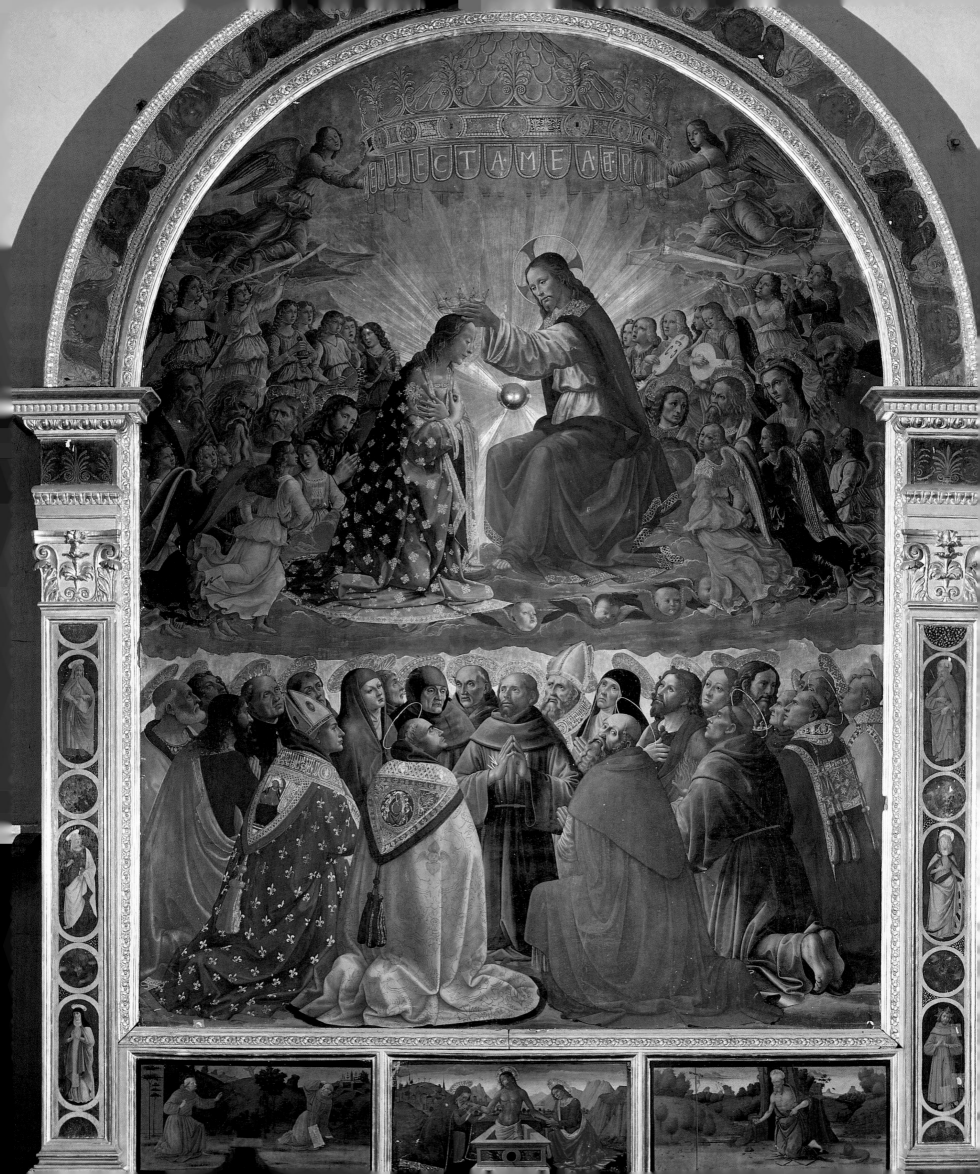

With some altar paintings the intention was to venerate the Virgin Mary as the Queen of Heaven, and this meant that the traditional *Sacra Conversazione* was not suited to the task. In cases such as this the painters divided the picture horizontally so that they could show the Coronation of the Virgin taking place above a row of saints. Vertical panels with rounded tops were particularly well suited to such compositions. Two panels on this theme by Ghirlandaio, both dating from about 1486, have survived. Though at first sight both works appear completely different, both are in keeping with the traditional form for this type of picture (ills. 119, 120). In the *Coronation* in the town of Narni, the gold background, which jars with the other colors, and also the number of saints and angels crowding the picture, are unusual for Ghirlandaio. It is possible that the clients from the provinces in Umbria had requested this conservative structural method. The *Coronation* in Città di Castello is also untypical of Ghirlandaio because of its limited palette: its impact is derived primarily from the contrast of various shades of blue and red with a few yellow highlights. In both works Ghirlandaio's workshop is considered to have painted a large proportion of the work, but despite this the painting in

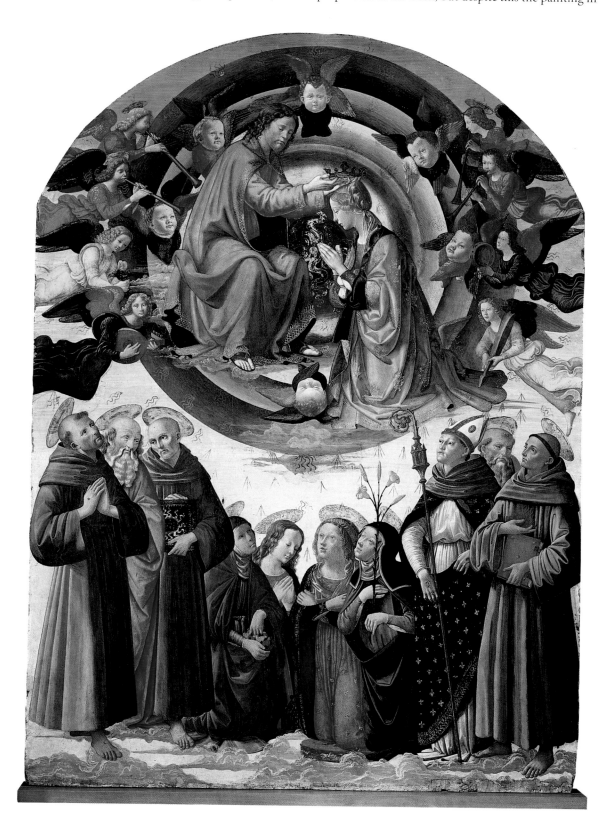

119 (opposite) *Coronation of the Virgin* (by Ghirlandaio's workshop?), 1486
Panel, 330 x 230 cm
Palazzo Comunale, Narni

Christ and his mother Mary appear on clouds amid the hosts of heaven. The angels are making music while Christ places the crown of the Queen of Heaven on the bowed head of the humble Virgin. In the lower register, many holy men and women are kneeling around Saint Francis and taking part in prayer in the solemn ceremony.

120 (right) *Coronation of the Virgin* (by Ghirlandaio's workshop?), ca. 1486
Panel
Pinacoteca Comunale, Città di Castello

In contrast with the old-fashioned picture in Narni (ill. 119), only the female saints in the center are kneeling in this *Coronation of the Virgin*; three holy men are standing on each side of them. This emphasizes the circular glory, composed of airy shades of blue, giving the work a dynamic and animated character. The saints on this picture are mainly ones from the Franciscan order. On the far left stands the founder of the order, Saint Francis of Assisi.

121 *Christ in Heaven with Four Saints and a*
Donor, ca. 1492
Panel, 308 x 199 cm
Pinacoteca Comunale, Volterra

The bald-headed donor with the striking profile
humbly takes his place among the saints
worshipping Christ. These are arranged in
a rigid symmetry. Two local female saints in
shining red are kneeling, seen from behind, in
the foreground. The two male saints, similar
to the point of confusion, are standing like
columns on either side.

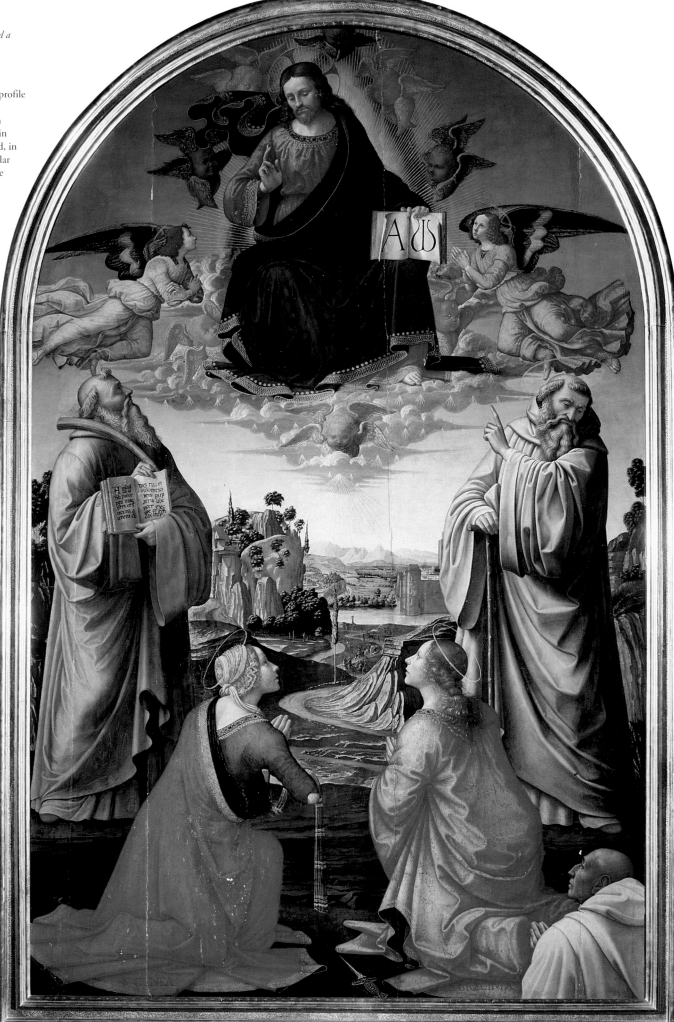

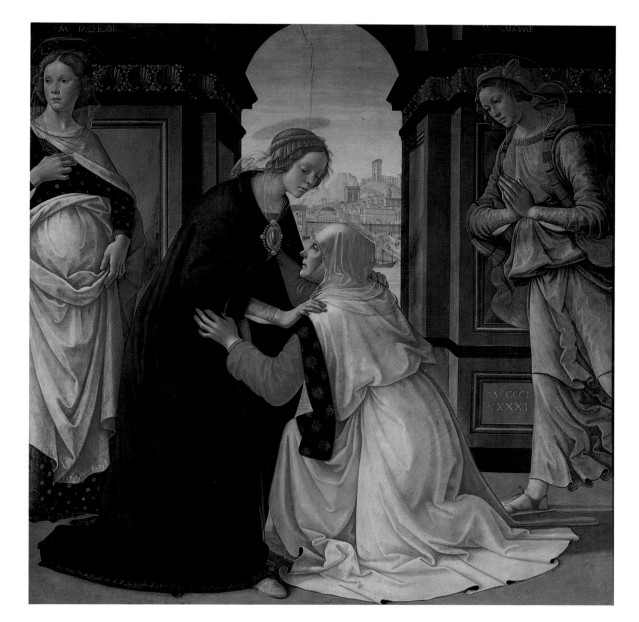

Narni, Ghirlandaio's largest panel painting, was so
successful that it was later copied more than once.

The compositional scheme of a central figure
surrounded by saints is used by Ghirlandaio in a later
work dating from about 1492: he depicts Christ, with
his hand raised in blessing, enthroned on a cloud bank
and surrounded by angels (ill. 121). The main lines of
the garments, the contours of the figures, and their gazes
all lead the eye to Christ, who crowns the composition
of the picture. In the bottom right hand corner kneels
the donor Fra Giusto Bonvicini, the abbot of a
Camaldolese monastery. He is wearing the habit of the
order of the so-called "white Benedictines", an order of
hermits founded by Saint Romuald. Ghirlandaio
structured this composition in an unusual manner, for
the figures appear to be circling an empty central space.
Here, however, we can see one of the most successful
landscapes Ghirlandaio ever painted.

The Musée du Louvre in Paris owns a panel painting
by Ghirlandaio which differs from others. Like one of
the frescoes in the Tournabuoni Chapel, it depicts the
Visitation (ill. 122). Ghirlandaio painted the work in
1491 for a private chapel the Tournabuoni owned in the
church of Santa Maria Maddalena dei Pazzi. Studies of
the garments show how carefully Ghirlandaio prepared
each individual figure for this unusual work (ill. 123).
That is particularly true of the figure of Saint Mary
Salome who is walking in from the right with her hands
folded in prayer; wearing a classical flowing garment, she
is reminiscent of figures by Filippino Lippi. On the
opposite side Saint Mary Jacobi is adopting a most
traditional pose, but unusually is looking out of the
picture to the left. These two figures at the sides are cut
off by the edge of the picture, and this brings a more
animated note to the peaceful group of the two main
figures. The quality of the painting makes this panel one
of the master's most outstanding works. Particularly
charming is the contrast between the youthful face of
Mary and the old face of Elizabeth.

Up to then, all Ghirlandaio's pictures had been religious.
His altar paintings stood out due to their clear structure,
which often adhered to traditional schemes. They show
that he was intent on creating a harmonic overall effect by
means of a picture's color and composition.

PORTRAITS

As has already been described, Ghirlandaio incorporated portraits of his contemporaries in many biblical scenes. It is probably for precisely that reason that he was so popular among the rich Florentines, who were particularly keen on self-portrayal. This makes it all the more astonishing that so few secular portraits by Ghirlandaio have survived.

At the end of the 15th century, portraits became a major part of Florentine art, and of sculpture in particular. Sculptors such as Mino da Fiesole, Benedetto da Maiano, Antonio Rossellino and Ghirlandaio's model Verrocchio all created impressive masterpieces characterized by a high degree of realism. Their portrait busts celebrated youthful feminine beauty, or with unsparing frankness immortalized the typical characteristics of male contemporaries. It was not until a hundred years after Ghirlandaio's time that official court portrait painters were employed by rich and powerful families. So Ghirlandaio cannot be considered an official portrait painter of Florence's upper classes, despite the fact that they considered him to be the most important and desirable painter. Almost all the leading personalities in his native city were depicted in his paintings.

Given that the intellectual elite based themselves on classical models, it is not surprising that Florentine

124 *Angel appearing to Zacharias* (detail ill. 91), 1486–1490

This series of portrait of contemporary Neoplatonists, their heads all at the same level, continues the row of classical heads in the relief behind them – this is Ghirlandaio's way of presenting the Neoplatonists as a continuation of the classical intellectual tradition.

THE FLOWERING OF A CITY: HUMANISM AND THE FLORENTINE RENAISSANCE

The works that were commissioned from Ghirlandaio were mainly religious. Why then did he depict set pieces from the pagan classical age in his religious works?

An explanation for the apparent incompatibility of Christianity and classical paganism is provided by a scientific movement of the age, humanism, which went hand in hand with the rediscovery of the classical era. The ground for this movement was well prepared by the great thinkers Dante and Petrarch. The literary and intellectual adoption of the classical era that occurred from the 14th to the 16th centuries was a prerequisite for the so-called "rebirth of the classical age", the Renaissance of the fine arts. During this period, the center of humanism was the Florence of the Medici. There the classical age was felt to be the embodiment of a perfect humanity, which it was thought could be recreated through education, which was considered the greatest good. Antiquity would be reborn in an idealized form. The classical backdrops in Ghirlandaio's frescoes are populated less by Roman gods and heroes than by contemporary representatives of the intellectual elite, which included the most important Florentine humanists of the age (ill. 124). Their main achievement was to publish, expound and translate classical texts. They produced a body of historical and biographical literature, most notably Vasari's much-quoted lives of the artists, modelled on classical works.

Hand in hand with humanism went a desire to improve life through study, art, and the cult of beauty. Fully aware of the beauty of classical works of art, the Florentines knew how to use them as diplomatic tools. After the ordination of Pope Sixtus IV in 1471, Lorenzo de' Medici, who had witnessed the event as Florence's representative, wrote the following: "I was received with great deference and returned with two classical sculptures that the Pope presented to me: a figure of Augustus and one of Agrippa." Ghirlandaio's client Francesco Sassetti also owned a famous collection of classical manuscripts and ancient coins.

The Italian humanists felt themselves to be the descendants of the Romans, as was made clear by the poet and scholar Agnolo Poliziano, who claimed that he was able to factually prove the legend that the Romans had founded Florence. Ghirlandaio portrayed him as the teacher of the Medici children (ill. 125); and on another occasion, in the Tornabuoni Chapel, depicted him standing alongside the other main representatives of Florentine humanism (ill. 126). The Platonist Cristoforo Landino can also be seen there. He wrote well-known commentaries on Dante's "Divine Comedy" and Pliny the Elder's "Natural History" (77 AD), lectured on poetics and rhetoric at Florence University, and became one of the best art critics of his time.

Next to these two scholars stands the philosopher Marsilio Ficino, who translated Plato and taught at the Academy in Florence. He attempted to detach culture from Christianity and place it under the influence of Plato.

125 *Confirmation of the Rule* (detail ill. 48), ca. 1485

The Italian humanist and poet Agnolo Poliziano – here with his student Giuliano de' Medici – was a professor of Greek and classical languages. He wrote odes and elegies in Italian, Greek and Latin and introduced textual criticism to the classical literary studies. Poliziano died in the same year as Ghirlandaio.

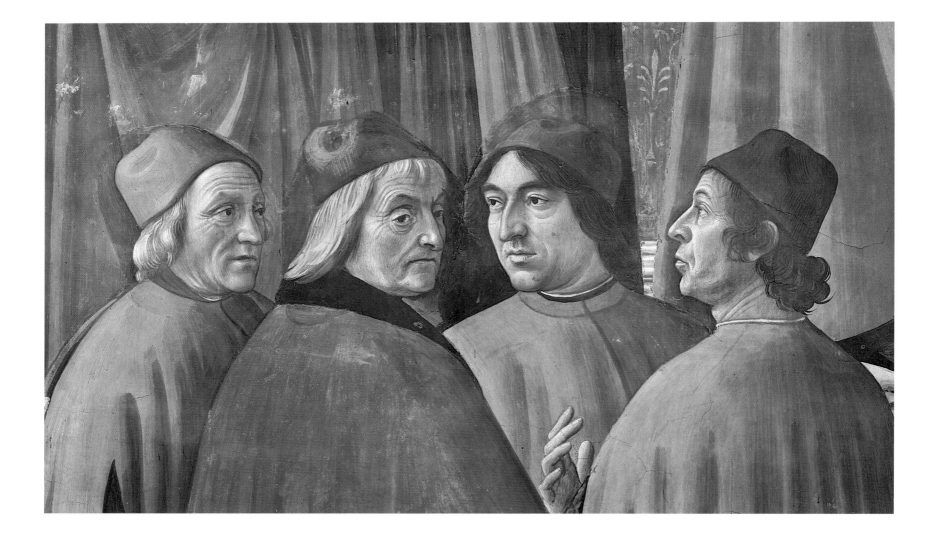

126 (above) *Angel Appearing to Zacharias* (detail ill. 91), 1486–1490

Here, the intellectuals of Florence are standing together. Vasari identified them as the Platonist Marsilio Ficino, the poet and orator Cristoforo Landino and the humanist Agnolo Poliziano. The profile head is either the contemporary Greek Platonist Demetrio Greco or Gentile de' Becchi.

127 (opposite) *Giovanna Tornabuoni*, ca. 1490
Panel, 77 x 49 cm
Thyssen-Bornemisza Collection, Madrid

Ghirlandaio painted this charming portrait of Giovanna Tornabuoni after her death. She probably died in 1488 in the weeks following childbirth, aged twenty. A note in the background praises the nature of the woman who died so young: "If art were also able to depict the character and soul, there would be no more beautiful picture on earth."

artists like Ghirlandaio traveled to Rome in order to study classical monuments. An extensive sketchbook now in the Escorial in Madrid, the "Codex Escurialensis", contains drawings of many Roman buildings and architectural details produced by Ghirlandaio's workshop.

One cannot help wondering how an artist who depicted the most horrific skin rash in art history came to be famed for his ability to paint portraits and was inundated with commissions from vain contemporaries interested in the prestige value of the works.

There are two paintings dating from about 1490, in the Paris Musée du Louvre and in Madrid, that are masterpieces of his art and yet fundamentally different: Giovanna Tornabuoni is idealized to the extent of becoming an "icon" of beauty for young Florentine girls (ill. 127), while the old man with the boy is painted with a pitiless degree of realism. Ghirlandaio does not shrink even from depicting his nose in all its disfigurement. (ill. 128).

The painting in Madrid depicts Giovanna degli Albizzi in a magnificent garment made of gold brocade with tight, slitted silk sleeves. She came from one of the most important Florentine families and in 1486 married Lorenzo Tornabuoni. After her early death Ghirlandaio created two portraits, and it is possible that he was able to produce the cartoon for them while she was still alive.

In a fresco in the Tornabuoni Chapel, Giovanna is depicted as an entire figure witnessing the Visitation. The artist used that portrait in his panel painting with a new background, though he unfortunately cut the arms and hands off rather awkwardly. The delightful young woman now stands out, in a clear contrast of light against dark, from the black niche in the background. The reserved beauty of the young woman is fittingly expressed in the formal clarity of the composition.

She is wearing a valuable piece of jewelry, comprizing a ruby in a gold setting with three silky shining pearls, hanging from her neck by a delicate cord. There is a very similar item of jewelry on the shelf behind her, and this, combined with red coral beads against the black background, gives the work a noble elegance. These beads are part of a rosary, and the section that is hanging straight down emphasizes the vertical line of her back, and also directs our gaze to the prayer book. Between these two "pious" objects is a little note alluding to the beautiful soul of the portrayed woman by means of an epigram written by the Roman poet Martial in the first century A. D. This outstanding portrait, one of the most famous of the Quattrocento, makes it clear that portraits of women were one of Ghirlandaio's ideal subjects.

In his double portrait in the Musée du Louvre, the artist succeeds not only in portraying the two figures with great tenderness, but also in conveying the deep

affection between them. The boy is gently snuggling up to the old man. Their eyes meet on a diagonal: this balances the composition, and also excludes the observer from the intimate scene. The boy is looking upwards along the old man's outline, which means that he is actually looking directly at the enormous nose projecting towards him. The contrast makes the little boy's snub nose, and the way his mouth is opened in astonishment, appear all the more childlike. The old man is sitting in the corner of a room in front of an open window. The delicacy of the beautiful view of the landscape is, so to speak, a commentary on the profound companionability of the two generations. A soft light is falling on the faces through the window, and the old man is lit from the right and the boy from above. As the lit halves of their faces are turned towards each other, and the same bright red is used for the garments and cap, producing a richness that contrasts with the gray wall behind, the two figures seem to merge to form one. The picture is entirely composed with their unity in mind. Flemish influences are unmistakable in both the choice of the corner of the room and the landscape, bringing to mind both Dirck Bouts' *Portrait of a Man* in London dating from 1462 and several portraits by Petrus Christus.

In the National Museum in Stockholm is a preparatory drawing by Ghirlandaio which shows the old man with his eyes closed, and for this reason it is frequently regarded as a portrait of a dead man. There are no grounds for assuming that he is shown sleeping there. Rather, one might assume that the dead man's relatives commissioned the work from Ghirlandaio in order to keep the memory of their beloved family member alive, particularly for the descendant depicted in the picture. It was precisely Ghirlandaio's ability to produce a depiction of a person's own features close to nature that were in demand here, as this was not so much an official painting destined for public exhibition as a private small format picture of remembrance. Today, in the age of photography and film, it is scarcely possible to gauge the personal value that such portraits had for contemporaries. Having pictures of deceased relatives in their private living quarters was a sign of respect and remembrance by rich and noble families towards those who had died, and could in addition be used to explain their origins to later generations. A poorer copy in the New York Metropolitan Museum, the painter of which has not as yet been identified, proves how successful Ghirlandaio's compositions were.

128 *An Old Man and his Grandson*, ca. 1490
Panel, 62 x 46 cm
Musée du Louvre, Paris

As the identity of the two figures is no longer known, it cannot be stated with certainty whether they are indeed, as is supposed, grandfather and grandson. The man's nose, disfigured by a skin disease, has in recent years led to the writing of several medical essays. Scratches in the paint layer disfigured it even further. This damage was removed by restoration work carried out in 1996.

CONCLUSION

During a creative period lasting scarcely 25 years, Ghirlandaio, the most popular painter of his day, created a large number of important works. He could do this only because he employed a number of assistants in his workshop, which was then the busiest in Florence. Ghirlandaio's atmospheric spaces, the distinctive features of his portraits, and the charm of his figures were highly valued even then. In 1490 the Duke of Milan, needing to commission the best artists to carry out a project, sent an agent to Florence. In his report the agent praises four painters working in Florence: Sandro Botticelli, Filippino Lippi, Perugino, and Ghirlandaio. His judgement about Ghirlandaio was that he was: "a good master on wooden panels and even better on walls. His things have a good appearance (*bona aria*); he is an experienced man and someone who can carry out a lot of work."

It is possible that Ghirlandaio was so successful precisely because he made use of traditional forms and often kept to strict iconographic prescriptions. He did of course lack the titanic character of a Michelangelo and the mystical dimension of a Leonardo da Vinci – he was not the stuff of legends. His personality was not suited to conveying a sense of mystery. Sensitive to tradition, Ghirlandaio created religious compositions that were sober, clearly structured, and balanced.

Ghirlandaio's works were a meeting of two new impulses with traditional painting, impulses that were transformed into his own personal style to form that type of art that is characteristic of Renaissance. Ghirlandaio felt keenly the influence both of art from north of the Alps, and also of "rebirth of the classical age": these two poles are clearly reflected in his works.

He created not only an imaginary architecture derived from ancient Roman models, he also created masterly town views. He was always finding new and ingenious solutions to the use of space, filling his scenes with clear light and air, a feature that is characteristic of his works. In this way he created elegant and graceful pictures with clear, rhythmically complete compositions.

By adding secular elements to sacred pictures, he frequently forced the religious events into the background. In the process he incorporated a larger number of portraits of his contemporaries into the stories, producing a delightful blend of concise portraiture and monumental stylization. In his portraits Ghirlandaio produced a detailed record of the balance of power and economic circumstances in Florence at the end of the Quattrocento, becoming the eloquent chronicler of Florentine society during the era of Lorenzo de' Medici.

CHRONOLOGY

1449 Domenico is born in Florence, the first son of the well-to-do Tommaso di Currado Bigordi.

1466 Sebastiano Mainardi is born in San Gimignano. He later works in Ghirlandaio's workshop.

to ca. 1472 According to Vasari, Domenico learnt the techniques of painting and mosaic making from Alessio Baldovinetti. It is probable that Domenico spent some years in the workshop of Andrea del Verrocchio. It can be assumed that he had finished his apprenticeship by 1472, as that was the year when Domenico's name appeared in the records of the painter's guild, the *Compagnia di San Luca* (the Brotherhood of Saint Luke).

ca. 1471 Apse fresco in the parish church of Sant' Andrea in Cercina near Florence, Ghirlandaio's earliest surviving work.

ca. 1472/73 Frescoes in the Vespucci Chapel in the Florentine church of Ognissanti, and frescoes showing the Baptism of Christ and the Madonna and Child with Saints in Sant' Andrea a Brozzi in San Donnino.

1473–1475 Frescoes in the Saint Fina Chapel in the collegiate church of San Gimignano.

1475–1476 In Rome, Ghirlandaio and his brother Davide paint decorative frescoes for Pope Sixtus IV in the Vatican Library. They show half-length portraits of Doctors of the Church next to classical philosophers holding banderoles.

1476 First fresco of the *Last Supper*, in Passignano near Florence.

1477 Decoration of the Tornabuoni Chapel in Santa Maria sopra Minerva in Rome (no longer in existence).

ca. 1479 Two altarpieces of a *Sacra Conversazione* in Pisa and Lucca.

before 1480 Domenico marries Constanza di Bartolomeo Nucci.

1480 Frescoes of the *Last Supper* and *Saint Jerome* in Ognissanti, Florence.

1481–1482 Two frescoes in the Sistine Chapel in the Vatican, Rome.

1482–1484 Wall decoration in the Sala dei Gigli in the Florentine Palazzo Vecchio.

ca. 1483 Altar painting of a *Sacra Conversazione* for the church of San Giusto alle Mura in Florence, now in the Uffizi.

1482–1485 Frescoes in the Sassetti Chapel in Santa Trinità, Florence.

1485 Altar painting in the Sassetti Chapel showing the *Adoration of the Shepherds*. The chapel is consecrated on 25 December 1485. On 1 September he is commissioned to produce the frescoes in the Tornabuoni Chapel in Santa Maria Novella, Florence. On 23 October, he is commissioned to paint an altar panel of the *Adoration of the Magi* for the Ospedale degli Innocenti, Florence.

1486–1490 Frescoes in the Tornabuoni Chapel in Santa Maria Novella, Florence.

ca. 1486 Fresco of the *Last Supper* in San Marco, Florence. Altar painting of a *Sacra Conversazione* for San Marco, now in the Uffizi.

1486 Altar painting of the *Coronation of the Virgin* for San Girolamo, Narni.

1487 Tondo of the *Adoration of the Magi* for the Tornabuoni family, now in the Uffizi.

1488 Altar painting of the *Adoration of the Magi* for the Spedale degli Innocenti, Florence. Following the death of his first wife, Ghirlandaio marries Antonia di ser Paolo di Simone Paoli.

1489–1490 Mosaic of the *Annunciation* for Florence Cathedral.

ca. 1490 Portrait of Giovanna Tornabuoni, now in the Thyssen-Bornemisza Collection in Madrid. Portrait of *An Old Man and His Grandson*, now in the Louvre.

1490–1496 Altar paintings for the main altar of Santa Maria Novella and the Tornabuoni Chapel, now in Munich and Berlin.

1491 Altar painting of the *Visitation* for the Tornabuoni Chapel in Santa Maria Maddalena dei Pazzi, now in the Louvre.

ca. 1492 Altar painting of Christ in Heaven, Volterra.

11 January 1494 Two years after the death of Lorenzo de' Medici, Ghirlandaio suddenly dies at the age of 45 of plague fever, just as he is about to begin large works in Pisa and Siena. He is buried in the old cemetery of Santa Maria Novella in Florence.

GLOSSARY

aerial perspective, a way of suggesting the far distance in a landscape by using paler colors (sometimes tinged with blue), less pronounced tones, and vaguer forms.

altarpiece, a picture or sculpture that stands on or is set up behind an altar. Many altarpieces were very simple (a single panel painting), though some were huge and complex works, a few combining both painting and sculpture within a carved framework. From the 14th to 16th century, the altarpiece was one of the most important commissions in European art; it was through the altarpiece that some of the most decisive developments in painting and sculpture came about.

apse (Lat. *absis*, "arch, vault"), a semicircular projection, roofed with a half-dome, at the east end of a church behind the altar. Smaller subsidiary apses may be found around the choir or transepts. The adjective is **apsidal**.

architrave (It. "chief beam"), in classical architecture, the main beam resting on the capitals of the columns (ie the lowest part of the entablature); the moulding around a window or door.

attribute (Lat. *attributum*, "added"), a symbolic object which is conventionally used to identify a particular person, usually a saint. In the case of martyrs, it is usually the nature of their martyrdom.

banderole (It. *banderuola*, "small flag"), a long flag or scroll (usually forked at the end) bearing an inscription. In Renaissance art they are often held by angels.

cantoria, pl. **cantorie** (It.), a gallery for singers or musicians, usually in a church. Two outstanding examples are those by the sculptors Andrea della Robbia and Donatello in Florence cathedral, both of which have richly carved marble panels.

cartoon (It. *cartone*, "pasteboard"), a full-scale preparatory drawing for a painting, tapestry, or fresco. In fresco painting, the design was transferred to the wall by making small holes along the contour lines and then powdering them with charcoal in order to leave an outline on the surface to be painted.

classical, relating to the culture of ancient Greece and Rome (**classical Antiquity**). The classical world played a profoundly important role in the Renaissance, with Italian scholars, writers, and artists seeing their own period as the rebirth (the "renaissance") of classical values after the Middle Ages. The classical world was considered golden age for the arts, literature, philosophy, and politics. Concepts of the classical, however, changed greatly from one period to the next. Roman literature provided the starting point in the 14th century, scholars patiently finding, editing and translating a wide range of texts. In the 15th century Greek literature, philosophy and art – together with the close study of the remains of Roman buildings and sculptures – expanded the concept of the classical and ensured it remained a vital source of ideas and inspiration.

Compagnia de San Luca (Guild of St. Luke), the painters' guild in Florence (named after St. Luke because he was believed to have painted a portrait of the Virgin Mary).

complementary colors, pairs of colors that have the maximum contrast and so, when set side by side, intensify one another. Green and red, blue and orange, and yellow and violet are complementary colors.

contrapposto (It. "placed opposite"), an asymmetrical pose in which the one part of the body is counter-balanced by another about the body's central axis. Ancient Greek sculptors developed contrapposto by creating figures who stand with their weight on one leg, the movement of the hips to one side being balanced by a counter movement of the torso. Contrapposto was revived during the Renaissance and frequently used by Mannerist artist, who developed a greater range of contrapposto poses.

conventicle (Lat. *conventiculum*, "meeting place"), a religious meeting or society.

Dominicans (Lat. *Ordo Praedictatorum,* Order of Preachers), a Roman Catholic order of mendicant friars founded by St. Dominic in 1216 to spread the faith through preaching and teaching. The Dominicans were one of the most influential religious orders in the later Middle Ages, their intellectual authority being established by such figures as Albertus Magnus and St.Thomas Aquinas. The Dominicans played the leading role in the Inquisition.

ensemble (Fr. "together"), a combining of several media grouped together to form a composite art work. Chapels were among the most notable Renaissance ensembles, sometimes combining panel painting, fresco, sculpture, and architecture.

entablature, in classical architecture, the part of a building between the capitals of the columns and the roof. It consists of the architrave, the frieze, and the cornice.

fluted, of a column or pillar, carved with closely spaced parallel grooves cut vertically.

Franciscans, a Roman Catholic order of mendicant friars founded by St. Francis of Assisi (given papal approval in 1223). Committed to charitable and missionary work, they stressed the veneration of the Holy Virgin, a fact that was highly significant in the development of images of the Madonna in Italian art. In time the absolute poverty of the early Franciscans gave way to a far more relaxed view of property and wealth, and the Franciscans became some of the most important patrons of art in the early Renaissance.

fresco (It. "fresh"), wall painting technique in which pigments are applied to wet (fresh) plaster (*intonaco*). The pigments bind with the drying plaster to form a very durable image. Only a small area can be painted in a day, and these areas, drying to a slightly different tint, can in time be seen. Small amounts of retouching and detail work could be carried out on the dry plaster, a technique known as *a secco* fresco.

genre painting, the depiction of scenes from everyday life. Elements of everyday life had long had a role in religious works; pictures in which such elements were the subject of a painting developed in the 16th century with such artists as Pieter Bruegel. Carracci and Caravaggio developed genre painting in Italy, but it was in Holland in the 17th century that it became an independent form with its own major achievements, Vermeer being one of its finest exponents.

glory, the supernatural radiance surrounding a holy person.

grisaille (Fr. *gris*, "gray"), a painting done entirely in one color, usually gray. Grisaille paintings were often intended to imitate sculpture.

hatching, in a drawing, print or painting, a series of close parallel lines that create the effect of shadow, and therefore contour and three-dimensionality. In **cross-hatching** the lines overlap.

iconography (Gk. "description of images"), the systematic study and identification of the subject-matter and symbolism of art works, as opposed to their style; the set of symbolic forms on which a given work is based. Originally, the study and identification of classical portraits. Renaissance art drew heavily on two **iconographical** traditions: Christianity, and ancient Greek and Roman art, thought and literature.

lectern, a reading stand or desk, especially one at which the Bible is read.

loggia (It.), a gallery or room open on one or more sides, its roof supported by columns. Loggias in Italian Renaissance buildings were generally on the upper levels. Renaissance loggias were also separate structure, often standing in markets and town squares, that could be used for public ceremonies.

Madonna of Mercy, a depiction of the Virgin Mary in which she holds her cloak open over those who seek her protection.

mandorla (It. "almond"), an almond-shaped radiance surrounding a holy person, often seen in images of the Resurrection of Christ or the Assumption of the Virgin.

medallion, in architecture, a large ornamental plaque or disc.

obsequies (Lat. *obsequia*, "services, observances"), rites performed for the dead.

panel painting, painting on wooden panels. Until the introduction of canvas in the 15th century, wooden panels were the standard support in painting.

Pantheon, temple built in Rome about 25 BC by Emperor Agrippa. Having a circular plan, and spanned by a single dome, it was one of the most distinctive and original buildings of ancient Rome.

pendant (Fr. "hanging, dependent"), one of a pair of related art works, or related elements within an art work.

perspective (Lat. *perspicere*, "to see through, see clearly"), the method of representing three-dimensional objects on a flat surface. Perspective gives a picture a sense of depth. The most important form of perspective in the Renaissance was **linear perspective** (first formulated by the architect Brunelleschi in the early 15th century), in which the real or suggested lines of objects converge on a vanishing point on the horizon, often in the middle of the composition (**centralized perspective**). The first artist to make a systematic use of linear perspective was Masaccio, and its principles were set out by the architect Alberti in a book published in 1436. The use of linear perspective had a profound effect on the development of Western art and remained unchallenged until the 20th century.

pilaster (Lat. *pilastrum*, "pillar"), a rectangular column set into a wall, usually as a decorative feature.

pointed arch, in architecture, an arch rising to a point (instead of being round, as in classical architecture). The pointed arch is characteristic of Gothic architecture.

predella (It. "altar step"), a painting or carving placed beneath the main scenes or panels of an altarpiece, forming a kind of plinth. Long and narrow, painted predellas usually depicted several scenes from a narrative

profil perdu (Fr. "lost profile"), a pose in which the figure's head is turned away from the viewer so that only an outline of the cheek is visible.

putti, sing. **putto** (It. "boys"), plump naked little children (usually boys), most commonly found in late Renaissance and Baroque works. They can be either sacred (angels) or secular (the attendants of Venus).

Quattrocento (It. "four hundred"), the 15th century in Italian art. The term is often used of the new style of art that was characteristic of the Early Renaissance, in particular works by Masaccio, Brunelleschi, Donatello, Botticelli, Fra Angelico and others. It was preceded by the **Trecento** and followed by the **Cinquecento.**

relief (Lat. *relevare*, "to raise"), a sculptural work in which all or part projects from the flat surface. There are three basic forms: low relief (*bas-relief, basso rilievo*), in which figures project less than half their depth from the background; medium relief (*mezzo-rilievo*), in which figures are seen half round; and high relief (*alto rilievo*), in which figures are almost detached from their background.

Sacra Conversazione (It. "holy conversation"), a representation of the Virgin and Child attended by saints. There is seldom a literal conversation depicted, though as the theme developed the interaction between the participants – expressed through gesture, glance and movement – greatly increased. The saints depicted are usually the saint the church or altar is dedicated to, local saints, or those chosen by the patron who commissioned the work.

sarcophagus, pl. **sarcophagi** (Gk. "flesh eating"), a coffin or tomb, made of stone, wood or terracotta, and sometimes (especially among the Greeks and Romans) carved with inscriptions and reliefs.

sibyls, in antiquity, women who could prophesy. In Christian legend, Sibyls foretold the Birth, Passion and Resurrection of Christ, just as the male prophets of the Bible did.

sinopia, the preparatory drawing for a fresco drawn on the wall where the painting is to appear; the red chalk used to make such a drawing.

sotto in sù (It. "up from under"), perspective in which people and objects are seen from below and shown with extreme foreshortening.

stigmata, sing. **stigma** (Gk. "mark, brand, tattoo"), the five Crucifixion wounds of Christ (pierced feet, hands and side) which appear miraculously on the body of a saint. One of the most familiar examples in Renaissance art is the **stigmatization** of St Francis of Assisi.

tempera (Lat. *temperare*, "to mix in due proportion"), a method of painting in which the pigments are mixed with an emulsion of water and egg yolks or whole eggs (sometimes glue or milk). Tempera was widely used in Italian art in the 14th and 15th centuries, both for panel painting and fresco, then being replaced by oil paint. Tempera colors are bright and translucent, though because the paint dried very quickly there is little time to blend them, graduated tones being created by adding lighter or darker dots or lines of color to an area of dried paint.

terracotta (It. "baked earth"), unglazed fired clay. It is used for architectural features and ornaments, vessels, and sculptures.

tondo, pl. **tondi** (It "round"), a circular painting or relief sculpture. The tondo derives from classical medallions and was used in the Renaissance as a compositional device for creating an ideal visual harmony. It was particularly popular in Florence and was often used for depictions of the Madonna and Child.

Trajan's Column, a monumental column erected in Rome in 113 AD to commemorate the deeds of Emperor Trajan. Around its entire length is carved a continuous spiral band of low relief sculptures depicting Trajan's exploits.

triptych (Gk. *triptukhos*, "threefold"), a painting in three sections, usually an altarpiece, consisting of a central panel and two outer panels, or wings. In many medieval triptychs the two outer wings were hinged so that could be closed over the center panel. Early triptychs were often portable.

triumphal arch, in the architecture of ancient Rome, a large and usually free-standing ceremonial archway built to celebrate a military victory. Often decorated with architectural features and relief sculptures, they usually consisted of a large archway flanked by two smaller ones. The triumphal archway was revived during the Renaissance, though usually as a feature of a building rather than as an independent structure. In Renaissance painting they appear as allusion to classical antiquity.

tympanum (Lat. "drum"), in classical architecture, the triangular area enclosed by a pediment, often decorated with sculptures. In medieval architecture, the semi-circular area over a a door's lintel, enclosed by an arch, often decorated with sculptures or mosaics.

typology, a system of classification. In Christian thought, the drawing of parallels between the Old Testament and the New. **Typological** studies were based on the assumption that Old Testament figures and events prefigured those in the New, eg the story of Jonah and the whale prefigured Christ's death and resurrection. Such typological links were frequently used in both medieval and Renaissance art.

vanishing point, in perspective, the point on the horizon at which sets of lines representing parallel lines will converge.

vault, a roof or ceiling whose structure is based on the arch. There are a wide range of forms, including: the **barrel** (or **tunnel**) vault, formed by a continuous semi-circular arch; the **groin** vault, formed when two barrel vaults intersect; and the **rib** vault, consisting of a framework of diagonal ribs supporting interlocking arches. The development of the various forms was of great structural and aesthetic importance in the development of church architecture during the Middle Ages.

SELECTED BIBLIOGRAPHY

Adelmann, W, H. Albertus, G. Boulboullé and others: Florenz. Ein Reisebuch, Bremen 1983

Baxandall, Michael: Painting and Experience in the Fifteenth Century Italy, A Primer in the Social History of Pictorial Style, Oxford 1972

Bialostocki, Jan: Spätmittelalter und beginnende Neuzeit, in: Propyläen-Kunstgeschichte, special edition, volume 7, Frankfurt am Main/Berlin 1990

Borsook, Eve and Johannes Offerhaus: Francesco Sassetti and Ghirlandaio at Santa Trinità, Florence. History and Legend in a Renaissance Chapel, Doornspijk 1981

Castelfranchi Vegas, Liana: Italian und Flandern. Die Geburt der Renaissance, Stuttgart/Zurich 1994

Davies, Gerald S.: Ghirlandaio, London 1908

Egger, Herman: Codex Escurialensis. Ein Skizzenbuch aus der Werkstatt Domenico Ghirlandaios, Vienna 1905

Hauvette, Henri: Ghirlandaio, Paris 1907

Kecks, Roland G.: Ghirlandaio, catalogo completo, Florence 1995

Kempers, Bram: Kunst, Macht und Mäzenatentum. Der Beruf des Malers in der italienischen Renaissance Munich 1989

Küppers, Paul Erich: Die Tafelbilder des Domenico Ghirlandajo, Strasbourg 1915

Lauts, Jan: Domenico Ghirlandajo, Vienna 1943

Micheletti, Emma: Domenico Ghirlandaio, Florence/Milan 1990

Prinz, Wolfram and Max Seidel: Domenico Ghirlandaio, Atti del Convegno Internazionale. Firenze 16–18 ottobre 1994, Florence 1996

Steinmann, Ernst: Ghirlandaio, Bielefeld/Leipzig 1897
Vasari, Giorgio: The Lives of the Artists, tr. by Julia Conaway Bondanella and Peter Bondanella, Oxford 1991

Warburg, Aby: Bildniskunst und Florentinisches Bürgertum. Domenico Ghirlandajo in Santa Trinità. Die Bildnisse des Lorenzo de' Medici und seiner Angehörigen, Leipzig 1902

PHOTOGRAPHIC CREDITS